THE
BODY ART
BOOK

THE BODY ART BOOK

A COMPLETE, ILLUSTRATED GUIDE TO TATTOOS, PIERCINGS, AND OTHER BODY MODIFICATIONS

JEAN-CHRIS MILLER

Illustrations by Denise de la Cerda

BERKLEY BOOKS, NEW YORK

This book stresses the need for safety precautions, the use of an experienced body art practitioner, and the importance of proper tools and techniques. Even if the cautionary advice is followed, tattoos, piercings, and other body modifications involve physical risk. The author and publisher specifically disclaim responsibility for any adverse effects or unforeseen consequences resulting from the use of any information contained herein and do not endorse any of the body art practitioners listed in this book. The reader is advised to consult his or her physician immediately if any complications arise.

A Berkley Book
Published by The Berkley Publishing Group
A division of Penguin Group (USA) Inc.
375 Hudson Street
New York, New York 10014

THE BODY ART BOOK

PRINTING HISTORY
First Berkley trade paperback edition / October 1997
Updated Berkley trade paperback edition / July 2004

ISBN: 0-425-19726-3

PRINTED IN THE UNITED STATES OF AMERICA

10 9 8 7 6 5 4 3 2 1

*This book is dedicated to Casey Exton,
who has tirelessly championed body art
and artists for many years.*

ACKNOWLEDGMENTS

I WOULD LIKE TO thank the following people for their support, advice, and inspiration: Denise de la Cerda, Anil Gupta, Dennis Feliciano, Myke Maldonado, Maya, Mike Martin, Artie Richard, Albert Sgambati, Mike Sirot, the crew at Streamline Tattoos, Nick Wiggins; my body art partners-in-crime: Amy Becker, Annemarie Fasulo, Tony Romel Garcia, Ken Knabb, Dan Levine, Brenda Mercado, Victoria Minervini, and Marco Turelli; Tom, Judy, Scott & Sean Miller, and Jean Demuth.

CONTENTS

INTRODUCTION

BODY ART IS EVERYWHERE these days. Tattoo designs are exhibited in galleries; pierced belly buttons are trendy among fashion models; Greek symbols are traditionally branded into fraternity brothers' skin. It seems as if the whole world has rediscovered the ancient art of decorating one's body with permanent marks.

These permanent marks are part of what define us as human beings. They are a means of self-expression and a vehicle of self-awareness, two qualities that separate us from other living things on this planet. No other animal decorates itself—and decoration is just one aspect of body art. Tattooing, piercing, and other adornments have been used for centuries in rites of passage, in religious rituals, or as a form of tribal identification—in *all* cultures.

Sometimes they're emblems that commemorate special events in a person's life. Many different tribes of Asian women shared the tradition of getting tattooed during pregnancy. The reasons for the tattoos varied, from protecting mother and child against demonic possession to influencing the baby's sex, but the end result was always the same: a permanent souvenir of a life-changing moment. This is also why many religious pilgrimages are documented with a sacred tattoo.

The fact that these designs are permanent also reminds the wearer that she is changed forever. Thus, the worldwide association of tattooing, cutting, branding, etc., as a rite of

passage. Because these procedures involve some degree of pain (much more in the past than now), they show the wearer to be strong and fearless.

Occasionally tattoos are clan markings that identify a person with a particular group. For example, some pre-Christian European cultures believed that when a person died, unless he bore the mark of his tribe, he'd wander around in the next world searching aimlessly for his own kind, throughout eternity. Tattoos were used to mark a person's clan affiliations in *this* world so that he could find (and be found by) other members of his clan in the next one.

Tattooing is by far the most popular kind of permanent body decoration, and is now considered a respected form of "folk art"—art created by the common people, for the common people, reflecting their particular traditions and culture. Unlike other body adornments, which are ruled by the whims of fashion—baby-blue or gunmetal-gray fingernail polish, long sideburns, short sideburns, no sideburns—tattooing is based completely on what *you* are into and think is cool, beautiful, or appropriate.

And unlike nail polish or hairstyles, which are temporary ways of revealing your personality, a tattoo is forever. That's why it's so important that the tattoo you choose be one you'll be happy with and proud of for the rest of your life (and beyond—tattoos are still clearly visible on mummies, even after five thousand years!). It must be a good design, placed properly on your body, be the right size, and most important, it must be done well. Remember, it will be there forever, so there's really no such thing as taking too long to decide what you want, where you want it, and whom you want to do it. Tattooing is a unique and artistic way to show the world what you're all about.

Piercing is another form of expression that's very creative and individualized—and also pretty permanent. You can remove the jewelry, but the hole will remain for quite some

time, so, like tattooing, it requires planning and knowledge to get something you'll always enjoy. Nor do you want to walk around with the wrong kind of jewelry in your piercing. You may think it's very cool to have that giant ring hanging from your septum, flapping over the top of your lips, but are your friends whispering *"toro, toro!"* behind your back? Nothing complements a face better than a well-placed piercing, one that's not too big or too small. That little gleam of metal adds character, mystery, and undeniable sex appeal. And don't let anyone tell you piercing is some weird, new craze; piercing and other body arts have always been a part of humankind's beauty vocabulary.

Today, in our Western culture, we're witnessing a renewed interest in tattooing, piercing, and other body modifications. Although these practices have always been around, they've usually bounced back and forth between acceptability and outsider status, depending on the cultural climate of any given period. During the Victorian era, for example, a time of public purity and private debauchery, it was fashionable for society women to have their nipples pierced. Yet the children and grandchildren of those Victorian women would have considered these matriarchs downright uncivilized, just as the great-great-grandchildren of those same ladies probably see nothing wrong with their, if you will, titillating decorations. In the past twenty years, the body art movement has exploded. The art itself has reached creative and technical heights never before imagined, and permanent personal decoration is gaining wider popularity.

Despite the long and important history of body art, some say tattooing is just a trend that will disappear in a few years. But with an estimated one out of every eleven people in the United States alone sporting some kind of ink, that hardly seems likely. Instead, we have reintroduced a means of expressing ourselves that can carry many levels of significance, both personally and culturally determined.

3

That's the difference between trendiness and timelessness—the significance and forethought you give the work. Something that requires such a big commitment (it's lifelong, it may hurt a little, you have to care for it to keep it looking good) requires a lot of planning. *Permanent body art is a big decision that will affect the rest of your life.*

There's a revolution in personal style happening now; high-fashion designers take their cues from funky streetwear while street kids flaunt their designer labels. These unforeseen convergences are breaking down the class stereotypes associated with a certain "look"—as the rules of style give way to individual taste. The unique and intimate nature of body art provides a means to express this individuality—something that's becoming pretty hard to do these days. In an age of the shop-at-home/bank-at-home/work-at-home lifestyle, it's very easy to feel that we are little more than a series of digits: credit-card numbers, E-mail addresses, PINs. Our neighborhoods and cities are losing their distinct flavors; one area looks so much like the next, it's as if the planet is becoming one big strip mall. There is little sense of community and even less cultural identification. On top of it all, we are faced with an increasing loss of personal freedoms, as more and more areas of our lives become regulated by the government. Wearing seat belts, getting immunization shots, or recycling our newspapers—these are no longer our decisions. It's easy to see how all of this could make us feel we're something less than unique individuals.

Certain folks use body art as a way to reclaim some of the customs and magic of their ancestors, or to symbolize important occasions or transitions in their lives. Some want to adorn themselves in ways *they* think are attractive; their definition of beauty is not the blond-haired, blue-eyed one that they see in *Vogue* or *GQ*—it's something wilder, more exotic. Others just want to shock and amaze the neighbors. Whatever the reason, tattooing, piercing, and the rest of the body arts can be very

powerful for two reasons. *They give us control over our own bodies and they express things about our inner selves that words alone often cannot articulate.*

Permanent body art is a dramatic and artistic way to show the world something about your personality—and the fact that this art is slightly unconventional and somewhat daring only adds to its appeal. There are so many possibilities and variations to tattooing and piercing that it can all seem overwhelming. In fact, learning about these possibilities is half the fun. As you become more familiar with the rich history and endless variety of tattooing, piercing, and other forms of body art and body modifications, you'll see just how creative and meaningful they can be.

There are also some very real health concerns you must be aware of before letting anyone come near you with a needle. Most significant is knowing how diseases are transmitted and what precautions the artist you choose must take to prevent contamination. But there are also infections, allergies, and other sensitivities to consider, all of which we will cover in this book. You play as great a part in assuring successful work as the person you choose to execute it does—ultimately, your body art is *your* responsibility.

This book will give you the information necessary to get the best and safest tattoo or piercing possible. It's written so that you can access data easily and quickly. You'll be able to refer to it again and again, because it covers everything from planning your design, to choosing your artist, through aftercare, and much, much more—everything you need to become a walking, talking work of art!

CHAPTER 1

A BRIEF HISTORY
OF BODY ART

TOOLS USED FOR TATTOOING, dating back approximately forty thousand years (the Upper Paleolithic period), were recently uncovered at several European archeological digs. This dates humankind's desire to adorn themselves with permanent markings to roughly the same period as the oldest known cave paintings. Could body art have been one of our original creative impulses, among the first means of expression developed by humans? As tattoos, piercings, and other forms of body art have been "reintroduced" into modern society, their historical and cultural importance have been acknowledged by the scientific community, which has led to greater and greater archeological documentation of the ancient art. This flood of data proves that body adornment is fundamental to what it means to be a human being; it is part of who we are.

The most ancient tattooed specimen, to date, is that of the "Iceman," a Bronze Age man recently uncovered after being frozen in a glacier on the Tyrolean Alps (between Austria and Italy) since about 3300 B.C. Fifty-seven tattoos have been identified on his body, with most found on his lower back (a band of stripes), behind his knee (a simple cross), and on his right ankle (more stripes). The tattoos could have been ornamental, or perhaps they marked his status in his tribe. It

is more likely they were healing or protective talismans used to prevent pain in those areas of his body.

There are lots of examples of tattooing in ancient Egypt, the oldest being two female mummies, who both lived over four thousand years ago. One was an Egyptian priestess. Her tattoos consisted of haphazard slashes all over her body. It's probably safe to assume, because of her status, that her body art had religious or magical connotations. The other mummy had both tattoos and decorative scarification. It's been speculated that her body adornments enhanced her sexual attractiveness and/or were talismans to ensure her fertility.

There's also evidence of piercing in ancient Egypt. A statue of Akhenaton, dating back to about 1400 B.C., depicts what many consider to be a navel piercing on the famous pharaoh. The sculptor carved out a hole above the navel from which, most likely, hung some kind of golden jewelry. As is the case with many ancient artifacts, that jewelry was stolen centuries ago.

In countries where people have dark skin, branding, piercing, scarification, and other elaborate body modifications have been practiced for centuries—and still are! The variety and uniqueness of body modifications found in these places is fascinating. Elongating the neck by adding a series of copper rings, inserting plates in the lip, and greatly stretched earlobes are just a few of the practices still seen in countries from Africa to South America and Asia.

Ancient Greeks found an interesting use for tattooing. It was not only a method of decoration and showing one's stature, but also a way to identify your secret allegiances to co-conspirators. There is some evidence of tattooing for tribal identification in ancient Rome, as well as piercing during the first century A.D. Some historians believe nipple piercing was used as a mark of rank among the centurions, a class of Roman military officers. It's even rumored that the centurions used their nipple piercings to fasten their heavy capes in place! What

better way to show your physical superiority and ability to with-stand pain than by attaching your clothing directly onto your chest? Mucho macho, centurion!

Some of the most diverse, ornate, and bizarre body art this planet has ever seen was found in the mysterious, complex world of the Maya. This civilization thrived in southeast Mexico, Guatemala, and Belize and reached its apex between 300 and 900 A.D. Mayan body modifications are among the most extreme, not only in the particular practices and the reasoning behind them, but in their incredible variety. For the Maya, body modifications, whether temporary or permanent, were done for spiritual reasons as well as beautification. At different times throughout their history, Mayan people favored various placements for their body art, but seen as a whole, there is practically no area that didn't get some kind of modification or adornment.

Full body tattoos, even facial tattoos, were acquired by men and women. Scarification was practiced by both sexes. Ears, nose, lips, navel, and genitals were all pierced, and often the holes were stretched bigger and bigger over time. Surface-to-surface piercings were done on the forehead, temples, arms, and legs. Teeth were filed to sharp points and inlaid with precious gems.

The Maya's extravagant modifications started at birth, when balls were hung between children's eyes to make them go cross-eyed. Babies were also fitted with wooden molds on their foreheads to reshape them into a continuous slope that started at the bridge of the nose and angled back to the top of the head. Crossed eyes and sloping foreheads were considered highly attractive features that every Mayan struggled to attain. Theirs is just one example of how different cultures use body art and body modification to achieve *their own idea of beauty*.

Sometimes body art is used as a defense tactic. Just as you might think twice before getting in the way of a big biker

with skulls tattooed all over his body and a thick ring through his nose, so did our ancestors ponder doing battle with wild tribes who had, as an example, blue skin (think *Braveheart*). British warriors stained themselves with woad (blue dye made from a mustard plant), and cut patterns into their skins, basically to psych out their opponents. Others used tattooing and scarification as a way to show which tribe they belonged to. The Picts, who inhabited northern Britain, are so named because of the pictures tattooed on their skins.

Just as in other cultures with tattoo traditions, when these pagan tribes were "converted" to the Christian religion, their spiritual and cultural rites (which included tattooing, piercing, and scarification) were outlawed. This banishment of body art stems from a passage in the Old Testament, Leviticus 19:28, which states, "Ye shall not make any cuttings in your flesh for the dead, nor print any marks upon you . . ." How this decree against mutilating yourself in memory of the dead was interpreted to include all tattoos is anybody's guess. For those of you who follow the spiritual laws decreed by the Old Testament, keep in mind that Leviticus 19:27 states: "Ye shall not round the corners of your head, neither shall thou mar the corners of thy beard." No tattoos, no haircuts.

As the Crusades gave way to the Inquisition, it became a serious offense to have tattoos because it meant the wearer had been involved in another religion. While these and other body modifications continued underground as a way for non-Christian people to identify each other, God forbid if you got caught and your mark was revealed. Well, according to Señor Torquemada and his cohorts, God *did* forbid it.

Tattoos remained an archaic taboo until their reintroduction to the Western world in the late eighteenth century by way of a British exploration to chart "undiscovered" lands. Captain James Cook, in his ship the *Endeavor,* sailed on August 16, 1768, planning to circumnavigate the globe. During his three-year journey, he identified many islands of the

Pacific Ocean, most of which included tattooing as part of their culture. It's Cook who gave us the word we spell as "tattoo," based on similar words in Polynesian cultures that were used to describe the practice.

On board the *Endeavor* was Sir Joseph Banks, a British botanist. Along with cataloging many types of animal and plant life, Banks documented the indigenous cultures at every stop along the way. Included in these notes are many references to tattooing, which are important not only historically, but also helped rekindle interest in the practice in Europe. When the *Endeavor* returned to England in 1771, Banks came back with a permanent memento of his voyage; the first tattoo on a modern Western man!

One of the tattooing cultures Banks wrote about was that of the Maori (of Polynesian-Melanesian descent) of New Zealand. The Maoris' tattooing custom is a facial decoration called *Moko*. It is an ancient practice that connects the wearers with their ancestors. Maori facial tattoos tell you everything you need to know about a person: their rank in the community, who their father was, even how many times they'd been married. After almost fading into oblivion, the Moko is now experiencing something of a revival. This is also true of the Samoan tradition of Pe'a, body tattoos which were so painful to receive that the wearer sometimes died. To survive the Pe'a tattooing process was a positive reflection of a person's strength and stamina. Both of these unique and beautiful tattoo traditions have been heavily researched and their styles are being revived by Western people using modern techniques.

The sailors that traveled the globe in the eighteenth and nineteenth centuries were responsible for the resurgence of tattoos in European cultures. Seamen returned from their exotic travels with stories of abduction and forced tattooing. (*Take your pick: Either you get a big tattoo on your back or we use you for target practice.*) In the early 1800s, it was a fad among the European upper classes to get tiny tattoos as a way to vicariously

live a small bit of the wild stories these men would tell—even though the veracity of these stories is highly questionable. It's much more likely that the excitement and freedom these men experienced on the open seas and in less restrictive cultures led them to do things which would be unacceptable in their homelands . . . like getting tattooed.

Soon a few sailors found themselves the darlings of the salon society. They would entertain rich people at private parties with stories of danger and adventure, made all the more believable by the strange tribal tattoos they sported. Western societies' fascination with tattooed people was exploited by circuses and traveling sideshows—many a retired sea dog made a bundle posing as a "Live Wild Man." But by the late 1800s, tattooed people were so common on the traveling show circuit that promoters had to go to greater extremes to attract the crowds. Entire tattooed families would be exhibited, and if that wasn't enough, even their tattooed pets would be put on display! By the turn of the century, audiences had seen tattooed people (and animals) of every kind, so shows added "geeking" (bizarre acts like swallowing worms or biting the heads off chickens) and exotic talents, like sword swallowing or pounding nails into the nose, to their side attractions' repertoire.

The custom of sailors (and all branches of servicemen) getting tattooed continues to this day. Traditional seafaring tattoos are still around, and have roots that go back more than a hundred years. Seamen are commonly known as superstitious folk. Many of the "sailor" tattoos still seen today have roots in seafarers' mysticism. Those tattoos were for protection, remembrance, or to signify a voyage. A rooster tattooed on one foot and a pig tattooed on the other was believed to prevent a man from drowning. Swallows, still a common tattoo symbol, served to help a sailor navigate the seas and make sure he made it home. They also served as markers for time spent traveling. One swallow meant the sailor had logged at least five thousand miles at sea, and each

additional swallow represented another five hundred miles. Other traditional symbols indicated the sailor had crossed the equator (Neptune/Poseidon, god of the sea) or the international dateline (a dragon).

Also, tattoos were a good way to recognize a person who may have died an ugly death in battle. Having this indelible mark meant that your body could be identified and sent home. Even now, just as with criminal records, military records make note of a person's body art as a means of identification.

On December 8, 1891, the first electric tattoo machine was registered by its inventor, Samuel O'Reilly, at the United States Patent Office. It was based on a machine patented by Thomas Edison in 1875, but rather than using the tool as a means to embroider fabric, which Edison did, O'Reilly's tattoo machine was meant to "embroider" skin. He began working out of a barbershop in New York City, calling his business a "tattoo parlor"—the first one in the United States.

Soon tattoo parlors were springing up all over the country—mainly in port towns to serve their naval clientele. With the advent of the First and Second World Wars, different branches of the military adopted the sailors' tradition of tattooing as a means of mystical protection, a souvenir or remembrance, or just to show what badasses they were!

The prison tradition of tattooing springs from these same motives. Inmates' permanent marks showed the world they were fearless and not to be toyed with (serving a purpose much like ancient warriors' body art). A whole style of tattooing, *Jailhouse* or *Black and Gray* (so named because the work was generally rendered in the available black ink), evolved from prison tattooing. Many books have been written about the secret language of prison tattoos all over the world.

In the 1970s, a handful of early tattoo events were held that changed the course of modern body art. For the first time, tattooists came together as a group to talk shop, and tattoo fans came together to show off their work. Up until the late

1970s/early 1980s, tattooing was a very secretive craft, and tattooists guarded their techniques, their equipment, and their territory ferociously. It was impossible to "break into the business"; no one would teach an outsider anything. If you were lucky enough to be taught how to tattoo by an old-timer, you were virtually an indentured servant to that person, working for him until he retired or died. Should you attempt to start your own tattoo business, you would be run out of town, your shop burned to the ground, and your hands broken to ensure you wouldn't be able to tattoo again—and that's if you were *lucky*! The territorial aspect of tattooing persists, in varying degrees, to this day.

Slowly, due to conventions, magazines, and other kinds of exposure, tattooing began to emerge from the underground. People started to recognize the artistic merit and folk art tradition of tattooing, and to see that skin art could be worn by more than just convicts, sailors, and carnival people. Its exotic and erotic nature appealed to a generation obsessed with liberating their bodies and their minds, as well as rejecting all things conventional and "square."

In the early 1980s, fine art discovered tattooing. Artists like Ed Paschke and Tony Fitzgerald began using tattoo imagery in their paintings. Others began exploring tattooing itself as a new medium of expression. The interest of fine artists in tattooing helped to not only legitimize it in many people's eyes, but also expanded tattooing's creative vocabulary—there was an explosion of styles and imagery. This is referred to as the *New School,* the period when tattooists started to consider their craft an art form, and began to share their knowledge with others while constantly pushing the limits of tattoo technology.

The body-art revolution had begun.

With the arrival of tattoo magazines and annual conventions, body art began reaching millions of people who would have never before considered it a legitimate means of expression. In 1989, Re/Search Publications put out a book called

Modern Primitives, which introduced the world to a California man who calls himself Fakir Musafar. Musafar has been exploring (and documenting) body adornments and rituals since his youth. His personal transformations include piercing, tattooing, suspension by hooks, neck stretching, waist cinching, and scarification—virtually any form of body modification known to humankind. Fakir Musafar now operates a school of body modification in San Francisco, and is generally considered the spearhead of the piercing movement—the "Godfather of Hole."

The influence of Fakir Musafar's exploration of other cultures' body adornments, plus movie role models such as the futuristic savages in *Mad Max,* and the biomechanical hybrids in *Hellraiser* and the *Alien* movies, turned "Modern Primitives" into a full-blown movement, which incorporates past traditions of many cultures, current social and political concerns, and futuristic visions of the human race.

As you can see from this brief history, body art is somewhat cyclical in nature. Today we're experiencing one of the biggest revivals ever. The combination of technology, history, and artistic ability have taken body art to heights never before imagined. It's very exciting to wonder just how far we can go. More than part of our past, body art is part of our present and our future.

CHAPTER 2

STYLES OF
BODY ART

TATTOOS

TATTOOING IS AN EXPRESSIVE, dramatic, and diverse art. Tattoo imagery is limitless—the only boundary is your imagination. The more you know about the options available to you, the more informed your decision will be about what design or image you want to wear forever.

Most tattooists specialize in a certain style of tattooing, the fundamentals of which can be summarized as three basic approaches: *Flat,* which is characterized by a lack of detail; *Traditional* (and *Neotraditional*), which is known for thick, black outlines and solid blocks of color; and *Fine Line,* which is distinguished by narrower, finer lines and greater detail. The first step in figuring out what kind of tattoo you want is choosing which of these techniques most pleases you.

Flat Tats

Flat tattooing employs solid blocks of color (often in black) with no shading, detailing, or texturing of any sort. Shapes and simple symbols are tattooed in one thick line (think of the

biohazard symbol or a music note), and can be filled in or left as an outline.

Flat tattooing is perhaps best represented by the *Tribal* style. This (also called *New Tribal*) is a catchall title for many different styles found all over the world. From Alaska to New

Zealand, Asia to Nicaragua, simple designs rendered in dark ink have been used to show a person's status, protect from harm, and enhance appearance.

Tribal takes two basic forms: *Geometric* (which uses shapes such as circles, squares, and triangles to create a cohesive overall design) and *Organic* (which uses flowing lines that follow the natural lines of the body).

Flat tattooing—if it's done well and complements your musculature—results in a very flattering, striking piece of abstract art.

The disadvantage is obvious: it's flat. A lump of color on your skin.

Traditional

Traditional (and its funkier cousin, Neotraditional) tattooing got its name from the kind of skin art that was done in the late 1800s into the early half of this century in the Western world. Traditional tattooing is based on clean, simple design and execution, and uses thick, black, outlines, filled in with solid blocks of color. There's little detail in the work apart from what is absolutely necessary to convey the design, and this is done with color and shading instead of more intricate outlines. Daggers, hearts, snakes, pinup girls, panthers, roses, eagles, and butterflies are all Traditional design motifs (although they can be rendered in any tattoo style, just as any design can be done in the Traditional style).

Neotraditional takes the imagery and aesthetic ideas of Traditional tattooing and throws in fine-arts techniques and pop-culture sass—the designs are a little more "cartoony." In Neotraditional tattooing, the skin that's *not* tattooed (called "negative space") is as important as the skin that *is* (a basic rule that applies to lots of tattoo designs); skilled shading and color layering give the work depth. Flat fill-in of an outline is *not* Neotraditional tattooing.

18

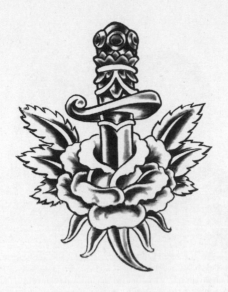

The advantages to modern Traditional tattooing are that the pieces are visually striking and they age well. These simple designs, with bold colors and thick outlines, are easy to "read." The consensus is that Traditional tattoos can be seen from great distances (as opposed to Fine Line work, which often requires much closer inspection in order to see the detail) and will still be visible years from now (whereas "busier" or more cluttered designs can turn to "mush" over time). The rule of thumb is: If it's bold, it will hold.

The potential problem with Traditional tattooing is that you could end up with a crude piece of work. Clean, simple work requires as much skill as more complicated work.

Fine Line

Modern Fine Line tattooing changed the nature of ink slinging. It expanded the imagery tremendously (virtually anything can be translated into a tattoo now) and opened the craft up to serious artistry. It's characterized by thin(ner) outlines, precise shading, and detailed designs. There is much

more focus on the lines of a tattoo. Using smaller needle configurations (the number of needles bunched together to create different tattoo effects)—single-needle to three- or occasionally five-needle setups—the tattooist can create complex work with delicate coloring, subtle highlights and undertones, intricate patterns, and realistic representations.

From *Portraiture* to *Black and Gray* to *Celtic,* the exactness of Fine Line allows for precision and intricacy in your tattoo. Complex shading gives the work more naturalistic shape, texture, and added dimension—the tattoo looks like it could jump right off of your skin!

The trick is to not cram too much into the design. Overdetailing will make the tattoo hard to read; and unlike other art mediums, *your* canvas is a living organism that will change through the years. It will wrinkle, sag, dry out, and change texture. Don't be swayed by overeager tattooists who say they can fit all two-hundred-plus bones in the human body into that tiny three-inch skeleton tattoo you want. Re-

member: *The more complicated the tattoo, the bigger it has to be.* That simple. A good Fine Line tattooist will give you a piece that lasts through the years—it's all a matter of skill.

A lot of tattooists combine the best of both worlds, incorporating the clean, solid blocks of color that characterize Traditional tattooing with the complex designs of Fine Line. The first step in choosing your tattoo is to decide which of these three basic approaches best suits you. This is the foundation for your choice of a design and of the tattooist who will realize it.

Within the context of Flat, Traditional, or Fine Line tattooing are grouped a number of different styles. For more on each of these styles, see the glossary of tattoo terminology contained in Chapter 4.

STYLES OF PIERCING

Piercing is an extremely popular form of body art these days. It can be understated and elegant, like a tiny nose ring; funky and fun, like a bunch of different piercing styles in the same ear; or radical and extravagant, like surface-to-surface piercings on the neck or hand. Whichever way you play it, you *must* go to a professional piercer. Not only are professional piercers trained in the areas of safety and health, they have an *aesthetic* understanding of piercing as well.

Body Jewelry: Styles, Metals, and Sizes

Just as important as choosing the right piercing professional is wearing the right jewelry. Many problems encountered with piercings, even after they're healed, result from putting the wrong kind of jewelry in the hole.

Professional body jewelry is hypoallergenic, which means it's unlikely to provoke an allergic reaction. The metals used

are highly inert (they don't react readily with other chemical compounds) and oxide-resistant (exposure to oxygen, water, or bodily fluids will cause most metals to corrode from oxidization). Body jewelry comes in many different sizes and is measured not just by how big the ring or barbell is, but by how thick it is (called the *gauge*).

With a little education, you can create a unique personal statement with the jewelry you wear. Once your pierce has gone through the primary healing process, you're ready to explore the options!

Jewelry Styles

The design and manufacturing of body jewelry is in its infancy; new styles are being introduced to the market every day.

The most common pieces of body jewelry are the *bead ring,* a ring with a bead that screws in the ends, and the *captive bead ring,* which is just what it says: a ring fastened by a bead that is held in place—"captive"—by tension. Bead rings come in many shapes besides round. They can be teardrop-shaped, oval, or even square.

Another common body jewelry design is the *barbell.* This is a long post with beads that screw into both ends. Barbells

can be straight, curved, or circular. Some barbells have one flat end and one beaded end for piercings that go through the inside of your mouth; these are called *labret studs*. This way, the end of the barbell is flat inside your mouth with no pesky bead to annoy you.

There is a special stud for your nostril, called a *nostril screw*. The post of this stud is corkscrew-shaped, which prevents it from popping out. For a wilder look through your septum, try a *spike* or a *tusk*. For a (much) milder look, a *septum retainer* is used to maintain your septum piercing when you don't want to wear jewelry. This open-ended, horseshoe-shaped piece pivots back into your nostrils to hide your piercing.

Some people stretch their piercings; they widen the holes by progressively inserting larger and larger gauges of jewelry. There are two kinds of special jewelry used in stretched piercings that really show off the size of the hole. The first is a *plug*, which is a cylindrical, solid piece that's held in place by a rubber ring on each end. A stretched hole can also be dec-

orated with a metal *earlet* (or *eyelet*), which is a hollow tube with flared ends—think of a thimble that's open on both ends. Earlets are also called *flesh tunnels,* an appropriate name because you can clearly see through their hollow center.

Jewelry Metals

A professional body piercer will offer you a wide selection of jewelry made from nonreactive metals. The most commonly used are *surgical stainless steel, niobium,* and *titanium.* To decrease the risk of infection or allergic reaction, and to ensure that your piercing heals properly, you *must* wear suitable jewelry, and that means one of the three above metals.

Surgical stainless steel should be of the highest grade, commonly referred to as "316-L"; this is the same grade surgeons use for implants in the body. It doesn't tarnish, it's scratch-resistant, and it's very strong, so it won't change shape. Of course it only comes in one color—silver—but the pieces that screw into the end of surgical-stainless-steel jewelry come in a variety of colors and shapes.

Niobium and titanium start out a silverish color, but through the process of anodization (electric currents and oxides are used to "coat" the surface, which then reflects a specific color when seen in the light), they can be produced in a rainbow of colors. There's a slightly greater risk of allergic reaction with niobium (but only if you suffer from extreme metal allergies already), but titanium is considered the least reactive metal that body jewelry can be made from. Both are corrosion-resistant and lightweight.

Gold and sterling silver should *never* be used for initial piercings. Some piercers do initial piercings with a high grade of gold (18K or higher), but since there is no such thing as "pure" gold, this is not recommended. All gold is mixed with other metals, which may cause an allergic reaction in people with metal sensitivities. It's fine to use once your piercing has healed.

25

Sterling silver, on the other hand, is not a good metal to stick in a piercing at any point. Because it's mixed with other metals and has a tendency to flake off, almost everyone will have a reaction to sterling silver in their fresh piercing. Even if you use it in a completely healed piercing, it will still oxidize and turn black (like sterling silverware does)—disgusting!

Platinum and its offshoot, palladium, are also great for body jewelry, but are not used as commonly because of their cost.

After your piercing is healed, you may want to try acrylic (plastic), glass, or organic (wood, bone) jewelry for more variety. They look great, but do carry a greater risk of infection because they're porous, which means pesky little bacteria and fungi can grow in them, and they can crack. Let your professional piercer determine whether or not your piercing is sufficiently healed before trying them out.

Jewelry Sizes

Body jewelry comes in many sizes, and is measured in terms of both thickness, by gauge, and of diameter (or length for straight jewelry). The thickness of jewelry is measured by the Brown & Sharpe gauging system; the smaller the gauge, the thicker the jewelry, thus a ten-gauge ring is much thicker than a sixteen-gauge. Initial piercings are usually done with a twenty, eighteen, sixteen, or occasionally a fourteen gauge. A professional piercer will determine the best gauge for your initial piercing based on where the jewelry is going to be placed and how you want it to look.

The diameter measures the distance inside a ring; this corresponds to length in the case of a barbell. Because certain piercings swell a great deal when you first get them, you will go through two or more sizes of jewelry. For the initial piercing, the piercer must select jewelry that is wide enough, in the case of a ring, or long enough, in the case of a barbell, to

allow for any tissue inflammation. Once the swelling has sub-sided, you will *downsize* to a better-fitting piece of jewelry. A common example of downsizing is tongue piercings, which require at least two sizes of barbells—one size for the antici-pated swelling and one for the final outcome.

Some people don't settle for the gauge of their piercing once it's healed. They keep stretching the hole, making it larger and larger. Stretching is a creative way to change the appearance of your piercing. If you start out with an eighteen or sixteen gauge, after the piercing is fully healed, you can go back and have your piercer insert a thicker gauge, such as a fourteen or a twelve. Once that size heals, you can go down even further, to a ten or an eight. You can gradually work your way down to a 00 gauge—and beyond! Another way of stretching your piercing is to use an *insertion taper,* which has a fine point on one end and gradually flares out; the thicker part is slowly pushed through your ear, widening your hole. Your professional piercer can also supply you with a weight to hang from your piercing that will have the same effect.

JEWELRY GAUGE CHART

| | Thickness in | |
Gauge	Inches	Millimeters
20	0.032	0.813
18	0.040	1.024
16	0.051	1.290
14	0.064	1.629
12	0.081	2.052
10	0.102	2.588
8	0.128	3.264
6	0.162	4.111
4	0.204	5.186
2	0.257	6.543
0	0.324	8.230
00	0.364	9.246

CHAPTER 3
WHY WE DO IT

BODY ART IS A mode of self-expression that's been with us since we developed the motor skills needed to hold the tools that carved holes in our bodies. It's widely considered the *first* means of visual expression. Early people cut open their skin and rubbed soot into the wounds to mark themselves. They punctured their skin with the bones and teeth of animals. They decorated themselves with scars that formed intricate patterns.

A common question asked of our ancestors' body marks as well as our own is: Why do it? There are as many answers to that question as there are styles of body art. Let's start with the ancient body modifiers.

Maybe they marked themselves for defense; a person with big black stripes on his face or a boar's tooth through his nose could frighten an attacker off just by his appearance. They may have used tattoos and scarification as an early form of magic; a permanent symbol of the warm sun, for example, may have been thought to help stave off the effects of a cold, dark night. They could have shown spiritual devotion by "sacrificing" their flesh to the gods or made permanent marks that signified tribal affiliation. It could have been a way of proving they were brave and courageous warriors strong enough to stand the pain of ancient body-art practices (a true test of stamina!). Or it's possible they were just trying to improve their looks.

At some point in time, all of the above were reasons people got tattoos, piercings, or other modifications; and they're the same reasons we do so today. Nothing has changed in thousands of years, except the symbols themselves—and (thankfully) improved methods for doing the work!

Because we have few rites and rituals that mark life transitions or prove our devotion to a particular group or idea, body art often fills that void. Whether to signal a life passage or to enforce a belief, the ritual and permanency of body art fulfills some basic need we have as sentient beings.

Many people today get body art to mark transitions in their lives—such as turning eighteen, a death in the family, or surviving an illness or accident. These same rites of passage were once big events in which the entire community participated. Their importance was clear because of the rituals and ceremonies connected to them. Since we don't have those rituals anymore, many people find the permanency of a tattoo or other body modification a good way to mark a life-changing occasion.

Tattoos can also show allegiance to a group or philosophy. Many people, the world over, get inked to exhibit their religious convictions. Christian iconography is a typical tattoo motif; praying hands, Christ on the cross, and the Virgin Mary are images commonly made into tattoos. Skin art can also show the world other alliances you may have. Military personnel, college fraternities, members of Alcoholics Anonymous, and Deadheads all have tattoo imagery particular to their affiliations.

Others get inked for mystical reasons. It can be something simple, like a lucky number or animal; or more complex, like an entire Tibetan prayer or ancient runic symbols. These tattoos act as protective and empowering talismans for the wearer. There are even some body artists who perform ritual tattoos, piercings, brandings, and cuttings. They may suggest you consult your astrological chart to pick the right time to get your body art. They will burn incense, light candles, and let your loved ones be present, all to create a more ritu-

alistic environment. By incorporating your personal beliefs into the process, you can make getting tattooed or pierced a truly powerful experience.

Body art is also a way of recognizing our physical bodies, celebrating our corporeal selves with marks that are aesthetically pleasing. Tattoos can really complement the body, enhancing the good parts and camouflaging the bad parts. The glint of metal jewelry against the skin is an exotic and erotic complement. There's nothing wrong with getting body art just because you think it looks good!

These days, piercing is trendy enough that people get holes in their nipples, tongues, navels, and genitals simply for style reasons, but, of course, the *real* purpose of those piercings is to increase sexual stimulation. C'mon, do you really think someone would have a twelve-gauge post inserted through a sensitive body part if there wasn't a *big* payoff? Body art makes you very conscious of your physical self—whether it's the stimulation that having a piece of metal shoved through your skin gives or just the personal satisfaction that comes from seeing your skin decorated with beautiful designs.

There are people whose body-art practices stem from an interest in the ways other contemporary cultures adorn themselves, express their beliefs, show their status, and mark important moments in their lives with tattoos, pierces, and other permanent marks. Such people are called *neotribalists*.

As the world becomes more of a "melting pot," linking us all together through advances in communication, travel, and trade, thousands of cultures are being swallowed by global Westernization. Traditions that have endured for centuries are suddenly rejected by people brainwashed into believing that television, fast food, and sneakers are more important than the values of their ancestors. Neotribalists try to preserve the unique flavor of each little pocket of civilization. They want to experience and learn from other customs, present and past, and develop their own meaningful rituals from that information.

Like many people into body art, neotribalists find the Western concept of beauty very puritanical and boring. Instead of following the clean-cut, unmarked, every-hair-in-place ideal that most Western cultures encourage, they look to the rest of the world for more variety and expressiveness in their appearance.

Modern primitives incorporate the traditions of other cultures with futuristic visions of the human race. They embrace not only the old world of magic and mystery, but the new world of cybernetics and virtual reality. They take body modification to new heights by using the latest surgical and chemical technology to re-create themselves according to their own wishes. This could mean using a piercing to create a metal "beauty mark" on your face, or implanting metal spikes under your skin that stick out of the top of your head. It also includes extreme body modifications like implanting marbles under your skin for a more reptilian look.

There is also a political element to body art. Modifying your body to what *you* want it to look like is a very strong statement. You're asserting control over your own physical being in a society that increasingly regulates what you can and can't do with it. From the moment you're born, you're bombarded with images of what your society wants you to look like. In the Western world, those images are really very plain—there's very little variety in the way we look. When you take the initiative to decorate yourself in a nontraditional manner, you're taking back power from a culture that doesn't want you to stand out or be different. You're also rejecting the conventional rules of decorum. It's *your* body and you can do what you like with it.

Of course, there's nothing wrong with getting work simply because you like the way it looks. Lots of folks find that a tattoo that follows the contours of their body can make them look thinner, shapelier, or more toned. A well-placed pierce can enhance a cute body part or camouflage a flawed one. Body art is also a good way to cover scars, birthmarks, stretch marks, and blemishes. And let's not forget the cool factor.

Since body art is still not mainstream, having marks on your body that you put there on purpose shows the world your rebellious or unconventional nature. Just make sure you're not a rebel without a clue. Don't slap ink and metal in your body to get even with your parents or try to gain instant credibility—people who do so are missing the whole point (and if you don't know what that point is by now . . .).

Once you start getting tattooed or pierced, you may find it hard to stop. You can really become addicted. It's hard to explain, but there's something about the anticipation of getting the work, the "endorphin rush" while the work is being done, and the thrill of showing off your new piece—it's a feeling like no other in the world. I promise you, once you get a tattoo or piercing that you've thought long and hard about and that has real meaning for you, you'll *never* feel the same again! It's very empowering to look at your body art and be reminded of why you did it and what it represents. It's a little part of your personality transformed into art. Besides, it just makes life on this planet more interesting, don't you think?

Whether you're getting work to mark an important moment or just covering up a birthmark, the challenge is to find something that's meaningful to you. You want to be proud of your body art and happy with it forever—so think before you ink! Make sure your tattoo is something that expresses your personality, a signature of your soul.

Below are a few personal accounts of different people's body art and their meaning.

Dennis

While in the military, Dennis and a few other soldiers in his barracks all got homemade tats from another private who had rigged up a crude tattoo machine with a small motor, a ballpoint-pen casing, and some guitar string. Dennis didn't think too

much about what he wanted then—the point was just to get one, since everyone else was. For years he hated the tattoo on his arm—not because of what it represented, but because of how poorly it was done. In 1995, Dennis went to a famous tattooist who specialized in Black and Gray tats in the Jailhouse tradition. Although he didn't want the original tat covered over, he did get it touched up and then had some beautiful, wispy smoke and the words *For My Bros, Ft. Jack* written around the tattoo in elegant script. This way, he kept the original meaning of the piece while turning it into a tribute to his buddies— as well as a good tattoo!

Sarah

Sarah sports a Celtic legband with a grapevine running through it. This is a representation of her heritage: her mother is Irish and her father's family worked the vineyards in Italy. She's currently designing a band for her other leg, a music staff (she's a musician) with different fruits and vegetables as the notes (she's a vegetarian). The notes correspond to the first two bars of her favorite childhood lullaby!

Jack

As a teenager, Jack pierced his ear with a needle and cork and wore one of his sister's earrings in the hole. When his father saw it, Jack was severely reprimanded. The sharpness of his father's reaction caused Jack to leave home. He didn't speak to his father for four years after that. These days, Jack sports ten holes in each ear and lobes stretched out about

half an inch. While you might think that his piercings are a reaction to his quarrel with his father, Jack says he's just fulfilling a desire he's had since that day with the needle and cork. He called his father two years ago and they quickly made up. They agreed to meet and Jack took wicked pleasure in his father's shocked face when he saw all of that metal in Jack's ears. "But you know what," says Jack. "He never said one word about it and he never has since."

Shelley

In the course of eighteen months, Shelley was mugged, involved in two accidents, and fell and broke her leg. She was really having a streak of bad luck and wanted to do something to break the cycle. Since she collects anything with angels, she picked her favorite angel design and got it tattooed on her shoulder. "I really felt like I needed an angel looking over my shoulder," she said. "I haven't had any trouble since then."

Maria

This is a girl who just loves the art of tattoo. She's a tattooist herself, her husband's a tattooist, and their house and studio are covered with tattoo memorabilia. All of Maria's tattoos are in the Traditional style—hearts, swallows, hula girls, panthers—and they are all over her body! She's into hunting down antique flash designs and having them inked on her body. Maria takes her inspiration from the tattooed ladies of the early-twentieth-century sideshows.

Malik

Malik has one small dot tattooed on the palm of his hand. Not much of a tattoo but very special to him because mixed in with the ink used to create it is a little ash taken from the urn that holds the remains of his grandfather.

Karen

After Karen had a hysterectomy, she was self-conscious about wearing a bikini because of the big horizontal scar running along her abdomen. Even though she's not, as she put it, the "tattoo type," she had a beautiful line of flowers inked over the scar to camouflage it. She's very happy with the results and is now considering more work.

Doug

The day he turned eighteen, Doug went to the closest tattoo shop and had a big American Indian portrait tattooed on his chest. He was very proud of it and spent most of the next year shirtless, showing off his tat. It gave him confidence and that certain outlook on life tattooed people have—call it "tattitude." Soon he bought a motorcycle, dropped out of college, and headed out on the road. He spent the next twenty years traveling the U.S., stopping at any place that looked interesting for a year or so and then hitting the highway again. At each new stop, he'd add to his ink collection. Now fifty-six, he's pretty much covered with pieces large and small and considers his tattooed body a living scrapbook of his

life and times. He's never regretted the direction he chose in life nor any of his skin-art mementos.

Kai

In school, she was a Girl Scout. She tutored children with learning disabilities on the weekends and graduated from high school with high honors. In college, she excelled and upon graduation landed a high-profile job in the financial world. If you saw her on the street, she would look like any corporate type, in conservative clothes and sensible shoes. But Kai has a secret. Under her navy-blue suit she sports many sexy piercings. She says she enjoys the metal in her body not just for the pleasure it gives her and her boyfriend, but because it's a way to express her wild side while protecting her professional image.

Stevie

Stevie has a strange patch of thick hair growing on his right shoulder. Although everyone else thinks it's disgusting, he's pretty attached to the black, curly growth. A while back, Stevie decided to make this oddity a little easier on other people's eyes, so he had a head tattooed under the patch of hair. Now instead of being totally repulsed, everyone gets a good chuckle.

There is no one right reason for choosing to have body art, since it's all about expressing your personality. The important thing is to take your time in deciding what you want and where you want it. When your work has been planned out, from idea to execution, you end up with living art that will bring you pleasure for a lifetime.

CHAPTER 4

LEARNING THE LANGUAGE

HERE ARE THREE SHORT glossaries that will familiarize you with tattoo symbolism, tattoo styles, and piercing terminology. They are by no means complete, but they will provide you with some basics and maybe motivate you to study the endlessly fascinating world of body art further.

TATTOO SYMBOLISM

When trying to decide what kind of tattoo you want, it's a good idea to turn to humankind's rich tradition of symbolism. Much imagery has a legacy of meaning that dates back to the beginning of time, culled from myths, fables, hieroglyphs, religions, and social customs.

Symbolism is the language of the psyche and tattoos are an expression of a person's individual consciousness. What follows are some common tattoo images and a brief description of their symbolical history.

Anchor

Anchors represent security or safety. For seafaring societies, the anchor was a mystical symbol that could prevent a ship

from sinking. To early Christians, an anchor signified salvation; like another water symbol, the fish, it represented Christ (it also bears a strong resemblance to a cross). It was frequently shown upside down, with a star, crescent, or cross indicating its spiritual nature.

Angel

In the oldest Hindu texts, angels were women who were "rewards" given to brave warriors in heaven. In alchemy, the angel represents sublimation (moving from a solid to an ethereal state), an analogy for the ability to move between earth and heaven, or the physical and spiritual states of being. In most religions, angels are heavenly beings, who are divine messengers and protectors.

Bat

In Western cultures, bats are associated with the mysterious, the unseen. Since bats use echolocation (finding an object by means of sound waves that are reflected back to who- or whatever emits them by the objects) not their eyes, to hunt and navigate, wearing a representation of a bat was thought to help a person see what's hidden. Since demons are associated with evil, they are often depicted with batlike wings. To the Chinese, bats symbolized happiness, good fortune, and longevity; to the Mayans, they were symbols of rebirth.

Bear

A ruthless and invincible foe in battle, the bear can either move on all fours or stand upright, giving it a dual nature, somewhere between animal and human. As a totem in Native American tradition, bears represented wisdom and indomitability.

Bird

All winged creatures have connotations of spirituality. Egyptians used a bird with a human head, *ba,* to express the belief that the soul flies away at death. Hindu tradition associates birds with higher states of consciousness.

Boat

As vessels by which one navigates the seas, boats have come to be associated with spiritual journeys. Boats represent the human body, waters the path of spiritual pilgrimage.

Butterfly

The ancient Greek word *psyche* means both "soul" and "butterfly." The butterfly represents the soul's ability to fly away from the body. The purification of the soul by fire is represented on ancient urns by the image of a butterfly too close to a flame. The butterfly's emergence from its cocoon is a common symbol for rebirth. Today, psychologists consider the butterfly emblematic of transformation. In China, it has the secondary meaning of joy, especially in marriage.

Cat

Across time and varying cultures, cats have been associated with witchcraft and women.

Freya, the goddess of fertility and love in Norse or Scandinavian mythology, rode in a chariot drawn by two cats. In Hindu tradition, cats are associated with the goddess of childbirth, Shasthi. Egyptians identified cats with the moon because of their nocturnal habits. They were also sacred representations of the goddess Bast, who was sometimes depicted with a cat's head. Bast presided over bountiful harvests, marriage, and fertility.

In the fifteenth century, when the agents of the Spanish Inquisition set about destroying all vestiges of ancient religions, many of which worshiped women, cats became identified as the familiars of witches and manifestations of the devil.

Clouds

Since clouds lie between heaven and earth, early Christian symbolism associates them with messages from God. The Chinese represented female sexuality in the form of clouds, giving new meaning, albeit unintentionally, to the phrase *having your head in the clouds*.

Clover

The patron saint of Ireland, Patrick, used a three-leaf clover to symbolize the Holy Trinity in Christian religion. To many ancient religions, it's a representation of the triple goddess, who has three aspects or manifestations.

The rare four-leaf clover is a representation of the mystical number four: the four seasons, the four elements, the four stages of human life, etc. Considered a symbol of luck, love, and fidelity.

Clown

In medieval courts, the jester was the inversion of the king— a buffoon, a fool. People with physical deformities are often associated with the figure of the jester. In ancient times, they were often human sacrifices. When a city suffered from a disaster, an ugly or deformed person was chosen to represent the evils that afflicted the community. These scapegoats were beaten, tortured, and burned on a pyre, a ritual performed to purge the community of its problem.

Many tattoos depict a "bad clown," an evil-looking char-

acter. This is a representation of the "trickster," a figure found in African and many other myths. The trickster is a magical being sent by the gods to vex humans. He is the great deceiver and can't be trusted or taken at face value—clowns paint a happy face over their real face.

Cobweb

Traditionally, a cobweb means the wearer has killed somebody. A representation of the fate that is "spun" for a person, its spiral shape suggests the expanding universe and the cyclical nature of life. At the beginning of the Christian era, the Gnostics depicted a spider sitting in the middle of a web to represent the belief that evil lurks not only on the "edges" of life but in the center, the very origin of existence.

Cow

A symbol of sustenance for human beings, a general representation of motherhood and nourishment. In Scandinavian mythology, the cow of Creation was Audumla, whose name meant "creator of the earth."

Cross

The most basic meaning is the joining of opposites, the horizontal and the vertical, earth and heaven, the material and spiritual, masculine and feminine. For Christians, it depicts the ultimate sacrifice—Christ's suffering on the cross.

Deer

Deer are the source of many things to people—their flesh, hide, and horns. They are great providers for human sustenance. Their horns symbolize strength and power.

Devil

The devil is a representation of worldly concerns, which stand in opposition to spiritual enlightenment. In the tarot, the devil card represents earthly desire, deviation, and confusion.

Dog

Dogs have long been thought to be keen judges of character as well as guards against unwanted intruders. In Greek mythology, a three-headed dog, Cerberus, guarded the gates of hell, just as Annubis guarded the Egyptian underworld. Protectors of the home, dogs are symbolic of loyalty and devotion.

Dolphin

Dolphins symbolize salvation, since they have a reputation as rescuers of people in the sea. According to an older symbolic meaning, they represent creation, passion, and sexuality; "dolphin" comes from the Greek word *delphinos,* which also means "womb." People in cultures that lived near the sea often believed that having a dolphin tattoo on their legs acted as protection against sharks.

Dragon

The dragon is a composite symbol of many cold-blooded animals that are hostile and frightening to humans, including some of humankind's early antagonists. In many myths, the dragon is the ultimate enemy, thus the modern psychological interpretation of the dragon symbol as a fear that a person must overcome on his or her path to maturity.

Dragons are also fierce guardians. In China, they are an emblem of imperial power, symbolizing the sovereign's protection of the people and victory over wickedness.

Eagle

Symbolizing the masculine, the eagle is generally associated with power and war. Characterized by its speed and ability as a predator, in traditions from Native America to ancient Rome, the eagle is a great warrior leader, powerful and wise.

The eagle is also associated with lightning, fire, and the sun—the great powers of the earth. When the eagle is shown carrying a victim, it represents the triumph of superior powers over baser instincts.

Elf

Elves can be helpful, granting wishes, doing humans' work while they sleep, guarding over children and animals. They can also be destructive, stealing people away or causing general mischief. A good representation of the uncontrollable, mystical nature of existence.

Fairy

Fairies represent the unseen, supernatural forces at work on earth, and like elves, are indicative of a belief in natural magic.

Feather

Egyptians believed that each soul would be weighed against the Plume of Maat (meaning truth), to determine how heavy with sin a person was. Thus, to be "light as a feather" meant that one was free of sin.

Feathers correlate with the element of air and the desire to break free of earthly bonds. In Native American societies, feathers are a powerful totem for spiritual enlightenment, used in rituals and as adornment.

Fire

Fire is the ultimate symbol of life, embodying both good (body heat, warmth) and bad (destruction). It's a symbol for the duality of our existence, at once an agent of death and destruction and a bringer of spiritual rebirth by purgation.

Fish

The fish was an early sign of Christianity, symbolizing the spiritual world that lies below the material world. It was chosen because fish inhabit water, a mysterious, unknown world. Because water is associated with the unformed and the subconscious, they symbolize dreams and visions.

The *vesica piscis* (vessel of the fish) was a female genital symbol that looked like a crude representation of the body of a fish. Thus fish also are a representation of the womb, or more directly, the womb's exit.

Flower

The language of flowers is complicated and intricate, with each variety and color having a specific meaning. Generally, a flower, by its very nature, represents the bounty and beauty of spring. The flower is an image of the natural unfolding of life.

Frog

Because of frogs' amphibian nature, able to hop between water (the original mother-womb) and land (our earthly home), they represent fertility and birth.

Gargoyles

Gargoyles, in their fiendish appearance, are designed to keep evil away. In the Middle Ages, cathedrals were covered with

gargoyles to protect their sanctity. In the hierarchy of architectural ornamentation, gargoyles are always placed under angels and other enlightened beings.

Heart

The heart has always been considered the center, a symbol of the eternal soul. Because a person's center represents his soul, the heart also represented the magnetic attraction one person has for another. To love is to encounter an overwhelming force that urges a lover toward his beloved's center. In Christian iconography, the heart is often pictured with flames, a cross, or a crown to represent spiritual love.

Knife

The symbolical opposite of the sword, which has a lofty spiritual meaning, the knife is analogous to the phallus and the masculine instincts of vengeance and combat. The short blade of the knife represents the physical strength of the person wielding it, whereas the long blade of the sword depicts the spiritual justness of the person.

Lion

The Roman sun god, Mithras, was represented in leonine form. The cult of Mithras was restricted to men, predominantly military men, so the lion has always been associated with brute strength, power, and other masculine traits. In African ritual dances, men became lions, harnessing their abilities for use in battle. The lion is king of the jungle, the earthly opposite of the ruler of the sky, the eagle.

Mandala

A ritualistic, geometric design. A symbolical "map" of the universe, used as a meditational tool in Hinduism and Bud-

dhism. A mandala is a visual aid in the contemplation of the complexity of life.

Mermaid

Mermaids spring from the tradition of water goddesses, who are associated with the womb (see *Fish*). In Africa, the goddess Yemaya was depicted with seaweed for hair and shells for jewelry. In India, the Nagas were human above the waist and water snakes below.

Mermaids that lure seafarers to their death can be found in many cultures' folklore. In this sense, they can be equated with the temptations one encounters "navigating" the course of one's life.

When you regard the sea as a representation of the subconscious, a half-human/half-fishlike creature symbolizes the two aspects of human consciousness, the subliminal and the sentient.

Moon

The moon's movements are cyclical in nature. Its changing shape corresponds to the stages of life.

The lunar cycle influences the physiological cycle of a woman, as well as the tides of the ocean—deep, mysterious events. The moon is associated with the feminine, and with moon goddesses such as Ishtar, Diana, and Artemis.

Because of its close association with the mysteries of the night and the hidden, subconscious quality of water, the moon is associated with imagination, mystery, and magic.

The moon tarot card illustrates the mysteries of the world. The "lunar way" is feminine, relying on intuition and magic; the "solar way" is masculine, relying on reason and objectivity.

Octopus

The octopus is related to the center of Creation, a specific core with tentacles reaching outward. As a creature of the sea, it's associated with the subconscious and unknown forces.

Panther

Known for their aggressiveness and strength, these large cats are also night hunters, which adds mystery to their activities. They are associated with the Roman Dionysus and the Greek Bacchus, the god of wine, revelry, and fertility. Mix all of the aforementioned qualities together and you have a masculine totem that gives you power through occult and sexual ability.

Rose

Because of its shape and nature, it's associated with the vagina. Like all flowers, it symbolizes beauty and perfection. Deeper meanings are derived from the color and number of petals. It was a sacred symbol of the Roman goddess of sexual love and physical beauty, Venus.

Sacred Heart

The Catholic saint Margaret Marie Alacoque had a vision in which her heart was surrounded by a crown of thorns, representing Christ. This is the source of the symbol.

Serpent/Snake

The characteristics of the snake explain some of its symbolic significance. Because it sheds its skin and is "reborn," it represents immortality. Because of its quick, serpentine movements, it represents strength. Because of its vicious nature, it

represents evil and treachery in the natural world. Because of its shape, it represents the phallus.

From Native American ritual to Greek mythology and ancient Sumerian theology, the snake is a symbol of healing through transformation.

Shark

In the language of the Haida, a Native American people inhabiting Canada and Alaska whose art has been borrowed by a popular tattoo style, the word *shark* means the "dogfish mother"—the womb that bites. It is the sharp-toothed "mouth" that is ancient and deadly enough to deserve our utmost respect.

Skeleton

The ultimate symbol of death. When a skeleton is depicted in a lifelike stance, it represents life after death. The skulls of an enemy were often kept by the victors. In many cultures, wearing the skull as a totem indicates the wearer has no fear of death.

Smoke

Smoke corresponds to the powerful spiritual elements of air and fire. Many religions used smoke in rituals meant to ward off evil. Smoke is symbolic of the transition from earth to heaven, indicating the path to salvation through fire. Medieval alchemists used smoke to represent the soul leaving the body.

Spider

The spider as a symbol has three distinct determinations: creativity is symbolized by the spider weaving its web; infinity is represented by the figure-eight shape of the spider's body;

and chaos is represented by the spider's pattern of building and destroying webs, luring prey then killing them.

In Indian tradition, the spider in its web is representative of "maya," a concept of the mysterious, incomprehensible nature of the world. Maya is the eternal weaving of the web of illusion—or the world as we see it, not as it really is.

Star

The ancients considered stars to be souls in the sky. They are also identified with ancient fertility goddesses like Astarte and Ishtar.

As a light that shines in the night, a star represents the spirit struggling against the forces of darkness. For seafaring people, who used them as navigational tools, stars were guideposts from heaven.

Special stars in the sky have always symbolized the imminent coming of a prophet or savior, as in the birth of Christ.

The hexagram, or six-pointed star, is an ancient good-luck symbol called the Seal of Solomon. In the nineteenth century, it became a universal symbol for Jews, corresponding to the Christian cross. It's called the Star of David because of the belief that a hexagram was pictured on the first King of Israel's shield. Before that, the hexagram was used in India to symbolize sexual union, with Kali represented by the downward-pointing triangle and Shiva represented by the upward-pointing triangle.

Egyptian hieroglyphics interpreted the five-pointed star, the pentagram or pentacle, as the spirit rising up toward its point of origin. The pentagram is formed by one continuous line and is used to ward off evil. An inverted five-pointed star is symbolic of the infernal when used in black magic.

Sun

A masculine symbol, representing ultimate power and sovereignty, the sun is personified by the Egyptian god Ra (or Re),

the son of heaven. As such, he possesses the best of all attributes: he sees all and knows all. Ra is the supreme deity, represented as a man with the head of a hawk crowned with a sun disk and a sacred serpent.

Associated with heroism, courage, and spiritual illumination, the sun is the original father, the divine eye, the source of all life—the opposite creative power to the moon. The sun is unchanging and eternal.

Sunflower

Since the sunflower loves the sun (the ultimate symbol of masculine creation) and follows its path across the sky, it can be interpreted as feminine adoration for the male and his reproductive capabilities.

Sword

Like the cross, the sword is a symbol of the phallus and has always been the property of men, a tool of war and defense. In medieval lore, a sword is the instrument by which a knight defends the forces of light against the forces of dark—symbolical of a hero's spiritual courage. A sword depicted with fire or flames represents purification through a quest.

Tiger

The tiger is associated with wrath and cruelty, the superior hunter with no mercy for its prey. Chinese philosophy equates the tiger with darkness and the new moon (darkness always implies darkness of the soul).

A Chinese symbol of five different-colored tigers represents the order of space and the elements against the forces of inconceivable chaos (the Chinese have five elements, not four). According to this concept, the Red Tiger reigns in the

south; his season is summer, his element fire. The Black Tiger governs in the north; his season is winter and his element water. The Blue Tiger's domain is the east, in the spring and among vegetation. The White Tiger dominates the west, in autumn and among the metals. The Yellow Tiger inhabits all the earth and rules supreme.

Unicorn

The unicorn is a phallic symbol, its single horn being its most prominent and unique feature. The oldest legends of the unicorn describe it as a very swift horse with a single horn, who doesn't like humans and is almost impossible to catch. The only way to snare a unicorn is to lure it with a virgin, whose very presence will cause the animal to fall submissively at her feet. For this reason, the unicorn is associated with purity and innocence.

Water

In the oldest Hindu sacred texts, the Vedas, water is referred to as *mâtriamâh* ("the most maternal") because it is the beginning of all life. Water is Mother, the beginning of all things. The enduring nature of water suggests infinity; the vigorous nature of water suggests movement and transition. Because of its mysterious, dark nature, it is often associated with the subconscious.

Baptism predates Christianity and was representative of transformation, protection from evil, and immortality. Baptism in water, as practiced by Christians, is the symbolic death of the sinner, who emerges reborn to salvation.

Waves

Waves signify infinity, as suggested by the endless repetitiveness of their movement.

Whale

The original Jonah and the Whale story can be traced all the way back to Babylonia and the sea goddess called the Whale of Det (Derceto), who swallowed the god Oannes and then "gave birth" to him. The Polynesian warrior Nganaoa was also swallowed by a monstrous sea creature and then returned to the world, as was the Finnish warrior Ilmainen. Being devoured by a whale indicates a rite of passage through which one is transformed. As with other creatures of the sea, the whale symbolizes a spiritual womb.

Wolf

Fenris, a wolf in Nordic mythology, was said to be held in shackles in the bowels of the earth. He would break free at the world's end to devour the sun, thus ending all life. In pre-Christian Europe, many tribes had wolf rituals during which men "became" wolves. Typified by their predatory skills and night prowling, they are mysterious and dangerous creatures and represent the dark, destructive side of man.

TATTOO STYLES

New styles and hybrid styles of tattoo design are coming into existence every day. As the visual language and tastes of our culture change, so does the language of tattoos. Here are some basics to help you identify what you see and articulate what you want.

Black and Gray

Work done only with black ink or dye (and the resulting shades of gray), is put in the skin with a single needle. The technique is also called *Joint Style* or *Jailhouse* because it origi-

nated in penitentiaries. Prisoners would handmake tattoo machines that were electrically powered by small, available motors (like the ones found in tape players). Their pigments were also handmade from, among other things, cigarette ashes and pen ink, and there was little variety besides shades of black.

The Jailhouse style was adapted and expanded by tattooists in the late 1970s and early 1980s and renamed Black and Gray. It's customarily used for portraiture or realistic pieces, since the artist focuses on the line and shading of the piece. As with other Fine Line work, the tattooist must be careful not to put too much detail into too small an area.

Biomechanical

Inspired by the "part human/part machine" artistic musings of people like Clive Barker and H. R. Giger, Biomechanical tattoos are often *trompe l'oeil*—i.e., they give the illusion that the wearer's skin has been peeled back to reveal steel rods and computer boards instead of muscles and bones—picture the Bionic Man with updated technology. Other pieces combine organic and artificial subject matter into an eerie hybrid. The ultimate cyberpunk skin art.

Celtic

Celtic designs often represent people and animals from Welsh, Breton, Gaelic, and Cornish folklore; they incorporate intricate weavings of a single line, called *knotwork*. Many Celtic designs originate from a famous tome created by monks in the sixth century called *The Book of Kells*. This book combined the ancient pagan religion of Central and Western Europe with Anglo-Roman Christian traditions in ornate illustrations. The original book can now be found at Trinity College in Dublin.

Darkside

Death and darkness have always been a classic tattoo theme—skulls, snakes, demons, spiders, and spiderwebs are all conventional tattoo imagery. Darkside tattooing takes our fascination with mortality, death, isolation, fear, and evil to

new levels. Inspired by fantasy/sci-fi/horror illustrations, intricate renderings of ghouls, ghosts, demons, mummies, vampires, and scenes of debauchery and heresy give the wearer a dangerous aura. There's a heavy emphasis on smooth shading and fine detail, and the best examples of this work have great depth and dimension.

Fantasy

Fantasy tattoos run the gamut from unicorns and wizards to intricate scenes of medieval battles and mythical characters. They are generally rendered in an array of colors to convey the fantastical elements of the work.

Gangster

The idea of Gangster tattoos comes from the habit of gang members tattooing the name or symbol of their crew on their

bodies to signify permanent allegiance, very much in the ancient tradition of tribal identification. Usually this takes the form of having your crew's name or motto tattooed in some kind of script on your stomach or back. There are also complex tattoo languages used in Gangster tattoos; for example, "cholo tears" are teardrops tattooed around your eyes, each drop representing someone the wearer killed.

Haida

The simple but expressive artwork of this Native American tribe (from the Queen Charlotte Islands of Canada and Prince of Wales Island in Alaska) has given rise to many popular tattoo motifs. Many people sport Haida renderings of animals or abstract designs. These are generally done in flat black, with red or another color as a highlight. (See page 59.)

Memorial

Memento mori, or "In Memory Of . . .", tattoos are usually a portrait of the person with his name, birth, and death dates. Memorial tattoos can also signify the birth of a child or a wedding.

New School

New School tattooing incorporates other skin-art styles (Western Traditional, Oriental, Fine Line) with fine-art and folk-art traditions to make a "multiculti" tattoo stew. New Schoolers often use subject matter that was previously considered inappropriate for tattoos, and radical styles from kitsch to cubism, to turn out big, beautiful works of skin art. Their color palette is bounteous, with hues that push the boundaries of pigment possibilities.

New School was born out of the fresh approach toward tattooing that developed in the early 1980s, when the scene was discovered by fine artists and exploded out of the underground. These eager young artists infused new vigor, creativity, and openness into a craft that was usually done in the "old days" (twenty years ago) in secrecy and with great mistrust. Prior to this new breed of tattooists, who treated the form more like an art than a craft, most tattooists hoarded technical information

like Houdini hoarded his tricks, for fear of losing business to some young gun with a steadier hand. They also did little to expand the range of conventional tattoo imagery. That's commonly known as "old-school attitude." New School signifies a revolution not only in style and technique, but in spirit. So even more than a method, it's a philosophy.

Oriental

Oriental-style tattooing usually refers to traditional Japanese tattooing. Colorful and intricate, concerned with musculature and placement, using a limited vocabulary of design motifs—fish,

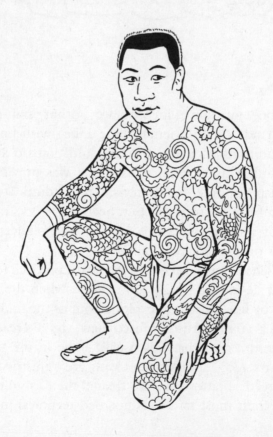

water, lotus flowers, religious imagery—Oriental style also implies that the work covers the whole physique. There's no such thing as a small Oriental piece. A person's work is planned out to cover the entire body, every inch of skin to be tattooed is mapped out and accounted for before the work begins. For centuries in Japan, tattooing, or *irezumi,* indicated that you were *yakuza* (a Japanese gangster) and was therefore associated with the criminal class, much as tattooed people in the West are.

Tribal

Along with Traditional, this is one of the most confusing tattoo terms around. Just what tribe are we referring to? Tattoos can be traced back thousands of years and are found the world over. What we think of as Tribal tattoos are generally black, abstract tattoos, based on designs found in Polynesia, Micronesia, and Borneo. Tribal can either be based on geometric patterns or organic lines that fit a person's body perfectly.

Wild Style

Based on hip-hop culture and skateboard and graffiti art, Wild Style runs the gamut—it can be a "tag" spray-painted on your body or a killer board design.

GLOSSARY OF PIERCING TERMINOLOGY

Ampallang

A male piercing done horizontally through the head of the penis, sometimes placed above the urethra (the passage that carries urine and semen out of a man's body), sometimes going through the urethra.

Antitragus

A piercing of the ear through the cartilage opposite the tragus.

Apadravya

Same type of procedure as the ampallang, but here the barbell enters vertically through the penis head and exits at its base.

The apadravya provides increased sexual sensitivity for the wearer and his partner.

Autoclave

A pressurized container used for sterilization. Every piercer or tattooist *must* have one of these and they must have it checked on a regular basis. All tools used in piercing and tattooing have to be autoclaved after each use. This is the only suitable method for destroying pathogenic bacterium, which cause infection and disease.

Barbell

A common body-jewelry design, recognizable as a long post with beads that screw into one or both ends. Barbells can be straight, curved, or horseshoe-shaped; the placement of your piercing will determine which barbell you need.

Beauty spot or beauty mark

Also called a Chrome Crawford (à la Cindy Crawford's famous beauty mark), this piercing uses a stud with a bead on one end, above the upper lip, slightly off to the side.

Bridge

A piercing done between the eyes on the bridge of the nose. This is a difficult pierce and one that does not easily heal.

Caliper

An instrument used to measure thickness and distances in piercing.

Cheek

A risky piercing because of the potential damage to nerves and blood vessels. It requires two lengths of labret studs, an initial longer length, and a shorter one once the swelling has subsided.

Clit or clitoris

The clitoris is pierced at the base, either vertically or horizontally. Most women prefer a captive ring for jewelry because the bead acts as a sexual stimulator.

Clit hood or hood

The flap of skin that covers the clitoris is also a popular spot for a sexually enhancing piercing. The trick is to properly place the piercing so that when a women is sexually excited, the bead of the clit-hood piercing lies directly on the clitoris, providing additional stimulation. Can be done vertically or horizontally.

Conch or concha

An ear piercing done in the recessed part of the ear leading to the ear canal.

Daith or daitch

This is an ear piercing that is done in the cartilage that curves into the inner part of the ear, above the tragus. A popular piercing, it can be very subtle with a small ring or really noticeable with bigger jewelry.

Diameter

One of the two measurements pertinent to body jewelry. The diameter is the measured space inside a ring or curved barbell, which corresponds to the length of barbells.

It's important to get jewelry wide enough or long enough to allow for swelling that may occur after the initial piercing. Once the swelling disappears, you can get a smaller piece of jewelry.

Downsizing

A term used when a pierce requires an initial jewelry size and then a smaller one after the swelling has gone down and it has sufficiently healed.

Dydoes

A penis piercing that should only be done on circumcised men. Dydoes are a pair of barbells placed on either side of the coronal rim of the penis head (if you're uncircumcised, this rim is covered by the foreskin unless the penis is erect). This piercing is another sexual enhancement, rumored to have been created by a Jewish medical student who wanted to replace some of the sensation he felt he'd lost by being circumcised.

Earlets or eyelets

A kind of jewelry used to show off stretched holes in your ears or nose. These hollow tubes have flanged ends to keep them in place. They look great by themselves, because you can see clearly through the hollow center, or you can hang other pieces of jewelry through them. Also known as "flesh tunnels."

Earlobe

The world's most common piercing is done on the soft, fleshy, lower part of the external ear.

Ear Project (a.k.a. Industrial)

Two or more piercings through which a single piece of jewelry is worn. This kind of piercing art requires planning. The piercer must initially measure the holes that will be threaded with one piece of jewelry, then put separate jewelry in each hole. After the holes have sufficiently healed, another piece of jewelry can be threaded through the holes to create a "woven" effect.

Eyebrow

As a rule, these piercings loop the eyebrow (if you're wearing a ring) or have one bead sticking out of the top and one out of the bottom (if you're wearing a barbell).

Forceps

An instrument that looks like a pair of tongs, used for grabbing and pulling a few layers of skin away from the rest of the derma.

Frenum

A layer of tissue that holds an organ in place, like the flap that connects the underside of the tongue to the floor of the mouth. As a piercing, it's commonly done on the underside of the penis, below the head. Barbell studs are the most common piece of jewelry used. Placement of this piercing is crucial so that the wearer doesn't experience discomfort when sitting. For a more unique piercing, the membrane under the tongue (called a frenulum) can be pierced, and a small ring placed in the hole.

Gauge

Measurement that identifies how thick a piece of body jewelry is. The lowest gauge number, 00, is the thickest piece of jew-

elry. Gauge, along with diameter, are the two sizing entities involved in body piercing.

Gauge wheel

An instrument used to measure jewelry.

Guiche

This male piercing is placed through the skin found between the anus and scrotum sac. Gentlemen rave about the sensation of having their guiche ring rhythmically hit the back of their testes while they walk or run.

Hafada

A male piercing done on the scrotum sac to increase sensation.

Helix

A piercing done on the folded rim of skin and cartilage around most of the outer ear.

Labia

Both the outer and inner labia can be pierced. Originally, these piercings were used as a chastity measure, with some sort of barrier device threaded through the piercings to prevent intercourse. These days, the whole purpose of labia piercings is to increase female sexual stimulation. Labia piercings are done with rings or circular barbells. As with a frenum piercing on a man, placement must be carefully determined, otherwise the wearer will experience discomfort when sitting.

Insertion taper

The insertion taper has a fine point on one end and gradually flares out; it's used to reopen or stretch existing piercings.

Keloid

This is a fibrous scar your body makes when trying to do extreme tissue repair because of a puncture, wound, or surgical incision. Sometimes in piercings, people get hard, knotty growths around the hole. That's keloid scarring.

Labret

A popular piercing done in the area below the lip and above the chin. It requires a special labret stud: a barbell with one flat end (to lie flush against the inside of your mouth) and one screw-on end. After it's healed, some people insert rings that loop through their lower lips; others prefer the aggressive look of a spike sticking out of their labret pierces.

Latex gloves

Latex gloves are one of the ways professional piercers (or tattooists) protect against spreading infection and disease. Every piercer *must* wear latex gloves when touching sterilized tools or jewelry, as well as while performing a piercing or touching a fresh piercing. Gloves must be changed if the wearer accidentally touches something that is not sterile (like a telephone, money, etc.). No glove, no pierce!

Migrate

This refers to a piercing slowly moving from its original spot, which is caused by jewelry that's too thin. Think of people who have worn thin, wire earrings in their pierced ears for many years. The original holes have slowly moved down their lobes, leaving a noticeable slash in their wake.

Mouth

The mouth can be pierced anywhere around the lips, as well as above, below, or to the side. Whether you have a bead ring hanging off the side of your mouth or a cute little "beauty spot" stud above your lip, this is a versatile area. There are also places inside the mouth that can be pierced, like the frenulum and tongue. The only drawback to any mouth piercing is that this is an area that tends to swell a lot, so many of these piercings may require two jewelry sizes, one for the initial piercing and one for when the swelling goes down.

Lorum

A variation of the male frenum piercing, done at the spot where the base of the penis joins the scrotum sac.

Navel

A favorite of supermodels and disco divas, it's also a tricky area to pierce. The size and shape of the jewelry, the properties of the navel (innie or outie, plenty of flesh surrounding the area or super-thin), and even the nature of the body of the person having the work done all play a role in a successful navel piercing. Far too many inexperienced piercers "do navels" on people without any consideration for the above factors. This is one reason why navels have the highest rate of rejection and/or infection among common piercings. The piercer must know what any particular body can withstand as far as depth of piercing and gauge/weight of jewelry.

Also, because of the location of the navel, it's easy to irritate the new piercing, which can lead to improper healing. The navel can also be subject to fungal infections—a yeasty, cottage-cheese-like discharge. Finally, there are very strict aftercare procedures with this piercing. Many people do not

properly care for their navels and that's why you see a lot of infections.

Niobium

A metal commonly used for body jewelry. It's extremely hypoallergenic and safe for most people's initial piercings. Through the process of anodization (using electrical currents and oxides to coat a metallic surface), niobium is produced in a variety of colors. It is lightweight and noncorrosive, but the color can come off from constant handling.

Nipples

A popular and pleasurable piercing for both women and men. All kinds of jewelry can be worn in nipple piercings (and hung off them!). The important rule of thumb is that the piercing must be made through the center of the nipple. This is another pierce that can be a little tricky to heal and it's imperative that you follow the aftercare instructions!

Nostril

This piercing normally takes either a ring or a nostril screw (the post is spiraled to keep the jewelry from falling out). The nostril can swell a lot when initially pierced, so be prepared.

Plug

A cylindrical, solid piece of jewelry that's held in place by a rubber ring on each end. Used in stretched piercings.

Prince Albert

The story is that this piercing was worn by Queen Victoria of England's husband, Prince Albert himself, to prevent any un-

seemly erections from popping up when he was in the presence of his wife. This piercing goes through the urethra and generally exits through the area where the shaft and the head meet. Traditionally, a ring is worn (through which the prince threaded a piece of leather to bind his penis to his leg) or a curved barbell.

Reject

The art of piercing is "tricking" the body into accepting a foreign object that it naturally wants to reject. This is done by piercing with the proper depth, width, and diameter, using the appropriate tools, jewelry, and procedures. When the above favorable conditions aren't met, the jewelry will force its way out.

Rook

The top ridge of cartilage on the upper ear. A good place for rings.

Scrumper

A piercing of the upper- or lower-lip frenum. A ring encircles the lip.

Septum

A thin partition that divides two cavities or soft masses of tissue in an organism, in this case, the nostrils. Just about anything goes with this piercing, from bead rings to wooden tusks. This is one procedure where piercers must really know their stuff and where you must be very careful to keep this hole from getting infected, since this area shares a common blood supply with the brain.

Septum retainer

A horseshoe-shaped piece of jewelry placed through a septum piercing. The two ends are then tucked up into the nostrils so that the piercing can't be seen. Used to keep a hole open when you're not wearing jewelry.

Surface-to-surface

Rather than completely going through tissue or cartilage (like nipples or ears), this piercing enters and exits through a few layers of skin so that the piercing "sits" on the surface of your body. Piercers must have a very good knowledge of anatomy and dermatology so that they don't go too deeply or not deeply enough. Some surface-to-surface piercings are made through the nape of the neck, the web of skin between the thumb and forefinger, or the top side of a finger, where a ring would normally be worn. These are very hard piercings to keep; they're easily snagged and ripped out of your skin. It's probably best to consider them temporary piercings; wear them for a little while, and then take the jewelry out and let the holes heal.

Stud

Another term for a barbell post.

Surgical stainless steel

A metal commonly used for body jewelry. Surgical stainless steel should be of the highest grade, 316-L, the same grade used for implants in the body. It's extremely nonreactive, it doesn't tarnish, it's scratch-resistant and very strong, so it won't bend.

Temporary piercing

Many people are getting into nonpermanent piercings, which are done just for the moment (whether that's an hour, a day, a month, or longer). They're usually done with very large gauges (which means small holes), such as a twenty or eighteen, so that when the jewelry is removed, there will be little or no scarring.

Titanium

Another metal commonly used for body jewelry. It's extremely hypoallergenic and safe for most people's initial piercings. Through the process of anodization (using electrical currents and oxides to coat a metallic surface), titanium is produced in a variety of colors. It is lightweight and noncorrosive, but bodily fluids like urine and sweat can wear away the color over time.

Tongue

The tongue can be pierced almost anywhere along its center. Placement of the piercing and size of the jewelry is important because you don't want your speech affected—some people sound like they have marbles in their mouths after they get their tongues pierced! The pierce is done with a barbell and requires downsizing. Because the tongue is a very muscular organ that gets a lot of use, it's important that the barbell be large enough so that it doesn't get pulled into the piercing by the reflexive action of the tongue.

Tragus

A flap of cartilage in front of the opening of the ear, located where your jaw is jointed together. This piercing can take many different kinds of jewelry.

CHAPTER 5

GETTING
GOOD WORK

THE KEY TO ASSURING a great piece of permanent body art is planning your work, whether tattoos or piercing. The more knowledgeable you are about the process—from concept through exceution—the better your work will be and the happier you'll be with it.

Also think about adding on to your existing work in the future. Some people have a bunch of little tattoos on their arm—and that's what it looks like: a bunch of little tattoos on their arm—they don't "tie in." Others get ten or twelve holes in their ear and then are unable to do anything more creative, like stretching. If you are seriously considering a lot of body work, you must deliberate about each piece and consider the end result. This is your only body and the work is permanent—make it a beautiful expression of your own creativity.

SUCCESSFUL SKIN ART

In order to get a good tattoo, you have to know what you want. This is a permanent decision, so don't be impulsive and *just pick something*. You may think the cover of that Melvins CD is the coolest piece of artwork you've ever seen, but who

knows how you'll feel about that illustration or the Melvins in another year? Part of the fun and a lot of the reward of having a tattoo is the research process. Do your homework and don't rush into anything.

"Homework" is thinking long and hard about what you want permanently etched in your body. Don't get the tattoo your friends, lovers, or family members want you to get—give it a little thought: Do you really want a tattoo? What can you put on your body that will always be meaningful to you? It's important to take all the time you need to come up with just the right piece. Research the design possibilities, how you want it to look, whom you want to do it, how big you want it, and where you want it. If you thoroughly research and plan out your work, you'll know when you've hit on the right combination.

Don't try to price-shop for a tattoo. There's a common saying among ink slingers: *Good work is not cheap and cheap work is not good.* Save up until you can afford the tattoo you want, or make several appointments so that you pay as you go, or wait. If you really *must* have some ink and you have little cash, start with a small, more affordable piece from a great tattooist, instead of a big, terrible piece from someone who'll do whatever you want for whatever cash you have.

Some tattooists charge by the piece, some by the hour. The hourly rates usually range from fifty to a hundred dollars. Just because a tattooist doesn't charge a hundred dollars an hour doesn't mean the tattooist is no good—it depends on the location, how much in demand or well known the tattooist is, maybe even what time of year it is (more people have work done in the warm months, when their skin is exposed). There are plenty of wonderful tattooists who aren't "famous," so don't think you should only get tattooed by people you read about in magazines or see at conventions. Some ink slingers don't like all that attention. In Chapter 8, there's lots of good tips about finding a great tattooist.

Beware of scratchers. Scratchers are people who tattoo although they have no skill in the art. Often they've purchased their equipment and supplies out of a mail-order catalog and just set up shop without doing an apprenticeship or even practicing a lot. They don't have control of their tattoo machines, so they often dig too deeply, causing scarring, or they don't "hit" deep enough, leaving patchy, uneven work that looks terrible and won't last long. Their lines are uneven, unconnected, or "blown out." Scratchers will promise you the sun and the moon but have no good examples of their work to back it up. If their work looks bad in pictures or on other people, then it's just bad work, no matter what excuse they offer. A scratcher will offer to do a full back piece for an outrageously low price—and when you see the outcome, you'll know why!

What are the elements of a good tattoo? There are four main considerations in getting a great piece of ink. *Concept*: what you want to get. *Design:* how that concept is translated into a tattoo. *Placement:* where you put that design. And *execution:* how the tattooist does the work.

CONCEPT

A concept is your idea for a tattoo. Ideas for tattoos can come from anywhere. They can be realistic representations of something (a person, an object, a scene), abstract (shapes, patterns, and lines), words (different kinds of calligraphy, different alphabets), or borrowings from the great mosaic of artistic and tattoo traditions (Celtic knots, Mayan heiroglyphs, Victorian wallpaper patterns)—anything that means something to you!

Start by buying tattoo magazines and books; they give you an idea of what other people have and which artists excel at certain styles. And don't be afraid to ask tattooed people

about their work. What do they have? Where and why did they get it?

If you're drawn to a particular subject, like dragons, start saving all the different representations of dragons you see every day. Whether it's a photograph, a cartoon, or a logo— the more examples you have, the easier it will be for you to decide exactly how you want your dragon to look. Your tattooist can also help you find the perfect design.

Tattooists use either *flash* (predrawn designs, usually decorating the shop walls or contained in a large book) or make custom designs (you come to them with an idea or an example of what you want and they draw it up). You should have a clear idea of what you want before you make an appointment—some tattooists won't touch you if you don't know *what* you want and *why* you want it! It's not uncommon for a tattooist to ask you the reasons behind your choice. This lets the tattooist determine whether or not you're serious about the work you're about to get. No conscientious ink slinger wants to tattoo someone who hasn't given their ink a lot of thought. They understand that it's a lifetime commitment, and for many people, one of the few permanent commitments they'll ever make! They take great pride in their craft and want their work to be beautiful, enduring pieces that the wearer will always be proud to have.

Most tattoo aficionados will tell you that custom work is far superior to "off the wall" flash. Tattooists either buy flash from other sources or draw their own. Either way, it is a design that anyone can have tattooed on himself. Custom work guarantees that your tattoo is unique, that you'll never see anyone else with the same piece. Even though flash designs are considered less appealing than custom tattoos, most tattooists will alter flash designs and personalize them to make them a little different so that you don't end up with the exact same piece as a thousand other people.

DESIGN

Do you want your dragon to be realistic or impressionistic? Do you want color work or black and gray? Do you want the whole dragon or just its head? Is the dragon snarling, ready to pounce, or lying down? Is there a background behind your dragon? The more you know about what you want, the easier it will be for you to get it. Don't worry, though: the responsibility for choosing the design is not entirely on your shoulders. Your tattooist will help you figure out just what can be accomplished with your idea.

Composition is a primary consideration in any design. Composition means the tattooist takes everything you want (the dragon, the colors, the background) and translates it into a "readable" tattoo. The artist can't cram too much detail into a small space. One of the most common problems a tattooist faces is clients who want that big, detailed, colorful design shrunk down to a little two-inch piece. Let's say you want a green-and-brown dragon that has a long, scaly tail and flaring red nostrils and sharp, gray claws, with orange-and-yellow flames shooting out of his mouth—do you really think all of that visual information can be put into a two-inch space? Remember, the more complex the piece, the bigger it will have to be. Your skin is a living, changing organism. As you get older, the tattoo lines will become less defined, and the colors will fade. If you try to put too much detail or too many colors into a small area, the tattoo will blur and look like mush. A good tattooist uses a large enough area in a design so that as age and gravity do their thing, your tattoo will still be clearly visible. Having sufficient negative space will give the tattoo a little breathing room as well.

On the other hand, you don't want so much negative space that the piece isn't interesting and cohesive. The lines must be thick enough, and the detail full enough, that your

tattoo doesn't look like a bunch of unconnected elements that will just fade into oblivion. If you ask for just the *outline* of a dragon, it may not look like much. It might need colors and shading and details in the scales and flames to bring it to life.

A tattooist may go through several drafts of a piece before you are both happy with the design.

PLACEMENT

Where you put your tattoo is almost as important as what you get tattooed. Placement is integral to the design process. Long, thin lines (such as a dragon's tail) look best on the long, thin parts of your body (such as your arm or your leg), and curvier lines (such as a dragon's head) look better on the rounder parts of your body (such as your biceps or pectoral muscles).

The shape, width, and length of the design correlates directly to where the tattoo should be placed. There's nothing funnier than a pumped-up two-hundred-pound muscle boy with a teeny-weeny dagger on his upper arm. It doesn't complement his round, well-defined muscles at all—it looks more like an ugly birthmark!

A good tattooist is always concerned about the "flow" of the design—how well it complements the recesses and protusions of the client's physique. Your body is not a two-dimensional canvas; your tattoo should flatter your form, look very natural and organic, and not stick out, look awkward, or obliterate your musculature.

Another placement issue is practical rather than aesthetic. A conscientious tattooist will not tattoo a first-timer on his hands, head, or neck, because it's impossible to cover these tattoos up with clothing. If you really want a tattoo in one of those places, try one out somewhere else first. See how peo-

ple react to a tattoo on a less conspicuous place before you jump into those radical areas. It's a good idea for any first-timer to get a tattoo in a spot that's easily concealed, such as the upper arm, back, torso, or buttocks.

You and your friends may think it's very cool to have sleeved arms or a big leg piece, but what about potential employers or mates? You may feel like an unconventional, F-the-world rebel right now, but who's to say how you'll feel next week, next month, or next year? There'll be time to get that skull tattooed on your hand *after* you've made your first million and don't have to worry about getting turned down for jobs because of a tattoo. Of course, some people desire radical ink to reinforce their commitment to a life outside the mainstream. Use common sense to make the right decision.

EXECUTION

This is the nuts and bolts of a good piece and how to tell if a tattooist is skilled. As well as being established, well-liked, creative, or "certified" (certified by whom? The Acme Correspondence School of Tattooing?), your tattooist must be a capable draftsperson. Any tattooist who tells you they don't need to know how to draw, just how to trace, is a fool. On the other hand, anyone who draws well and thinks he can just pick up a tattoo machine and start laying in ink is a moron. Tattooing requires creativity, artistic ability, and technical skill.

Look at other pieces your tattooist has done and don't settle for so-so, kinda-sorta work. If the tattooist's work isn't artistically and technically excellent (misshapen body parts, crooked lines, spotty color) *leave!* If you settle for less-than-perfect work, you're not going to be happy.

The first thing to check out is the outline. It should be consistent in size and form—not thin, then thick, then thin again. The outline shouldn't "skip" (the line is unconnected

in some places), "explode" (expand into a big blotch in the middle of a line), or cross over another line where it's not supposed to. If the tattooer is incapable of drawing a clean, regulated line, he's definitely not the artist for you—or anyone!

The next thing to notice is the tattooist's shading. Shading is a very subtle talent; the color must gradually lighten or darken. It requires a fine touch—too much or too little shading makes for a really sloppy, cheap-looking tattoo.

You must also check out the way the tattooist lays in the color. The most important thing is that the color is even. You don't want "fill-in" that looks like a bad crayon drawing. The color should be consistent all the way through, not patchy (light in one spot, dark in the other). And it should definitely stay within the lines!

Too often, the uneducated tattoo consumer wants a complicated piece done really small, placed in a bad spot, or duplicated exactly like a flat design that the tattooist knows won't read on a three-dimensional body. An experienced tattooist has lots of troubleshooting experience in making a client's idea work. Listen to your tattooist and follow the suggestions she makes—you'll be happier in the end.

PLEASING PIERCINGS

As with tattooing, you have to know what you want. While piercing is not quite as permanent as tattooing, every abandoned hole will leave a mark on your body—a glaring reminder of your bad decision. Piercing also carries a greater risk of infection or allergic reaction; being aware of the safety and aftercare issues involved in piercing has a lot to do with a successful outcome.

First and foremost, body piercing must be done by a trained, professional piercer (please don't let your friends put holes in your body!). The professional piercer uses a new, dis-

posable, hollow piercing needle for each customer; works with only autoclavable surgical steel tools and jewelry; and follows all contamination-prevention procedures. A professional piercer never uses a piercing gun!

The three creative considerations of piercing are: *location, type of piercing,* and *size of jewelry*.

LOCATION

Piercing locations are broken down into four main categories. They are above the neck, oral, above the waist, and below the waist.

Above the neck includes the most common locations, such as the various ear and nose piercings. They also include some unusual placements, like the bridge of the nose and the eyebrows.

Oral piercings are any that have a portion of the jewelry in the mouth. These are distinguished from above-the-neck piercings because they are harder to keep clean, can be trickier to heal, and involve piercing some sensitive areas that may swell a lot. These include the cheek, the lip, the labret (below the lip and above the chin), and the tongue.

Above the waist refers to the nipples and the navel. These piercings involve extra care to heal, mainly because they are often covered with clothing that can rub against the fresh piercing, aggravating it.

Below the waist means the whole gamut of genital piercings—think of any spot on your crotch and there's probably a piercing for it!

Some piercers won't work below the neck or below the waist, since these piercings require greater expertise. But that doesn't mean that piercings above the neck are a breeze—that's why you must choose a knowledgeable, professionally trained piercer to do *anything* on your body. Ask if they have

experience in the piercing you're interested in. Most piercers state in their advertising or somewhere in their studio policy exactly what areas they work on.

TYPE OF PIERCING

Piercings are also distinguished by the kind of *organic matter* the piercer will be dealing with. Different kinds of tissue require different styles of jewelry, piercing techniques, and aftercare.

Soft tissue piercings are done through fleshy or membranous matter, like the earlobe or nipple.

Cartilage is tough, elastic, connective tissue, found throughout the body. Ear piercings like the tragus or conch refer to specific spots along the top of the outer ear, which is made up of cartilage.

Surface-to-Surface is a term used to describe piercings where both the entrance and exit holes are made through the surface of the skin; instead of hanging from your body, the piercing appears to be "sitting" on your skin.

Piercing is generally differentiated in terms of degree of technical difficulty. Some procedures are very simple, low-risk affairs that any trained piercer should be able to perform and that heal (with the proper aftercare) quickly and without problems. Other, more extreme piercings require superior ability and medical knowledge. They must be planned in advance and may require you and the piercer to do a few "practice runs." The healing process could be lengthy and somewhat complex, with you and the piercer both keeping a careful eye on the progress.

There are piercings that seem pretty easy but actually involve a great deal of risk. Nose piercings require a lot of commitment on your part; you must carefully follow the aftercare

instructions. Because the nose shares a common blood supply with the brain, an infection in this area can be fatal.

SIZE OF JEWELRY

Along with location and type of piercing, you'll need to consider the size of your piercing.

Not every face, nipple, or belly button can handle every size of jewelry or piercing hole. Some of us are not anatomically equipped for certain piercings. A naval piercing requires a deep innie. Small nipples may not be able to handle jewelry of a sufficient size. Your piercer will measure the place you want pierced with a caliper to determine technically what size jewelry you need.

If the gauge is too thick, you may experience keloid scarring or abscessing because the weight of the jewelry is cutting off oxygen to the tissue.

If the gauge is too thin, your body will reject the jewelry and push it out. Visualize the ears of a woman who has worn wire earrings all of her life—they have a fine scar tracing where the piercing originally was to where it has moved.

If the diameter or length is too large, your jewelry will snag easily on clothes, hair, etc., and can rip out.

If the diameter or length is too small, you may develop keloid scarring and your body may actually *absorb* the jewelry!

Then there's the issue of aesthetically sizing and placing the jewelry. A lot of it is your own personal preference, but listen to your piercer's input.

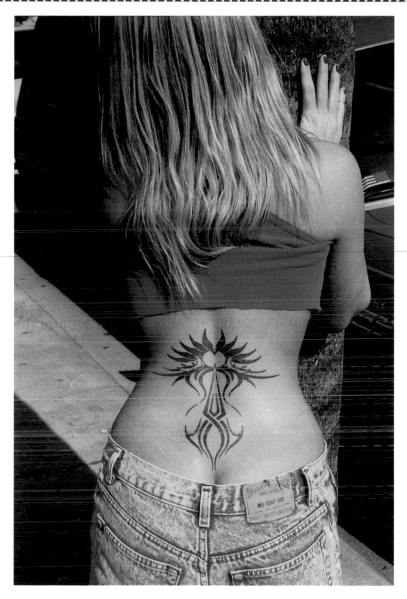

Tribal tats work best when they complement your shape.
Tattoo by Tattoo Mike, Streamline, San Diego, CA.

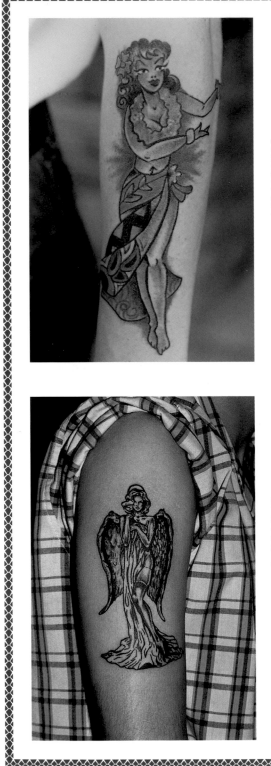

The hula girl is a common Traditional tattoo motif. Tattoo by Albert Sgambati, Lone Wolf Tattoo, Bellmore, NY.

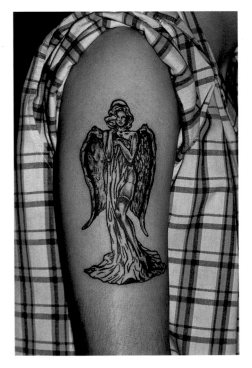

Solid outlining and subtle shading make for good Black and Grey tattoos. Tattoo by Rob Semple, Streamline, San Diego, CA.

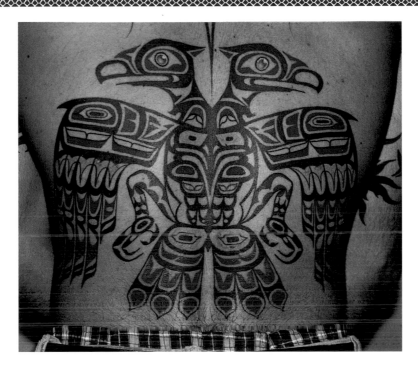

Haida designs are a good example of just how interesting flat tats can be. Tattoo by Tattoo Mike, Streamline, San Diego, CA.

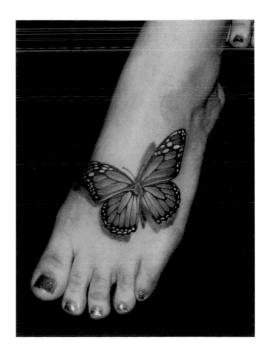

Delicate shading gives this Fine Line piece its punch. Tattoo by Dean Semple, Streamline, San Diego, CA.

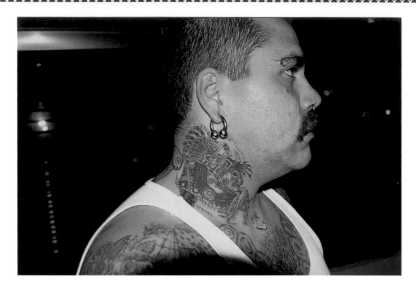

The Mayan figure tattoo (Rob Semple, Streamline Tattoo, San Diego, CA) is a fitting symbol for this serious body mod. Piercings: surface-to-surface (laying on sternum), stretched lobe, eyebrow, and septum.

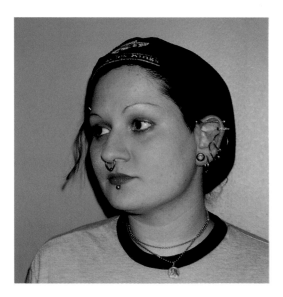

Amy has a labret, a septum piercing, and many ear piercings, which are examples of an ear project, an eyelet and several lobe piercings. (Photo by Marco Turelli.)

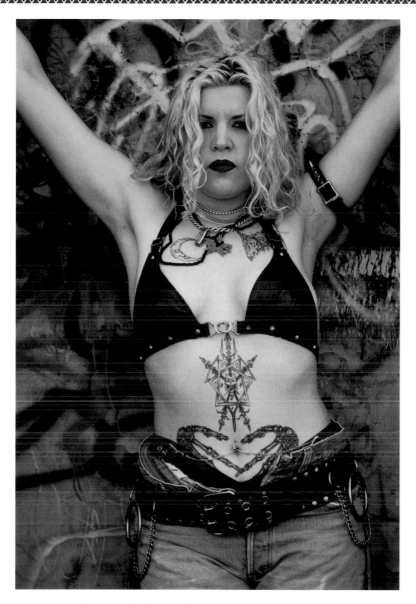

Stacey attaches a chain to her navel piercing (May, Superfly Third Eye, Brooklyn, NY) to spice up the look. Tattoos by Chrystofur, Tattoo Seen, Brone, NY, and Steve, Virginia Beach, VA. (Photo by Mike Martin.)

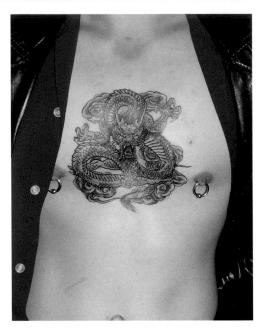

Tattoo by Rob Semple, Streamline Tattoo, San Diego, CA.

Some fineline artists can achieve astounding detail in very small tattoos. Tattoo by Anil Gupta, Inline, New York, NY.

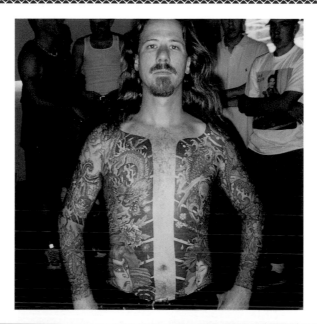

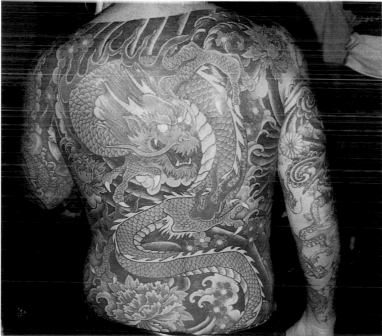

Artie's full-body tattoo is a real attention-grabber and an example of Oriental tattooing. Tattoo by Andrea Elstoin, East Side Ink, New York, NY. (Photo by Dennis Feliciano.)

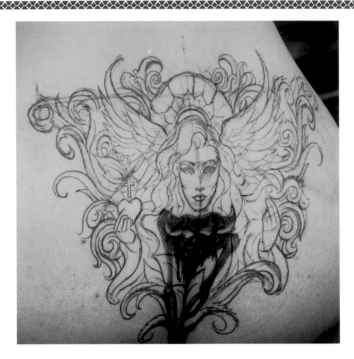

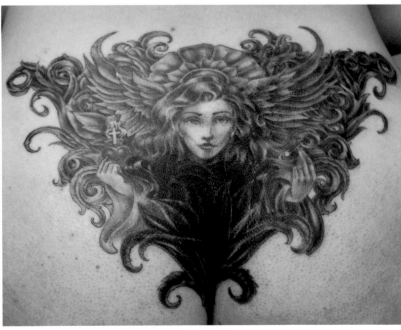

A lot of planning goes into a successful cover-up. Tattoo by Nick Wiggins, Mark of Cain, Champaign, IL.

CHAPTER 6
SAFETY
FIRST

WE CAN'T STRESS ENOUGH that *safety and common sense* are the most important considerations in body-art work. Anything that involves penetrating even the outermost layers of your skin must be done with a new needle that is used only once on you and then discarded. A legitimate, well-trained tattooist or piercer follows strict health guidelines and is *happy* to answer any of your questions about her procedures and *show you* her autoclave. An autoclave is the only reliable means of sterilization recognized by the Center for Disease Control. It must be tested monthly by an independent lab to make sure it's working within acceptable levels.

The primary fear most people express about getting tattooed or pierced is that they may contract the HIV virus, which may cause AIDS. HIV is only one of many viruses that can be transmitted. Syphilis, tuberculosis, strep, staph, and hepatitis are just a few of the other diseases to take into consideration. However, professional practitioners of the permanent body arts use Universal Precautions (a set of standards adopted by all medical and related professions). This strict code of practices takes every safety measure so the risk of transmitting HIV or other diseases is virtually nonexistent.

Still, you shouldn't rely on this assurance when you go for body-art work. You must *take responsibility for your own health and welfare*. Ask questions of your tattooist or piercer.

- Have they had any *specific* training in preventing disease transmission?
- Is there an autoclave on the premises and is it tested regularly?
- Do they use disposable, one-use-only needles?
- Is all of their nondisposable equipment made out of sterilizable stainless steel?

If the answer to *any* of the above questions is no, take your business elsewhere.

Look with your own eyes. Here are some important questions that you can answer through your own observations.

- Is the shop clean?
- Is the workstation thoroughly cleaned and disinfected after each tattoo/piercing?
- Are supplies kept in sterile receptacles with lids?
- Is there a covered "sharps" container for disposing used needles?
- Does the tattooist/piercer wash her hands *a lot*?
- Does the tattooist/piercer use latex gloves when working on a client?
- And are those gloves changed if the tattooist has to touch something else during the procedure (including herself)?
- Is the artist clean and sober?

A good body artist appreciates your interest and concerns; it shows that you're committed to getting good, safe work and that you've thought about it beforehand. Many artists will *insist* you watch them set up before the procedure

and clean up afterward. They want you to be aware of exactly what they're doing.

If someone makes you feel stupid or uncool for asking a lot of questions about how they do things, they're not the artist for you! You're a paying customer, the way this person makes a living. Anyone who's serious about their work will not be offended, put out, or condescending about your concerns. Remember, it's your body and health that are at stake.

INFECTIONS

There is little risk of your tattoo becoming infected if you choose an artist who meets all of the above requirements, and if you properly care for your new ink (see Chapter 7). Just keep it clean and for heaven's sake don't touch it with dirty fingers! If you notice any swelling, redness, or burning that doesn't go away after a few days, consult a doctor.

Piercings have a greater tendency toward infection because 1) oftentimes the piercing goes through actual flesh, not just between skin layers; 2) bacteria from unsterilized jewelry moves through a fresh pierce like the Germ Express; 3) most people just can't keep their filthy hands off of it! If you just had an operation on your stomach, would you be putting your dirt-encrusted, nicotine-stained paws all over the incision? Then why do you think it's all right to be fingering your new belly ring all day?

Every piercing discharges a little during the initial healing; that's the goo that dries and forms a crust around your jewelry. Once a sufficient layer of tissue forms around the hole, it will stop. Other times, what people perceive as an infection in their piercing is actually a reaction to the cleanser they're using. The area may be inflamed and sore, giving every indication of a low-level infection. Check with your

piercer; he may suggest trying a gentler cleansing solution or may tell you not to clean the new hole so often.

What are the signs of an infection? Throbbing pain, a feeling of heat at the piercing site, redness and swelling, or an unusual discharge. These are all pretty normal reactions in a fresh piercing, but they should subside in three to five days. If not, you may have an infection.

Should you develop an infection, *don't remove the jewelry*. Keeping the hole open is the only way for the area to drain. Once you remove the jewelry, your body will close up the hole, sealing the infection inside of you. Don't try to medicate yourself with over-the-counter antibiotics; return immediately to your piercer. If it's not too bad, the piercer will suggest a sea-salt-water soak or maybe an ointment. Your immune system is designed to neutralize pathogenic organisms, so give it a chance. If the infection isn't noticeably better within the twenty-four to forty-eight hours, *go to a doctor*.

Remember, nose piercings are especially dangerous if they get infected. Don't waste any time if you notice problems with that piercing.

ALLERGIES

In tattooing, the greatest potential for an allergic reaction comes from the pigments. Tattoo "ink" is a misnomer, because black is the only actual ink used in tattooing. The rest of the colors are made from mixing dry pigments (made from vegetable matter) with a suspension fluid. Tattoo pigments are seldom reactive to human tissue, although the metallic salts in certain colors can cause a slight irritation in some people. The suspension fluids that are mixed with the pigment may also cause an allergic reaction. Usually the fluid used is water or one of several kinds of alcohol, which are rarely a

problem. These risks are slight to none, except to people who have extreme sensitivities already.

Some tattooists use commercially packaged, premixed colors that are made from plastic-based pigments, like acrylic (*It's a floor wax—no! It's a tattoo pigment!*), and complex chemicals. These are much more likely to cause allergic reactions. Still, the potential is pretty slim, and symptoms are generally mild. You can check with your tattooist to see whether she uses plastic or organic-based pigments. If you're concerned about ink allergies, ask your tattooist to do a "patch test" on a discreet part of your body, punching a tiny bit of ink under your skin to see how your body reacts.

Look at it this way: people have been getting tattooed for thousands of years with no ill effects. If you have severe allergies, especially to metals or plastics, consult your physician before getting inked. If you experience any out-of-the-ordinary symptoms (shortness of breath, rapid heartbeat, fever, swelling, a rash, dizziness, etc.) after being tattooed, seek medical attention immediately.

Allergies in piercing come from the type of material the jewelry is made of or the cleaning solution you're using. For your initial piercing, the piercer should use only jewelry made of the highest grade of surgical stainless steel, niobium, or titanium. These metals are preferred because they are the least reactive and won't "leach" any impurities into your body (for more on this see the body-jewelry section in Chapter 4). Some piercers use gold for an initial piercing, but since gold is a highly mixed metal, it's more likely to cause a reaction. If you have a sensitivity to nickel, an element found in both gold and surgical stainless steel, try niobium or titanium.

A FEW MORE WORDS ABOUT PIERCING SAFETY

There's a much greater risk of damage or infection with piercing than with tattooing—especially when you consider how many untrained people are doing it. Some folks think all they need is a needle or a piercing gun, a piece of jewelry, and *voilà!*—they're a piercer. *Nothing could be further from the truth!* Not only do you run the risk of infection by using unsterilized or improperly sterilized tools, you can also cause permanent damage by "hitting" too deeply or not hitting deeply enough. *Body piercing must be done by a professional!*

Let's start from the beginning. Rule number one: A piercing "gun" is not suitable for any piercing. Not your ears, not your nose, not your navel, not your nipples, not your lip—*nowhere!* Here's why: First, because of the way piercing guns are made, they can *never* be properly sterilized. Even if the part that touches you can be removed and autoclaved, the rest of the gun cannot, so it's a breeding ground for a million living microorganisms that can cause disease. Second, guns pierce by blunt trauma, ripping out a jagged wound of flesh with a dull-ended stud. This immensely increases the chance of infection, rejection, and scarring.

Any piercing you get should be done by a trained professional (and renting a shop in the mall does not qualify one as a professional!). As in tattooing, some people receive their training by apprenticing with a "master piercer." Others attend instructional programs, such as the ones offered by the Gauntlet and Fakir Musafar (see appendix). They may even have varying degrees of medical training. A piercer must have knowledge of anatomy (nerve and capillary paths), dermatology (physiology and pathology of the skin), and biology. Keep in mind, your body's natural reaction is to *reject* any for-

eign object. Piercing works on the theory of "tricking" your body, through a complex combination of:

- depth and width of the piercing
- proper gauge and diameter of the jewelry
- purposely building up scar tissue around the new hole
- precise timing in the use of an antibacterial (or not)

Without these skills, the artist won't be able to coax your body into accepting the piercing and your system will do everything it can to force it out.

Professional piercers use latex gloves, sterile surgical stainless-steel piercing tools, and disposable hollow piercing needles. They must know proper techniques so that the pierce isn't crooked, ill placed, or uncomfortable for the wearer. They must have enough anatomy knowledge to know where you can be pierced and where you can't, and they must know how to manage infection, scar tissue, and events that could occur during the healing process.

Many people who sell jewelry (and not necessarily acceptable piercing jewelry) also offer "full body piercing." Even if they're using disposable, hollow piercing needles instead of a gun, they may have little or no training. These people are very dangerous! *Please* get all of your work done by a *trained piercing professional*.

CHAPTER 7

PROCEDURE AND
AFTERCARE

YOU MUST BE EIGHTEEN years old to get a tattoo or piercing. Not just because that's the age of legal consent, but also because most of your physical growth has stopped at that point. Your tattooist/piercer will ask you to sign a legal waiver and he may ask you to produce ID if there's any question as to your age.

It's a good idea to eat a light, healthy meal two to four hours before your appointment. If that's not possible, drink some juice or nondiet soda before your appointment to keep your blood sugar level up. *Never* go to a tattooist or piercer under the influence of alcohol or drugs. Any professional artist will kick your butt to the curb if you show up high.

Wear appropriate clothing. If your piece is going to be covered by an article of clothing, make sure it's loose fitting and made of light, soft material. Be clean. You're going to have to refrain from the bath and shower for a bit after the procedure—and you don't want to offend your artist, right?

The initial steps in prepping for a tattoo or piercing are much like prepping for an operation—and the same precautions for infection control and contamination prevention (called Universal Precautions) are observed. Anything that will come into direct contact with your skin is either:

- disposable—used only on you then discarded, or
- sterile—the few tools that aren't disposable are steril-ized in an autoclave after each use

To begin, the artist puts on latex gloves. The artist must be careful not to spread potential infection by touching *any-thing* that could possibly contaminate you or that could be contaminated. Tattooists and piercers go through several pairs of gloves to do one piece. Something as inconsequential as scratching their noses or answering the phone means a new pair of gloves.

One final word of advice: a conscientious, well-trained tattooist or piercer washes her hands *a lot*!

TATTOO PROCEDURE

Once you've decided on your tattoo, discussed design and placement with the artist, the actual procedure can begin. First the tattooist shaves the area where the tattoo will be placed with a disposable razor. No matter where you want your new ink, there *will* be shaving involved, since tiny hairs cover our entire body. Then, using paper towels, the area is cleaned with an antiseptic solution. Another paper towel is run across a stick of clear deodorant and then applied to your prepped skin. The deodorant is what makes the stenciled image stick to your skin. It also allows the image to be quickly and completely wiped away if the placement isn't right.

Depending on where the tattoo is to be placed, the artist may ask you to stand with your arms and legs straight, to see exactly how the piece will "lie." Because of the way muscles wrap around our body, our skin is constantly twisting. If you lay your arm flat out on a table, your skin will be in a differ-ent position than if your arm hangs down your side. The tat-tooist will place the tattoo with you in a natural stance.

Once the exact positioning has been determined, the tattooist carefully presses a stencil of your design onto your skin and then slowly peels it off. Now you've got a purple outline of your impending tattoo. Look long and hard at this outline to make sure it's exactly where you want it; once the tattooing starts, there's no stopping!

Some tattooists draw freehand, directly onto your skin, without using a stencil. This is okay if you trust your artist one hundred percent, but it's always good to get things down on paper first. This way you and the tattooist both agree, in advance, on exactly what the design will look like, down to every little squiggle and dash. When your stenciled design has dried, you're ready to be tattooed.

The tattooist will put everything that's needed for your tattoo out on a tray. Petroleum jelly, disposable ink caps filled with every color in your tattoo, packets of needles, the tattoo machine. Once everything has been set up, the tattooist must put on disposable latex gloves. Anything that will come into direct contact with your skin is either used once or, in the case of the ink, placed in small, throwaway containers. *All needles must be disposable, and used only once.*

After a little petroleum jelly is traced around the stencil design (to help the tattoo machine glide easily over your skin), the tattooist will find a starting point and, with one hand, stretch that patch of skin out taut. With the other hand, the needle configuration (the number of needles used to achieve a certain effect) is dipped into the tattoo pigment.

The tattoo machine looks like, and is sometimes called, a "gun." An electrical current provides enough power to push the tattoo needles through your skin. The needle configuration (it could be one or more, and several different configurations can be used in one tattoo) is placed in a tube that the tattooist has autoclaved ahead of time and is attached to the end of the tattoo machine. By pressing a foot pedal, the needle(s) move quickly in and out of the end of the tube, mak-

ing approximately three thousand punctures per minute. There's a very distinctive noise to a tattoo machine. The buzz has been compared to everything from a dentist's drill to a swarm of angry bees. That sound is a big part of the tattoo experience, so get used to its high, whining pitch.

Now it's magic time. The tattooist presses the machine to your skin and outlines the design. Initially, it looks like the ink is going everywhere, but don't panic. As the tattooist proceeds, the extra ink will be blotted off and you'll see a nice, clean line. You'll also see little dots of blood emerge from the freshly tattooed spot, but don't worry, there's seldom any more than just those few tiny bubbles. How much you bleed has a lot to do with your personal physiology as well as outside factors (like the presence of alcohol in your bloodstream, which can make you bleed like a stuck pig). Usually your

blood will coagulate within a few minutes, clotting up the tiny punctures that have been made.

What does it feel like? Scratch your fingernail on your skin, really fast. That's what it feels like. You may experience an annoying burning sensation during your tattoo, but that soon passes, once the endorphins kick in.

What are endorphins? They're hormones that bind to the opiate receptors in your brain. They reduce the sensation of pain (among other things) and produce a feeling of euphoria. Endorphins allow you not only to handle physical discomfort but get a little buzz from it as well! Athletes, especially runners, are very familiar with the "endorphin rush." So are tattoo fanatics.

How deep does the tattoo needle go? Skin is composed of three layers. The *subcutaneous* layer is the deepest; that's where our fat and collagen are. The *dermis* (also called the *corium* or *cutis*) is the center layer and contains nerve end-

ings, sweat, sebaceous glands, and blood and lymph vessels. The *epidermis* is the outer layer and contains the cells that manufacture pigment and provide immunological defense against foreign substances. The tattoo needle punctures between the epidermis and the dermis.

You'll notice during the tattooing that your skin becomes raised and irritated. This is normal and it, too, will pass. Your tattooist can soothe your skin with cool water during the tattooing process to help alleviate irritation.

Depending on the size and complexity of your piece, the tattoo can take anywhere from thirty minutes to a few hours, even a few sessions! A lot of people try to push their tattooist to finish big pieces in one sitting, but generally it's not a good idea for you or the artist to go longer than a few hours, without at least a break. Just think of what *you* feel like when you sit, intently focused, on something complicated and important for long periods of time. If you want the best work for your money, then stop when the tattooist needs to stop and come back another day. You can't rush perfection!

When your tattoo is finished, the artist will clean it gently with an alcohol/water solution. Once that dries and little blood bubbles have ceased rising to the surface, the artist may want to snap a few photos of your piece. These photos may be used for the tattooist's own records, put on her studio walls or in a portfolio with other work she's proud of, or possibly sent to a tattoo magazine for publication.

If the artist wants to take pictures of your piece, be sure and ask what she plans to do with the photos. Some people don't like to have their tattoos displayed in a studio or in a magazine because they don't want other people copying their designs. Others are very proud of their work and want the whole world to see their skin art! Either way, you have the right to know exactly what your tattooist plans to do with the pictures.

Once the area has been cleaned, the tattooist will apply a light coat of A and D ointment or a comparable emollient. This salve helps repair the damage done to your skin and aids in the healing process. The tattooist may have a tube of A and D ointment to sell you; otherwise, you can find it at most pharmacies. The tattooed area will be loosely bandaged with surgical gauze and medical tape. Some tattooists cover fresh tattoos in plastic wrap—this is *not acceptable*! Even though your new tat needs to be protected, it also needs to breathe. To say nothing of the fact that plastic wrap is a breeding ground for nasty bacteria that could infect your tender new artwork. If you've just gotten a large piece of work, you may want to pick up a few bandages and some medical tape as well, since you might need to change your bandage.

Tattoo Aftercare

Aftercare instructions vary slightly from tattooist to tattooist. Your artist *must* give you written instructions for the care of your new piece. Here are the basic things to remember.

1. Depending on the size of the piece and your tattooist's advice, you need to leave the bandage on anywhere from four hours to overnight.
2. When it's time to remove the bandage, do so *very gently*. Slowly peel back the dressing, and if it sticks at all, *stop*! Pour cool water between the skin and bandage. Don't stick your tattoo under a full-force tap. Remember, easy does it. Wait a few minutes and try again. The cold water should loosen your skin from the bandage without yanking the color out.

 During the entire healing process, you must be very careful not to pull any skin or scabs off because

you'll also pull the ink out. This will leave uncolored holes in your tattoo.

3. Once you get the bandage off, wash your tattoo very gently *with your fingertips*. *Do not* use a loofah, sponge, washcloth, cotton ball, paper towel, or anything else but your fingers. *Do not* stick your tattoo under a full-force tap. If you're taking a shower, *do not* let the water directly hit the tattoo. If you're taking a bath, *do not* submerge your tattoo in the water. Use a mild antibacterial soap or any other gentle soap free of deodorants, skin softeners, or other additives. Rub gently, rinse gently.

4. After you've cleaned the tattoo, gently pour cold water over it for a few minutes. The cold water will tighten your pores, which helps the tattoo heal more healthily and quickly, and some tattooists believe it helps the color "set."

5. Lightly pat the tattoo dry with a soft towel.

6. Carefully apply a light coating of A and D ointment. Don't smear it on too thick, because your skin needs to breathe. Smothering your skin with ointment will cause your tattoo to scab up a lot and it could increase your chance of infection. You can use Bacitracin or even a very gentle, additive-free lotion in a pinch (as long as it's *water-based*), but since A and D ointment contains nothing but skin-healing vitamin A and vitamin D, it's the ideal balm.

 Depending on your tattooist's instructions, you may need to apply another bandage. If so, put it on very loosely. You don't want it to stick to your tattoo.

7. For the next two weeks, when you shower or bathe, keep your tattoo away from the water as much as possible. When washing it, use only your fingers. Blot it dry with a soft towel.

No rubbing, scrubbing, picking, or scratching—
no matter how much it itches!

For the ncxt two weeks, avoid swimming (ocean
or pool), hot tubs, Jacuzzis, and tanning beds.

For the next two weeks, stay out of the sun.

Once the ink has settled into your skin, you can return to
life as usual. Always use a strong sunblock on your tattoo
when you're going to be outside for any length of time, be-
cause the sun's rays will fade your tattoo (there's actually a
sunblock on the market designed specifically for tattoos).
Also, just like the rest of your body, your tattoo will look bet-
ter longer if you get into the skin-lotion habit.

If, after the tattoo is fully healed, you're not happy with
the way it looks (the color is patchy or has holes, the lines are
crooked), *go back to the tattooist*! Artists want to do the best
job they can for you and most of them will happily touch up
a piece once it's set.

PIERCING PROCEDURE

The first step in the piercing procedure is for the piercer to ex-
amine the area to be pierced. Measurements are taken in
order to select the proper jewelry dimensions. Once this has
been determined, you can choose your jewelry based upon
the piercer's recommendations.

After the area to be pierced has been thoroughly cleaned,
the placement of your piercing (entrance and exit holes) is
marked with a nontoxic marker. Some piercers use a tooth-
pick dipped in nontoxic coloring to eliminate any chance of
contamination.

The piercer will have everything that's needed set up on
a nonporous work surface (a stainless-steel tray, for example),
covered with a paper towel or dental bib. You may see some

pretty scary tools, but rest assured, the only thing going into your skin is a hollow needle and your jewelry. If your piercer doesn't tell you, ask for an explanation of each tool's use. A caliper is used to take the measurements. Pliers are used to open and close the jewelry (if you're getting a ring). Forceps are sometimes used to clamp onto the area that's going to be pierced. That's not so scary, is it?

The piercing is done with disposable, one-use-only, hollow needles, which have been beveled and sharpened. They are usually about two or three inches long. The needle stays in its sealed package until the piercer is ready for it.

Some piercers use a one-use-only, sterilized cork on the exit side of the pierce. This gives support to the area to be pierced and prevents any unwanted pokes with the needle. Other professionals frown on this practice because it gives piercers a false sense of security—and a false sense of their ability. A technically elegant piercing is done with as few "crutches" as possible.

The exact piercing method depends on the jewelry and the pierce. Generally, a hollow receiving tube is placed on the entrance mark. The needle goes into this. One good push and the needle is through! Your jewelry fits into the hollow end of the needle so that there is no loss of "contact." That means the initial hole the needle makes is followed immediately by the jewelry, since it's attached to the needle. If a piercer loses contact, the piercing has been botched. This needle/jewelry configuration is pushed through your new hole until the jewelry is in place.

Let's talk about pain for a minute. Most people find that the *anticipation* of pain is a thousand times more stressful than the actual piercing sensation. The most common response to a piercing is, "Is that it?" You can do a lot to alleviate not only any actual pain, but the anxiety of anticipating pain, by remembering one simple thing: *breathe*. When nervous or excited, we tend to forget to breathe properly. Take

deep breaths: in through the nose, out through the mouth. In through the nose, out through the mouth. This is a very helpful mantra to repeat and practice when you're getting pierced.

Anesthetics of any sort are not recommended for piercing. Anesthetics can cause an allergic reaction, inflammation, and *pain*. Many people feel that piercers who use anesthetic are just trying to hide their own incompetence.

Good piercers will provide an almost pain-free piercing experience. They'll talk you through the entire process, making sure to ask how you're doing as they go. A piercer's soothing voice and friendly manner goes a long way to reducing anxiety. The artist will also pick up on your breathing pattern and perform the piercing as you exhale, which helps alleviate the shock. He'll thread the needle and jewelry through as quickly as he can.

Lots of folks don't consider what happens during a piercing "pain"; they call it a *sensation*.

When it's all over, sit for a minute, or two, or more. The piercer will give you a mirror so that you can see your new body art—fantastic!

PIERCING AFTERCARE

Never touch your piercing unless you're cleaning it. *Always* wash your hands with antibacterial soap before you touch it.

Your fresh piercing may be itchy, swollen, secreting a light-colored fluid, or bleeding a little for the first few days. That's all perfectly normal. The piercing may get crusty, making rotation (turning) of jewelry difficult. Loosen your crust with a hot compress (a damp, clean washcloth, cotton swab, or sterile gauze) and immediately proceed to your aftercare regimen.

As with tattooing, aftercare instructions vary among

piercers—and among piercings. Your piercer *must* give you written instructions for the care of your *specific* pierce.

Here's a rundown of the general steps for aftercare of your new piercing.

1. Clean your piercing twice a day, never more than that. Excessive cleaning can actually hinder the healing process. If you feel you absolutely must clean it more than twice in a day, use a sea-salt (*not table salt*) soak or compress. Add a quarter teaspoon of sea salt to a cup of warm water.

2. Your piercer will recommend an antiseptic appropriate for your specific piercing. After you've removed any crusties, clean the area with the antiseptic and gently rotate the piercing so that the antiseptic gets inside.

3. Wear loose, light clothing over your pierce. Try not to bend, twist, or otherwise move the pierced area any more than necessary. For nipple piercings, keep them covered in a loose T-shirt when you sleep. For genital piercings, women and men may find it a good idea to wear a panty liner. This will absorb any moisture.

4. Keep body fluids away from your fresh piercing, even your own. The one exception is your urine, which is sterile to your body. Use latex barriers to protect genital piercings during sex even if you usually don't.

5. In the case of oral piercings, if you smoke, eat, or put anything in your mouth, rinse with an antibacterial mouthwash, diluted fifty percent with water, afterward.

6. You may find that taking vitamin supplements helps speed up the healing process. Vitamin C and zinc, as well as a good multivitamin, seem to work well.

7. No matter what the primary healing time is, you must wear your initial jewelry (unless your pierce requires

downsizing) six to ten months before you can even think about changing it.

8. Keep following your aftercare instructions even if the pierce looks healed. (Primary healing may only take a few months, but a piercing doesn't completely heal for a couple of years.)

Here are some approximate primary healing times for different piercings:

Ampallang	4–8 months
Apadravya	4–8 months
Cheek	2–4 months
Clit	1–2 months
Clit hood	1–2 months
Dydoes	2–6 months
Ear cartilage	2 months–1 year
Earlobe	6 weeks–2 months
Eyebrow	6 weeks–2 months
Frenum	2–6 months
Guiche	2–6 months
Inner labia	1–2 months
Labret	6 weeks–2 months
Naval	6 months–2 years
Nipple	2–6 months
Nostril	2 months–1 year
Outer labia	2–4 months
Prince Albert	1–2 months
Scrotum	2–6 months
Septum	6 weeks–2 months
Tongue	1 month–6 weeks

CHAPTER 8
HOW TO FIND THE RIGHT ARTIST

FINDING THE RIGHT PERSON to do your work is very important to a successful piece of body art. Remember, this is the only body you have and you should not cut corners when choosing an artist. If you're not "in" the body-art scene, how do you locate that special artist? The following are ways to make a body-mod connection.

READ THE RAGS, BUY THE BOOKS

There are a number of body-art magazines and books on the market. Unfortunately, you'll only find bits and pieces in each of them, so be prepared to look through a lot of material before you get the information you need. The best ones will educate you, inspire you, and expose you to a wide variety of work from artists all over the world.

Some magazines are story-driven; they profile artists and fans, feature articles on the history of body art, and address technical and safety concerns. Others are more like picture books; they contain photographs of different tattoos, piercings, or pages of designs, and they usually identify the artists. Make sure you look through a magazine before buying it to see if it's got what you need in it.

BE A PEST

Start paying attention to other people's work. Whether you like the piece or not, ask about it. (It's good to know which artists suck as well as which ones shred.) Who did the work? Is the artist local? How long ago did he have the piece done? Would he recommend the artist to other people? Most folks don't mind talking to you about their work, especially if they know you're interested and appreciative and not just an annoying geek (*"Uh, did that hurt?"*). Tattoo/piercing fans are usually very opinionated about artists, styles, and trends—they have a lot to say on these subjects because they themselves enjoy learning and sharing information about body art.

VISIT LOCAL SHOPS

With very few exceptions, tattoo and piercing establishments are set up so that you can stop in and look around. There is a "front" person whose job it is to answer all your questions, and photo albums full of the artists' work for you to examine. Often, flash designs cover the walls and there may be a reference library full of books that the artists use as design sources.

When you walk in, make it clear you just want to check out the studio. Any professional establishment will respect your curiosity and not mind your taking a few minutes to look around. If a studio won't let you look around or answer your questions, they're probably too busy to accommodate you at that moment. In that case, ask when would be a good time for you to come back. If they're just giving you attitude or blowing you off, you probably don't want to give them your business anyway—unless you *like* being treated badly.

There are a few things you should keep in mind when visiting a studio. First of all, don't go snooping around unless

you ask! Studios generally have a specific waiting area that's separate from their work area; respect the artists' and customers' privacy. As discussed in Chapter 6, you *do* want to see how clean the environment is, if they have an autoclave, and maybe even watch the artist work—but get permission before you go exploring.

Ask to see examples of the artist's work. There should be photos on the walls or in an album that show tattoos/piercings the studio has done. A lot of studios have more than one artist available, so make sure you know whose work you're looking at when you go through a shop's portfolio. Use the guidelines in Chapters 2 and 5 on Styles of Body Art and Getting Good Work to see if a given artist is the right person for you.

A word of caution. Some studios cut pictures out of magazines and put them on their walls or in their photo albums, but the pieces are not their work, they're just examples. If you ask them if the work is theirs, they may say, "No, but we can do something just like that." Maybe they can, maybe they can't. If you're not familiar with a particular artist's capabilities, it's much better to go by concrete examples of his work instead of undocumented promises.

Body artists are as diverse a group as they come. While plenty of tattooists and piercers are versatile and skilled in many different styles, there are also quite a few that specialize. Some tattooists only do a specific type of skin art, and some piercers won't do certain piercings. Make sure the artist has experience in exactly what you want.

CONVENTIONS, EXPOS, AND SHOWS

A great way to see many of the artists in your area, as well as artists from all over the world, is to attend one of the many annual body-art conventions, expos, and shows. These

events take place over a long weekend and are held in a hotel or large meeting hall. Different artists set up portable tattoo booths in an auditorium or ballroom, or work out of their hotel rooms. The conventions follow the strict guidelines set up by the hosting city's local department of health as well as the convention's sponsors, so there's little risk of unsterile conditions.

You can either pay a one-day entrance fee or purchase a pass for the duration of the event. If you're interested in attending a convention in a city other than your own, there are usually special hotel and airfare packages offered for convention goers.

What happens at these events? Lots of tattooing and piercing! But people don't go just to get work done. There are also vendors selling T-shirts, jewelry, books, and other body-art-related merchandise. And there are tattoo contests. For a registration fee, you can enter your tattoo in a competition. There are different categories (for example, Best Realistic, Best Overall Female, Best Small Tattoo) and prizes can be cash, trophies, or both.

Many people who want work by a specific artist seek that artist out when she attends a convention in their area. It's a good idea to set up an appointment ahead of time, though, as a lot of other people may have the same idea.

It's also great fun simply to absorb the atmosphere. You can watch artists in action, see samples of their work (in photos and on live skin), and talk body art until you're blue in the face.

Certain artists charge more for their services at conventions than at their own shops, because they need to recoup their travel expenses. If you're never going to have another opportunity to get the work done, then it may be worth paying the higher price. If the tattooist or piercer is within traveling distance of your home, though, you may want to wait until you can get to his studio.

However, it's ill-advised to start a piece at a convention, with an artist from a different area, that won't be finished that weekend. There are some poor souls walking around out there who have back pieces from two years ago that aren't completed because the artist never came to town again!

Some conventions advertise that "stars" of the body-art world will be *attending* their event, but that doesn't always mean they'll be *working* at the event. Check this out ahead of time if you're trying to get work from a living legend.

You can find information about conventions, expos, and shows in tattoo magazines, in local alternative newspapers, and at area studios.

CONSULTATIONS

If you've found a person whom you feel is capable of giving you the body art you want, you may still wish to have a consultation before committing your flesh to her. In fact, many artists insist on a consultation before they start the work. This allows all the details to be worked out before actually sticking the needle to you. Consultations are mainly used for custom-designed tattoos, but it isn't unheard of in the piercing world.

Usually a deposit is required at the time of your consultation, which is then applied to the final cost of the tattoo. This is a way for the artist to be assured that you're committed to the work and not wasting his or her time.

Bring visual examples of your design idea to the consultation. The more visual input the tattooist has, the easier it will be to render the design exactly the way you want it. The artist may need a little time to work on your tattoo design, so don't be surprised if you have to come back *again* to okay the final design! And don't be afraid to speak up if you're not satisfied; communication is very important to making sure you get what you want.

111

Just keep in mind that the artist has certain criteria for doing a *good tattoo* that are a lot different from doing a good drawing. You may ask for things that the tattooist knows won't "translate" well onto your skin. You're paying this person to give you a great piece of art—listen to him!

APPOINTMENTS

Some studios take "walk-ins" (where you just show up and have the work done right then) and some require you to make an appointment. If you make an appointment, *keep* the appointment—don't cancel at the last minute. Remember, this is how your artist makes a living. If she reserves three hours of her time for you and you don't show, that's three hours she could be working on someone else, making money!

UNDERGROUND ARTISTS

A few places do not look favorably upon body art (tattooing is illegal in some cities, counties, or even states in the U.S.) and therefore artists are forced to be very discreet or work completely "underground" (no shops with signs out front). This makes finding a competent tattooist or piercer much more difficult. Not only is it harder to locate the artists, but you can't be sure they're following adequate safety precautions because they're not monitored by the local department of health.

Most shops have much stricter safety guidelines than their local health department requires anyway. The majority of underground artists follow these rigid regulations, which are based on *industry* standards that are more thorough and informed than the local authority's. If you follow the tips laid out in this book, you shouldn't have any problems. That

doesn't mean there aren't some dangerous scratchers out there, but there are also plenty of good artists forced to work underground due to state or local law. Some artists who work underground don't *want* their profession legalized. They feel by opening the craft up to any jerk with the money to start a shop, then that's just what will happen—any jerk with the money to start a shop, will!

If you live in a place where body art is banned, you can still locate artists using the methods outlined above. Word of mouth is an underground artist's primary means of advertisement. In one sense, this means they'd better be pretty good, otherwise no one will ever bother to track them down! Underground artists often leave flyers or business cards at local businesses connected with the body-art scene—bike and skate shops, clothing and record stores, bars and such. They may even take out small ads in local alternative rags. They also show their work in magazines and attend area conventions.

PROFESSIONAL ORGANIZATIONS

There are national and international organizations for professional body artists. Many of these organizations require their members to have taken classes in preventative measures and safety procedures, as well as to prove they have an on-premises autoclave. Membership to one of these organizations doesn't necessarily mean the artist is great or even that she follows Universal Precautions, but it does give you a place to start. A few of these organizations are listed at the end of this book.

CHAPTER 9

MEHNDI, SCARIFICATION, AND OTHER PRACTICES

As MENTIONED THROUGHOUT THIS book, many types of body art and body modifications are being practiced today. Some are based on ancient rites and traditions and some are as new as the latest medical procedures. Here are a few examples of the options available in the wild and wonderful world of body art.

MEHNDI

Mehndi is an Indian tradition of decorating a woman's hands and feet with henna dye. Originally it was done to celebrate her wedding. These days women from New Delhi to Calcutta have Mehndi designs applied as often as they have their nails done. Traditionally, the patterns are very intricate, and it takes many hours to complete a design. Since Mehndi is pretty much the same texture as the henna dye we use on our hair, it requires a very steady and skilled hand to turn something the consistency of mud into a beautiful, ornate design. The henna dye lasts anywhere from ten days to six weeks, and the color varies from deep brown to reddish brown to orange, depending on your particular chemical makeup.

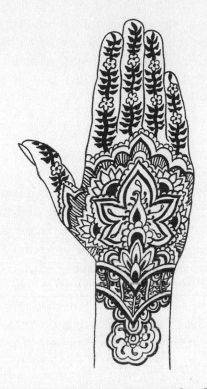

Mehndi is becoming a very popular form of body art in the West, and shops are opening up in large American cities where you can have any kind of design put anywhere on your body. It's becoming one of the hottest body-art trends, since it's not as temporary as body paint or as permanent as a real tattoo. There's no pain involved and the work can be done anywhere on your body. It's a good idea to select parts of your skin that don't bend or move a lot, as this movement will wear the color off.

BODY PAINT

This temporary body art has evolved quite a bit since Goldie Hawn had *Sock It to Me* scrawled in tempera paint on her

stomach in the sixties. A good example of how far body painting has come can be seen on the *Vanity Fair* cover that featured a nude Demi Moore wearing a suit made of body paint. Beautifully executed designs can be just as wild as you want them, since they wash right off!

TEMPORARY TATTOOS

Even temporary tattoos have come a long way since the days of "Lick N' Sticks" that came with boxes of Cracker Jacks. Today there are lots of different designs, some of which are created by real tattoo artists. The best temporary tattoos are made on special paper (like rice paper) with cosmetic ink. They're waterproof and last about one to two weeks, depending on how you care for them. Some people get temporary tattoos in the place where they want a real one so that they can see how it looks. Other people are just tattoo wannabes and slap on a temporary tattoo to temporarily be perceived as cool.

Pretty lame, but hey, it's all about expression, right?

SCARIFICATION

Some body mods are taking their skin art a step further by using scars as decorations. Scarification is done two basic ways: by branding the skin with a hot piece of metal or by cutting it with a scalpel. This is not an exact art form. The results vary, based on the ability of the person who does the work, your body's own ability to raise keloids (fibrous scar tissue), and how much melanin (the natural pigments in your skin) you have. If you have dark, lasting scars from past injuries, then you probably have sufficient melanin to give lasting color to a scarification.

As with any other permanent body modification, this procedure *must* be done by a professional. The professional will know how deep to cut, how long to hold the hot brand to your skin and how to heal your wounds—an interesting subject in itself, because you're not really trying to "heal" these marks, the whole point is to leave a big scar! A professional will also spend *a lot* of time making sure you really want a scar before giving you one.

Branding is done by fashioning pieces of metal into a design, then heating those pieces of metal and applying them to your skin. The burn will spread two to three times the width of the brand, which the design must compensate for. Each strike only lasts a few seconds, and yes, it hurts. Does it hurt when you touch hot metal? Well, then it will hurt when hot iron touches you. People who have been branded speak about the incredible endorphin rush they get (sometimes they go into a low level of shock!)—and the incredible pain they feel once the endorphins wear off. We *are* talking about second- and third-degree burns here. There is a great risk of getting an infection if the brand isn't properly cared for. Third-degree burns actually heal more easily, because the wound is cauterized.

One well-respected body artist has been sculpting intricate "brands" using a surgical laser. The precision of the laser gives the artist more control, making an even line and a cleaner heal.

Cutting is most often done with a surgical scalpel. The sharp blade allows for a more delicate scarring than branding, so you can achieve fine lines and intricate patterns. The person performing the cutting may take a piece of paper and lay it over the design, making a "blood rubbing" of the piece. After the initial cut heals, some people go over the line again (and again) to achieve more depth. Pain is minimal, compared with branding. One New York artist uses a tattoo machine loaded with different needle groupings (but no ink) to

achieve a variety of scar shapes and sizes. Much like the laser procedure described above, he gets much more control over the final outcome this way.

Darker skin tends to scar up better, producing heavier keloids (fibrous scars) and more melanin (our natural pigment) in the wound. Since the point is to raise scars, the healing process can involve purposely irritating the wound by introducing a foreign substance or picking at the scabs. Once again: kids, don't try this at home. If you're interested in scarification, find a pro.

AESTHETIC DENTISTRY

Aesthetic dentistry refers to creative techniques that are done to the teeth to change their appearance. Creative dentistry is nothing new. Gold, silver, and porcelain caps are pretty common ways to hide imperfections and generally "jazz up" your mouth. The metal caps can be stamped with your initials or a symbol, and "tooth-toos," little wax designs stuck on your caps, can be added for extra pizzazz. There are more radical procedures such as having a hole drilled into a tooth and then implanting a jewel into the hole for a truly *dazzling* smile. You can have your teeth filed to points—just the canines à la Dracula or all of them, à la the Wolfman. For the less adventurous, porcelain vampire fangs that you can wear temporarily are all the rage.

EXTREME BODY MODIFICATION

Some people change their physical bodies in other ways that are familiar or really push the envelope of body art. These alterations can be as common as muscle training and plastic

surgery or as radical as extreme tissue modification and implants.

You can change the physical shape of your body in many ways. Lots of people work out or do muscle training to sculpt their bodies into a desired shape. Plenty of people undergo plastic surgery or have implants to alter their appearance.

While some of the following procedures may seem very radical, keep in mind that many conventional procedures such as removing ribs to make your waist smaller, injecting collagen into your lips to make them fuller, or implanting saline bags in your chest to make it bigger may seem very strange to other people.

Some people bind parts of their body to change their shape either temporarily or permanently. The most common form of this is corset or waist training, which involves wearing a cinch or corset for a certain period of time every day to remold your middle. People who are into this kind of modification keep track of their waist measurements, noting the diminishing size. Reduction can be achieved quickly and temporarily by tightly lacing a corset or cinch—your "wasp" waist will last only as long as you're wearing the gear—or permanently by slowly cinching in your garment while you increase the period of time you wear it. There is a potential danger of damaging your internal organs or bones, so read up on the subject before actually starting the process.

Extreme tissue modification refers to surgical procedures that reshape your body in a radical way. One way of doing this is by implanting foreign material under your skin. This could be metal spikes that stick up out of the top of your skull (which, believe it or not, more than one person has done!) or inserting marbles in your skin between the dermis and the muscle fascia.

One legendary body modifier has created a flap on his stomach about half an inch wide and two inches long—much like a belt loop. Under general anesthetic, two incisions were made. The resulting "flap" was then lifted away from the abdominal wall and the remaining gap was sewn shut by suturing the two incisions together. Since the top and bottom of the flap are still connected to the main body of tissue, blood still circulates through it—if it didn't, the modification would have never healed. Through this flap he sticks a plug, a

feather, or any cylindrical object . . . occasionally he hangs his keys from it!

BODY PLAY

Body play takes many forms. It can be temporary piercings or cuttings that are done for a specific event and then removed. It can be more intense, like body suspensions, where piercings are made in key points on your body, chains are attached to the jewelry, and you are then lifted off the ground, suspended by your piercings. Body play has roots in many different religious ceremonies performed by different cultures around the world, and people who partake in these extreme forms of body play usually do so for their own spiritual or sexual reasons.

CHAPTER 10

GETTING RID OF
YOUR WORK

EVEN THOUGH THE PURPOSE of this book is to guide you toward body art that you'll enjoy forever, you may already have an atrocious piece of work that you're dying to get rid of. Are you one of those people who is forced to wear socks with sandals so that no one sees the horrible Tasmanian Devil on your ankle? Does your *new* girlfriend start fuming every time she sees the name of your *old* girlfriend on your chest? That pot leaf inked on your arm doesn't seem like such a good idea now that you're trying to get a job, right? There's nothing worse than having to live with a mistake that you're constantly reminded of every time you look in the mirror. If you've got ink that you just can't bear any longer, the options are either touching up/covering up the tattoo, or removing it.

TOUCH-UPS AND COVER-UPS

Some tattoos just need a little new life breathed into them. If you're basically happy with your piece but think it needs a little work, you can have the tattoo touched up. A common reason for a touch-up is that the lines are bad or blotchy, or the ink was laid in unevenly. A good tattooist can repair these

problems without totally losing the original piece. Also, since the tattoo will fade over time, some fresh color will make it look like new again.

You can also perk up a droopy piece by adding on to it. You can add more detail to an existing piece or surround it with new work that ties in to your original design. This is a good way to "camouflage" a crappy tattoo, but keep in mind that the new ink will look fresher and brighter than the old.

If you want to go for a complete cover-up, there are a few things to consider. The more complex the piece is, the harder it will be to cover. A good tattooist maps out the colors and lines of your existing tattoo and then designs a new piece that corresponds to the old one. For example, if your old tattoo had brown at the top and yellow at the bottom, the new one—while being a completely different design—will also have to be a dark on top and a darker color on bottom. The reason is that you can't cover dark pigment with a lighter pigment, although some tattooists will suggest the method below.

Some tattooists may suggest spending a few initial sessions covering your old tattoo with flesh-colored pigment. This gives the tattooist a "cleaner palette" to put the new piece on. However, flesh-colored pigment is not a solution— it's just a preparatory step before getting a cover-up. Flesh colors never blend in enough to look natural, especially if you have light skin. Certain inks—namely black—do not cover well with white or light colors. Still, your tattooist could suggest part, if not all, of your tattoo be prepped in this manner before doing the actual cover-up.

Plenty of bad tattoos get covered up in Tribal designs because Tribal is most often done with black ink; since it's abstract, it can be shaped to cover practically any design. The unfortunate thing is that, like hair in a can, *it usually looks just like what it is.* Hey, sometimes there's just not a whole lot of leeway in masking a bad tat.

LASER REMOVAL

Removal of tattoos is achieved through four basic methods: acid peels, which burn off layers of skin with chemicals; dermabrasion, which involves scraping off the skin layers; surgery, wherein the tattoo is actually cut out of your skin; and laser removal. Since the first three methods leave dramatic changes in your skin color and/or scarring, we'll concentrate on laser removal.

A laser removes tattoos from the skin by rapidly pulsing a specific wavelength of light onto the area. These wavelengths pass through the top layers of skin and are absorbed by the cells that hold the tattoo pigments. Because the light is flashing so quickly, it breaks up these pigment-filled cells, which are then flushed out naturally by your body.

The procedure requires an initial consultation (usually free) by a dermatologist who is also a trained laser surgeon. The doctor will try to determine how successful removal of your tattoo will be and estimate how many sessions it will take. Since tattoo pigments are not regulated by the FDA, there's no standard in pigment consistency, making it pretty hard for the doctor to predict exactly how well the laser-removal treatment will work or how many sessions your piece will require. Most tattoos require anywhere from two to eight treatments, spaced four to six weeks apart, to give the pigment time to be completely flushed out of your body. The precise number of treatments will depend on exactly what kind of tattoo pigment was used, how big the piece is, how deeply it was poked into the skin, and how many different colors are in the tattoo. Obviously, a big, multicolored piece will be more difficult to remove than a small, black one.

Also, certain colors respond better to laser removal than others. The general consensus is that the darker the color (blue, black) the better the chance of total removal. Red and

yellow are difficult colors to remove. There are many different types of lasers, each specializing in certain treatments, and new ones are being introduced all the time. Ask your doctor which laser she uses and what colors it's most effective on. As is the case with getting a tattoo, you'll need to do a little research to find the person best suited to remove a tattoo.

The removal process can be a little painful. Most people liken it to being snapped repeatedly with a rubber band or being splattered with tiny drops of hot oil. Local anesthetic is used in some cases, but if you could stand the rapidly pulsing needles that put the pigment into you in the first place, you should be able to handle the rapidly pulsing light used to remove it.

During the session, you (and the doctor) will have to wear safety goggles to protect your eyes from possible damage. The laser component itself is a monstrous machine that has a swing-arm attachment through which the laser is emitted. The doctor holds the end of this swing arm to direct a very fine beam of light onto your skin and controls the laser pulse with a floor pedal. Each procedure lasts only a few minutes. Afterward, an antibacterial ointment and bandage will be applied to the treated area. Keep the area clean and use any ointment the doctor gives you. You can bathe the area the following day, but don't scrub the spot.

You may notice some scabbing and your skin will look a little lighter in the treated area. Your skin's natural pigment will return in a few months. Laser removal works best on light-skinned people; the darker you are, the more likely you'll experience a permanent change in skin color. Laser removal is not recommended for people with very dark skin, although advances in treatment are being made all the time and some doctors are reporting success with dark-skinned patients.

Laser removal is a costly and lengthy procedure that doesn't guarantee total removal of the tattoo. A lot of people

who get crappy tattoos removed end up putting new work in the same place to camouflage traces of leftover pigment. Better to be sure about the tattoo you're getting in the first place.

PIERCING RIPS, TEARS, AND SCARRING

If you rip or tear your ear, you can have the spot sewn up. The longer you wait, the more difficult it will be to eliminate successfully, because scar tissue will start building up. Sometimes plastic surgery is required to repair really bad tearing or scarring.

One of the most common cosmetic problems associated with piercing is keloid scarring. Keloids can be removed by a dermatologist or plastic surgeon, but there's no guarantee that more scar tissue won't develop in the same spot! Keloiding is a hereditary condition; if you're predisposed to keloid scars, they may very well return.

Steroid and cortisone injections have been used by some dermatologists to reduce the size of a keloid. This lets you keep the jewelry in place, but the keloids don't disappear entirely.

If you notice the development of a keloid, try using hot compresses and massage with vitamin-E oil. Massaging will help break up the fibrous tissue so that your body can remove it naturally. This doesn't happen overnight. In fact, it's kind of an ongoing battle. As a keloid develops, you may break it down with massage and then—*boom!*—another one pops up! Consult your piercer.

NATIONAL DIRECTORY
OF BODY ART

THE NATIONAL DIRECTORY OF Body Art includes studios from all over the country. It is no way complete, but it is a hefty start. *This is not an endorsement of the studios,* it's just a listing.

There are many international, national, state, and local body art organizations. Where possible, we have noted a studios' affiliation with one of the three U.S.-based professional body arts associations. They are the Alliance of Professional Tattooists (APT), the Association of Professional Piercers (APP), and the National Tattoo Association (NTA). While affiliation with a professional body art organization does not guarantee a sterile environment nor assure you the piece of your dreams, it is one indication that the studio takes the craft seriously. That being said, there are many fantastic body artists that do not belong to any professional organizations. You still have to do your homework.

Finally, body artists tend to move around a lot. Some studios open and close within a short period of time. We have tried to make this directory as up-to-date as possible, but don't blame us if your favorite artist has developed a traveling jones and moved on!

Alabama

Name	Address	City	Phone	Website/Email	Notes
Southern Ink Tattoo Studio	119 S. Quintard Ave.	Anniston	205-236-7561		
The Tattoo Workshop	807 S. Quintard Ave.	Anniston	205-237-5955		
Voodoo Needle	435 N. Dean Road	Auburn	334-826-1195	www.voodooneedle.net	
Skinworx	115 19th Street N.	Bessemer	866-519-4781	www.skinworx.Net	APT
Branding Iron Tattoo Parlor	9212 Parkway E.	Birmingham	205-836-8287		
Skin Deep Tattoo Studio	3927 Vanderbilt Road #A	Birmingham	205-849-0811		
Southern Ink Tattoo Studio	124 20th Street S.	Birmingham	205-328-8111		NTA
The Tattoo Workshop	1306 1st Ave. N.	Birmingham	205-251-8288		
State of the Art Tattoo & Body Piercing	169 Schwaiger Road	Cullman	256-734-3034		
Platinum Dragon Tattooing	12 Olde Towne Square	Daleville	334-598-4644		
Ink City Tattoo	909a 6th Ave.	Decatur	256-306-9099	inkcitytattoo@aol.com	
Ink City Tattoo & Exotic Piercing	1016 6th Ave. S.E.	Decatur	256-306-9099	www.inkcitytattoo.com	
Inkslingers Domain	1030 5th Ave. B	Decatur	256-308-0006		
Under Your Skin Tattoos	1030 5th Ave. S.E.	Decatur	205-351-6796		
B & E Tattoo Co.	1909 Wise Dr.	Dothan	334-677-7454		
Haven Tattoo & Body Piercing Studio	638 15th Street	East Tuscaloosa	205-248-0200		
American Emporium	3939 Rucker Blvd.	Enterprise	334-308-2504		
Precision Ink	871 Florence Blvd.	Florence	205-766-1387		
Quad-Cities Tattoo Studio	1002 Florence Blvd.	Florence	205-766-1387		
Rainbow Tattoos	2306 West Meighan Blvd.	Gadsden	256-547-3311		
Rainbow Tattoo	1800 Gunter Ave.	Guntersville	205-582-4713		
Non Stop Art & Tattoo	195-G West Valley Ave.	Homewood	205-945-6762		
Delinquents Tattoo Studio	4820 University Dr. N.W., Suite #9	Huntsville	205-830-1309		
Hot Rod Tattoos	3310 Governors Dr.	Huntsville	256-534-0221		
Magic Needles Tattoo Studio	417 Jordan Lane N.W.	Huntsville	205-830-0102		
Screamin' Tattoos	1109-E Jordan Lane	Huntsville	205-837-822		

Name	Address	City	Phone	Note
Wicked Tattoos	7540 Memorial Pkwy S.W.	Huntsville	205-881-8070	
Deep South Tattoo	6921 Highway 90 W.	Irvington	334-957-2534	
Chained N Ink & Steel	3324 E. Main	Millbrook	334-315-3160	APT
Bay City Tattoos	135 Schillinger Road North	Mobile	251-607-9999	
Booths California Concepts	60 Schillinger Road North	Mobile	251-633-2575	
Eternal Expressions Tattooing	5725 Old Pascagoula Road #12	Mobile	334-653-8411	
Kaoz	330 University Blvd. S.	Mobile	251-344-5343	
Tattoo Zone Tattooing	3722 Moffett Road	Mobile	251-460-2779	
The Tattoo Zone	1640 Varner Dr. # C	Mobile	334-660-1775	
Watcha Wunt Tattoos	816 Holcombe Avenue	Mobile	251-478-4033	
Capitol City Tattoo	4127 Troy Hwy.	Montgomery	334-286-9070	
Darkdesires Flash	4524-B Beth Manor Dr.	Montgomery	334-356-3187	
Dixieland Tattoo Studio	2415 E. South Blvd.	Montgomery	334-284-3999	
Dragons Lair Tattoo Studio	1204 Madison Ave.	Montgomery	334-832-9331	
Outlaw Tattoo Company	430 Twain Curve	Montgomery	334-215-8152	
Pretty Woman Inc.	2600 Spruce Street	Montgomery	334-832-4804	
Frogs Ink House	2129 Moody Pkwy.	Moody	205-640-1542	www.frogsinkhouse.com NTA
Ink House	Moody Pkwy.	Moody	205-699-2569	
Living Dreams	1305 E. Avalon Ave.	Muscle Shoals	205-383-0444	NTA
Perfect Touch Tattooing	815 Snow Street	Oxford	256-832-0058	
A White Foot Tattoos	1804 E. Andrews Ave.	Ozark	334-774-5288	
Tattoos by Southern Design & Body Piercing	311 S. Memorial Dr.	Prattville	334-365-0310	
Tattoo's By T.	1592 County Rd. 584	Rogersville	256-247-5221	www.TattoosbyT.com
Pleasure Of Pain Tattoo Expressions	802 Allen Ave.	Russellville	205-332-3025	
Gulf Coast Tattoo Studio	7470 Theodore Dawes Road	Theodore	334-653-8063	NTA

Alaska

Name	Address	City	Phone	Note
Anchorage Tattoo Studio	706 W. Benson Blvd.	Anchorage	907-561-0065	NTA
BPU	2408 C Street	Anchorage	907-279-1300	
Rebirth Tattoo	C Street and Fireweed	Anchorage	907-279-8287	
Skin Illustrations	137 E. 7th Ave.	Anchorage	907-274-7546	
Dodge City	PO Box 1991	Cordova	907-424-7242	

Name	Address	City	Phone	Website	Notes
Good Karma	1450 S. Cushman	Fairbanks	907-457-8287		
Midnite Sun Tattoos	313 Well Street	Fairbanks	907-456-4657		APT
Top of the World Tattoo	2845 Mack Road	Fairbanks	907-479-5345		APP
Top of the World Tattoo	120 Hall Street	Fairbanks	907-456-6787		NTA
Pair-A-Dice Tattoo	18 Main Street	Haines	907-766-3704		APT
Real Studio	174 S. Franklin Street, Suite 104B	Juneau	907-463-3338		APP, APT
Tattoo Sue's	1614 Mill Bay Road	Kodiak	907-486-3691		APT
Lindsey's Tattoo Studio	242 N. Santa Claus Lane	North Pole	907-488-8282		APT, NTA
Ground Zero	2451 Mountain Village Dr.	Wasilla	907-376-NUKE		NTA

Arizona

Name	Address	City	Phone	Website	Notes
Blue Dragon Tattoo	5008 W. Northern	Glendale	623-939-8244		APP
Body Creations	5008 W. Northern Street, Suite 7	Glendale	623-934-9964		APT
Creative Skin Tattoo	4935 W. Glendale Ave.	Glendale	623-937-7443		NTA
Hierarchy Tattoo Studio	6031 N. 67th Ave.	Glendale	602-341-3630		APT
Urban Art	340 W. University Dr., #33	Mesa	480-844-7429	www.urbanarttattoo.com	APP, APT
Valhalla Modification	610 S. Beeline Hwy.	Payson	928-472-4704	www.valhallamodifications.com	APT
Blue Dragon Tattoo	322 W. McDowell Road	Phoenix	623-973-4093		APT, NTA
Crawling Squid Tattoo Studio	2611 W. Bethany Home Road	Phoenix	602-433-9008		NTA
Halo Precision Piercing	10 W. Camelback Way	Phoenix	602-230-0044	www.halopiercing.com	APP
Ancient Art Tattoo	2108 S. Alvernon Way	Tucson	520-747-3340	www.dennisdwyer.com	APT
Halo Precision Piercing	2807 E. Speedway Blvd.	Tucson	520-795-8500	www.halopiercing.com	APP
Old Town Tattoo	4240 E. Speedway Blvd.	Tucson	520-321-9042	www.oldtowntattoo.com	APT, NTA
The Enchanted Dragon II	4243 E. Speedway Blvd.	Tucson	520-323-2817		NTA
The Enchanted Dragon, Inc.	2237 E. Broadway	Tucson	520-884-5494		NTA
The Enchanted Dragon, Inc.	4138 E. Grant	Tucson	520-332-0611		NTA
The Enchanted Dragon, Inc.	2756 N. Campbell	Tucson	520-326-7807		NTA
The Enchanted Dragon, Inc.	200 Fry Blvd.	Tucson	520-459-0500		NTA

Arkansas

Name	Address	City	Phone	Website
Jujuz Tattooz & Body Pierzing	14601 Hwy. 62 W.	Eureka Springs	479-253-1847	
Black Dragon Tattoo	2218-B N. College Ave.	Fayetteville	479-443-4774	www.blackdragontattoo.net

Name	Address	City	Phone	Website	Codes
Ink Spot Tattoo	920 Garrison Ave.	Ft. Smith	501-782-8498		APT, NTA
Knight Times Tattoo & Body Piercing	2207 Rogers Ave.	Ft. Smith	479-783-6465		
Redbeard's Living Canvas	413 Park Ave.	Hot Springs	501-623-4744		
Altered Images Tattooing	8302 Chicot Road #1	Little Rock	501-562-5967	www.alteredimagestattooing.com	NTA
The Parlor	4108 Macarthur Dr. N.	Little Rock	501-753-9200		
Tattoos by Wild Child	219 Russell Street	Mountain Home	870-425-0369	www.tattoosbywildchild.com	NTA
Express Yourself Tattooz	1906 East Market Ave.	Searcy	501-279-0345		
AAA Tattoos By Smilin' Jack & Co.	399 Hwy. 412 W.	Siloam Springs	479-524-4257		NTA
Tattoos By Wild Child Inc.	441 Hwy. 62 E. Arkansas	Yellville	870-449-4969	www.tattoosbywildchild.com	NTA

California

Name	Address	City	Phone	Website	Codes
Outer Limits	3024 W. Ball Road, Suite 1	Anaheim	714-761-8288		NTA
Body Graphics	5586 Mission Road	Borsall	760-945-0888		
Blue Star Tattoos and Body Piercing	1950 Concord Ave., Suite #202	Concord	925-685-4221	www.bluestartattoos.com	APT, APP, NTA
Orange County Ink	2981 Bristol Street, Unit B-4	Costa Mesa	714-241-8287		
The Hole Thing	8573 Gravenstein Hwy.	Cotati	707-793-9991	www.theholethingonline.com	APP
Beachin Tattoo	454 N. Coast Hwy. 101	Encinitas	760-942-2333		NTA
Art Throb Tattoo	611 E. Valley Pkwy.	Escondido	760-480-8288		NTA
Alpha Omega Tattoo	1121 N. Texas Street	Fairfield	707-428-6519		NTA
Triangle Tattoo & Museum	356B N. Main Street	Fort Bragg	707-964-8814	www.triangletattoo.com	NTA
Skin Décor Tattoo Studio	5048 N. Blackstone Ave. # 118	Fresno	559-225-2284		NTA
Tower Tattoos	1140 N. Van Ness Ave.	Fresno	559-233-7656		NTA
World Class Tattooing	2913 N. Blackstone Ave.	Fresno	559-224-2270		NTA
Tattoo Magic	7111 Garden Grove Blvd.	Garden Grove	714-530-0444		APT, NTA
Flesh Skin Grafix Inc	1155 Palm Ave.	Imperial Beach	619-424-8983	www.fleshskingrafix.com	NTA
Thee Ink Cup	61877 29 Palms Hwy.	Joshua Tree	760-366-2870	www.theeinkcup.com	APP
Lucky 7 Tattoo	8635 North Lake Blvd.	Kings Beach/Lake Tahoe	530-546-8282		
Trigger Happy Tattoo	704 E. Whittier Blvd.	La Habra	562-691-8925	www.thtink.com	APT
Laguna Tattoo	656 S. Coast Hwy.	Laguna Beach	949-497-3702		NTA

Studio	Address	City	Phone	Website	Codes
Psycho City Tattoo	1243 W. Ave. I	Lancaster	661-949-7649	www.psychocitytattoo.com	NTA
Lou's Tattoos & Body Piercing	246 W. D Street	Lemoore	559-925-1553		APT
5150 Tattoo Studio	223 E. Kettleman Lane	Lodi	209-333-8288		APT, NTA
Art & Soul Tattoo Co.	2604 S. Robertson Blvd.	Los Angeles	310-202-7203		
Malu Tattoo	PO Box 725	Los Angeles	310-210-9963	www.malutattoo.com	APT, NTA
Tabu Tattoo	12206 Venice Blvd.	Los Angeles	310-391-5181		NTA
Vintage Tattoo Art Parlour	5115 York Blvd.	Los Angeles	323-254-6733	www.vintagetattooparlor.com	APT, NTA
Tattoo Time	1570 Yosemite Pkwy	Merced	209-388-1067		APT, NTA
Buffalo Bill Ink	619 14th Street	Modesto	209-522-3021		NTA
Skin Works Tattoo/Rif Raf Body Piercing	313 E. Balboa Blvd.	Newport Beach	949-675-8905	www.skinworks-rifraf.com	APT, NTA
FTW Tattoo Parlor	6536 Telegraph Ave.	Oakland	510-595-0389		
Body Temple Tattoo Studio	3753 Mission Ave., Suite 118	Oceanside	760-439-8288		
Outer Limits Tattoo	125 N. Tustin Ave., Suite G	Orange	714-744-8288	www.karibarba.com	APT
Prix Body Piercing	56 E. Colorado Blvd.	Pasadena	626-405-9253		APP
Sacred Saint Studio	3763 E. Colorado Blvd.	Pasadena	626-568-1055	www.sacredsaint.com	APT
Goguè Art	1690 E. Main Street	Quincy	530-283-3521		
Empire Tattoo	2850 W. Foothill Blvd., #105	Rialto	909-875-2833		NTA
Wild Bill's Tattooing	205 Vernon Street	Roseville	916-783-9090		NTA
Studio 13 Tattooing & Piercing	115 John Street	Salinas	831-758-1313	www.studio13tattoo.com	APP
John Montgomery's Tattoo Syndicate	721 North D Street, Unit 6	San Bernadino	909-884-0609		NTA
Absolute Tattoo	5375 Kearny Villa Road	San Diego	858-715-8288		NTA
Ace Tattooing	5058 Newport Ave.	San Diego	619-222-5097		NTA
Avalon Tattoo	1035 Garnet Ave.	San Diego	858-274-7635	www.avalontattoo.com	APT, NTA
Avalon Tattoo 2	3039 Adams Ave., 2nd Floor	San Diego	619-280-1957	www.avalontattoo.com	APT, NTA
Big City Tattoo Inc.	Studio 2913, 2913 University Ave.	San Diego	619-299-4868		NTA
Classic Tattoo	6780 Miramar Road, Suite 110	San Diego	858-549-2567		.
Dogspunk Tattoos	1459 University Ave.	San Diego	619-297-7777		
Judy Parker's Pacific Tattoo	3478 Main Street	San Diego	619-544-1121		APT, NTA
Black & Blue Tattoo	381 Guerrero at 16th Street	San Francisco	415-626-0770	www.black-n-blue-tattoo.com	APT
Cold Steel America	2377 Market Street	San Francisco	415-621-7233	www.coldsteel.co.uk	APP
Cold Steel America	1783 Haight Street	San Francisco	415-933-7233	www.coldsteel.co.uk	APP

Name	Address	City	Phone	Website	Type
Diamond Club Tattoo Studio	2500 Van Ness Ave., # 8	San Francisco	415-776-0539		NTA
Ed Hardy's Tattoo City	700 Lombard Street	San Francisco	415-345-9437	www.tattoocitysf.com	NTA
Lyle Tuttle Tattoo Studio	841 Columbus Ave.	San Francisco	415-775-4991	www.lyletuttle.com	APT
Spirits in the Flesh Tattoo Studio	1517 Pine Street	San Francisco	415-749-1368		NTA
Body Exotic Piercing	957 W. San Carlos	San Jose	408-993-9684	www.bodyexotic.com	NTA
Area 51 Tattoo	1295 Second Street, Suite 100	San Rafael	415-455-8367		
Tattoo Santa Barbara	318 State Street	Santa Barbara	805-962-7552	www.luckyfish.com	NTA
The Electric Rose Tattoo Studio	317 N. Lincoln Street	Santa Maria	805-614-4570	www.electricrosetattoo.com	APT
Monkey Wrench	1066 A 4th Street	Santa Rosa	707-575-0610		NTA
Charlie's House of Tattoos	881 Royal Ave.	Simi	805-584-1591		NTA
Leo's Tattoo	3894 Pioneer Trail	South Lake Tahoe	530-541-5366		APT
F Kirk Alley Tattoo	11632 Vertura Blvd., Suite #204	Studio City	818-506-6046		NTA
Tehachapi/Newport	20725 South Street	Tehachapi	805-823-9553		APT
Body Graphics Inc.	28950 Front Street, #101	Temecula	909-693-4922	www.bodygraphicstattoos.com	NTA
12 Monkeys	917 Central Ave.	Tracy	209-839-1265	www.12monkeystattoos.com	NTA
Truckee Tattoo	10306 Trout Creek Road	Truckee	530-587-4559		NTA
Classic Tattoo Studio	521 N. Harbor Blvd.	Fullerton	714-870-0805		NTA
The Red Genie Tattoo	728 Tuolumne Street	Vallejo	707-649-1454	www.redgenie.com	NTA
Izzy's Yreka Tattoo Studio	104 Miner Street	Yreka	842-6100		NTA

Colorado

Name	Address	City	Phone	Website	Type
Bonaroo Tattoo & Piercing	15464 E. Mississippi Ave.	Aurora	303-295-0221		
The Tattoo Shop	12167 S. Chambers Road	Aurora	303-755-2800		NTA
William Thidemann Tattoo	2735 Iris Ave., Suite A	Boulder	303-444-7380		APT
Snake's Tattoo Co.	2340 E. Platte	Colorado Springs	719-475-TAT2	www.snakestattoo.com	
A-Z Masters	2053 B Street	Colorado Springs	719-579-0220		
Ink Pitt Tattoo Studio	5698 S. Hwy. 85/87, #106	Colorado Springs	719-392-9388		
Off The Wall 5 Body Art Studios	908-C N. Circle Dr.	Colorado Springs	719-473-3344		APT
Pikes Peak Tattoo & Piercing #1	2924 Wood Ave.	Colorado Springs	719-632-6141		APT
Pikes Peak Tattoo & Piercing #2	902 N. Circle Dr., Suite 201	Colorado Springs	719-632-5300		APT
Sinister Tattoos & Body Piercing	2216 E. Platte Ave.	Colorado Springs	719-575-0646		
Snakes Tattoo Studio	2340 E. Platte Ave.	Colorado Springs	719-475-8282		NTA
Emporium of Design	2028 E. Colfax Ave.	Denver	303-333-4870	www.emporiumofdesign.com	NTA

Name	Address	City	Phone	Website	Notes
That Scary Place	7739 E. Colfax	Denver	303-394-2253		NTA
The Blue Door	562 S. Broadway	Denver	303-282-8290	www.thebluedoor.net	APT, NTA
Th'ink Tank	1518 Wazee Street	Denver	720-932-0124		
Trinity Tattoo Studio	3923 Tennyson Street	Denver	720-855-3858		
Twisted Sol	1405 Ogden Street	Denver	303-832-1311	www.twistedsol.com	APP
Phantom 8 Tattoos	3969 S. Broadway	Englewood	303-762-0660		
Pine Street Tattoo	215 Pine Street	Fort Collins	970-472-9394		
Millennium Gallery of Art	211-213 Jefferson Street	Fort Collins	1-800-TOP-TAT2	www.tats4u.com	NTA, APT
Skibo's Tattooing	1008 N. College Ave.	Fort Collins	970-224-5241	www.skibostattoo.com	APT
Tyme Tattoo	105 E. Laurel	Fort Collins	970-416-9835		NTA
Fountain of Ink	105 S. Main Street	Fountain	719-382-6222		
Pinz & Needles Inc.	812 Grand Ave.	Glenwood Springs	970-928-7515		
Griffin Rose Tattoos	480 28 1/4 Road #5	Grand Junction	970-234-4755		
Skibo's Tattooing	609 9th Ave.	Greeley	970-356-6772	www.skibostattoo.com	APT
The 2nd Millennium	833 16th Street	Greeley	800-346-8282		
Wizards Workshop Tattooing	7004 W. Colfax Ave.	Lakewood	303-232-9289		NTA
The Chameleon Inc.	700 Ken Pratt Blvd.	Longmont	303-774-1755	www.cpcpiercing.com	APP
Monsters Ink	129 S. Cleveland Ave.	Loveland	970-308-5828		
Calamity Jane's Tomboy Tattoos	526 Hwy. 133	Carbondale	970-963-0745		NTA
Dragons Lair Tattoo	1707 S. Prairie Ave.	Pueblo	719-560-0901		
Eights And Aces Tattoo	410 W. Northern Ave.	Pueblo	719-583 8301		
Steel City Tattoo & Piercing	1322 E. Hwy. 50 Bypass	Pueblo	719-545-3602	www.SteelCityTattoo.net	NTA
The Image Maker	204 Park Place	Salida	719-539-4955		
Mile Hi Tattoo & Body Piercing	8888 Washington	Thornton	303-286-8282		
Maxrats2	7180 W. 44th	Wheatridge	303-287-1691		

Connecticut

Name	Address	City	Phone	Website	Notes
Lucky Soul Tattoo	334 E. Main Street	Ansonia	203-732-5825		
Black Rock Tattoo.Com	2750 Fairfield Ave.	Bridgeport	203-335 3555		
Bridgeport Tattoo	1749 Barnum Ave.	Bridgeport	203-366-1317		NTA
Valle's Tattoo & Piercing	290 White Street	Danbury	203-748-2553	www.vallestattoo.com	NTA

Name	Address	City	Phone	Website	
Fine Line Tattoo	160 Main Street, Suite B	Deep River	860-526-2011		NTA
Guide Line Tattoos	429 Burnside Ave.	East Hartford	860-289-2698	www.guidelinetattoos.com	NTA
Darkside Tattoo	13 Foxson Blvd.	East Haven	203-469-9208		
Bigg Dweeb Studios	1 Enfield Street, Apt. 1	Enfield	860-741-6811		
Media Factory Show	2 Enfield Street	Enfield	860-741-6812		
Phantom Ink	122 E. Main Street	Forestville	860-582-8818		
Ink Tribe Tattoos L.L.C.	35 N. Water Street	Greenwich	203-613-6465		
Inktribe Tattoos	35 N. Water Street	Greenwich	203-532-7819		
Flats Tattooing and Body Piercing Shop 1	1060 Poquonnock	Groton	860-448-6844	www.flatstattooing.com	APT
Phat Car Tattoo Co.	1131 Albany Ave.	Hartford	860-278-8612		
Enchanted Ink	1261 E. Main Street	Meriden	203-630-6567	www.enchantedinktattoo.com	APT
No Regrets Tattoos & Body Piercing	195 Rubber Ave.	Naugatuck	203-729-3115		
Studio Zee	934 State Street	New Haven	203-787-2773		
Artifact Tattoo Studio	117 Fenn Road	Newington	860-666-1102	www.artifacttattoo.com	NTA
Derma Flicks Tattooing	174 Main Street	Norwalk	203-847-6859		
Ride the Needle	28 Broadway	Norwich	860-887-6063		
Flats Tattooing and Body Piercing Shop 2	1 New London Road	Salem	860-859-3545	www.flatstattooing.com	APT
The Wild Side Tattooing & Body Piercing	1232 Queen Street	Southington	860-793-9453		NTA
Body Art Inc.	76 Water Street	Torrington	860-496-1292		NTA
Artifact Tattoo Studio	17 Fenn Road	Newington	860-666-1102		NTA
Beauty Mark Tattooing	1741 E. Main Street	Waterbury	203-575-1195		
Sacred Art Productions	70 Alder Street	Waterbury	203-597-8822		

Delaware

Name	Address	City	Phone	Website	
August Moon Tattoos	623 Pulaski Hwy.	Bear	302-328-8113	www.augustmoontattoos.com	APT
Little Gary's Tattooing	1552 S. Dupont Hwy.	Dover	302-678-0409		APT, NTA
Mystic Realm Studios	140 E. Market Street	Georgetown	302-854-0151		
Fatlarrys Tattoo Shop	7019 Sharptown Road	Laurel	302-875-4579		

Name	Address	City	Phone	Website	Designation
Ancient Art Tattoo Studio	#1 Tenley Court /1420 Hwy. One	Lewes	302-644-1864	www.ancientarttattoo.net	APT, NTA
Inkworks Tattoo	39 N. Walnut Street, Penny Square	Milford	302-430-0130		
Explosive Tattoo	265 N. Dupont Hwy.	New Castle	302-322-3457	www.explosivetattoo.com	APT
Creative Touch	22876 Sussex Hwy.	Seaford	302-629-2449		
Independent Tattoos	#3 W. Fenwick Station	Selbyville	302-436-5581	www.independent-tattoo.com	APT
Tattoos by Jesse Overton	102 W. Camden-Wyoming Ave.	Wyoming	302-698-9443		

Florida

Name	Address	City	Phone	Website	Designation
Body Jewelry by the Chain Gang	PO Box 1633	Auburndale	863-666-9574	www.thechaingang.com	
Solid Image Tattoo	3860 N. Federal Hwy.	Boynton Beach	561-731-0310		
Dead-Eye-Pete Tattoo's	4113 18th Street W.	Bradenton	941-739-9035		NTA
9 Lyves Tattoo Inc.	4222 B 26th Street W.	Bradenton	941-752-3003	www.9lyves.com	APT
After Shock Tattoos	20178 Cortez Blvd.	Brooksville	352-796-3875		
Tattoo Artistry	861 S.E. 47th Terrace	Cape Coral	941-542-2443		
Deana's Skin Art Studio	25026 E. Colonial Dr.	Christmas	407-568-9200	www.deanaskinart.com	APT, NTA
Lou's Tattoo's of Clearwater	1356 Cleveland	Clearwater	727-461-0454		NTA
Artistic Bodyworks	4285 N. Atlantic Ave.	Cocoa Beach	407-799-1630		NTA
Whole Addiction	8083 W. Sample Road	Coral Springs	954-753-4151		
Stoney's Ink Slab 1	2550 S. Nova Road	Daytona Beach	386-763-1988	www.stoneysinkslab.com	NTA
Body Impressions Tattoo	41 S. Hwy. 17-92, Suite B	Debary	386-668-9100	www.phillyjohn.net	APT
Feelin Lucky Tattoo Co.	308 S. Spring Garden Ave.	Deland	386-740-9717		
Exographix Tattoo	513 E. Hwy. 98	Destin	850-654-5038	www.exographix.net	APT
Moms Tattoos Inc	110 Overcash Dr., Suite F	Dunedin	727-736-5350		
Feelin' Lucky Tattoo	425 Plaza Dr.	Eustis	352-589-8288	www.feelinluckytattoo.homestead.com	APT, NTA
A Lasting Image	6450 S. Hwy. 17-92	Fern Park	321-231-9230		
A Wild Thing	2673 N. Federal Hwy.	Fort Lauderdale	954-537-1011		
Funhouse Tattoos	2667 E. Commercial Blvd.	Fort Lauderdale	954-771-2443		
Stevie Moon Tattoo	1948 E. Sunrise Blvd. #2	Fort Lauderdale	954-568-9231	www.steviemoon.com	
Ancient Art Tattoo	1262 N. Tamiami Trl.	Fort Myers	941-995-8282		NTA
Ft Myers Beach Tattoo	1901 Estero Blvd.	Fort Myers	941-463-7273		NTA
Needful Things	2265 Main Street	Fort Myers	941-332-4727	www.inedatattoo.com	APT, APP
South Florida Tattoo Company	1717 S. U.S. Hwy. 1	Fort Pierce	407-465-0012		APT, NTA

Name	Address	City	Phone	Website	Codes
Tattoos Forever	8776 Thomas Dr.	Fort Walton Beach	904-234-8282		NTA
Big Stick Specialties	1150 5th Sreet	Fort Myers Beach	239-463-9991		
Tattoos by Lou Hialeah	1193 W. 37th Street	Hialeah	305-828-8944	www.tattoosbylou.com	APT
My Tattoo Shop	5920 Hallandale Beach Blvd.	Hollywood	954-894-9939		
Twistedheart	203 S. 21st Ave.	Hollywood	954-925-9933		
Scavo's Skin Design	3790 E. Gulf To Lake Hwy.	Inverness	352-756-8366		
8th Day Tattoo Gallery	1031 Park Street	Jacksonville	904-358-8222		
Big City Tattoo	52 Cassat Ave.	Jacksonville	904-693-9009		NTA
Carribbean Connection	1034 Park Street	Jacksonville	904-633-9161		
Skinlab	1021 Park Street, Suite A	Jacksonville	904-598-5011		
Carribbean Connection	777 S. 3rd Street	Jacksonville Beach	904-241-4231		
Tattoos by Lou Kendall	9820 S. Dixie Hwy.	Kendall	305-670-6694	www.tattoosbylou.com	APT
Paradise Tattoo	5160 U.S. Hwy. 1	Key West	305-292-9110	www.paradisetattoo.com	APT
Kissimmee Tattoo Company	619 N. Main Street	Kissimmee	407-931-2022	www.armadillored.com	APT, NTA
Lizard Lounge Ink Inc.	609 W. Vine Street, Suite C-3	Kissimmee	407-932-1922		
American Ink Tattoos	3719 S. Military Tr.	Lake Worth	561-641-2573		
Louie Lombi's Tattoo Paradise	5371 10th Ave. N.	Lake Worth	561-966-8814	www.tattooparadise.com	NTA
Rj's Tattoo Studio	3273 Lake Worth Road	Lake Worth	407-641-5745		NTA
To The Point Tattoo	2947 S. Florida Ave.	Lakeland	863-682-9002		
Atomic Tattoos	9043 Ulmerton Road	Largo	727-581-4444		APT, NTA
Feelin' Lucky Tattoo	1030 N.W. Blvd., Hwy. 441	Leesburg	386-435-0509	www.feelinluckytattoo. homestead.com	
Taboo Tattoo	1026 N.W. Blvd.	Leesburg	352-360-1113		
Leather Tiger Tattoo	600 N. Hwy 17-92	Lorgwood	407-339-TAT2		APT, NTA
Sailor Bill's Tattoo Time	9210 S. U.S. Hwy. 17-92	Martland	407-331-5928	www.tattoo-time.com	APT
Tattoo Time	9210 S. U.S. Hwy 17-92	Martland	407-331-5928	www.tattoo-time.com	
Against The Grain Tattoo	1380 Cypress Ave., #1	Melbourne	321-255-9449		
Automatic Tattoo	32 W. New Haven Ave.	Melbourne	321-952-7990		
Silhouette Studios	8456 S.W. 40 Street	Miami	305-220-7707		
Studio X Tattoos	3015 N.W. 79 Street	Miami	305-835-6691		
South Beach Tattoo Company	861 Washington Ave.	Miami Beach	305-538-0104 or 305-534-7984	www.southbeachtattoo.com	APT, NTA
Tattoo Circus	1059 Collins Ave., Suite 208	Miami Beach	305-534-4900		NTA
Tora Tora Tattoo Inc	6141 S.W. 37th Street #2108	Miramar	954-328-8676		

Name	Address	City	Phone	Code
Body Branding	1650 Airport Road. S., Unit B	Naples	239-732-8868	APP, NTA
Another Dimension	4148 U.S. 19 N.	New Port Richey	727-847-7551	NTA
Darkwerks Tattoo	6617 U.S. Hwy. 19	New Port Richey	727-849-8310	
Tattoos By Lou North Beach	456 N.E. 167th Street	North Miami Beach	305-944-0888	APT
Inksters Tattoo Inc.	505 Northlake Blvd.	North Palm Beach	561-881-8287	www.tattoosbylou.com
Tattoo Ink Tattoo Studio	1717 N. Pine Ave.			www.inksterstattoo.net
Subculturez	2481 N. Volusia Ave.	Ocala	352-369-1712	
Adrenaline	7513 International Dr.	Orange City	386-456-0009	
Ancient Art Tattoo	5575 S. Orange Blossom Trl.	Orlando	407-345-8850	
Peaches Tattoos	6440 E. Colonial Drive	Orlando	407-855-8288	APT
Picasso Tattoo	1148 N. U.S. Hwy. 1	Orlando	407-275-5050	NTA
Tattoo & Piercing By Charlie	825 S. Yonge Street	Ormond Beach	386-677-7674	
Trendkill Tattoo & Body Piercing	2425 Crill Ave.	Ormond Beach	386-672-1888	www.tatsbycharlie.com APT
Delmonico's Tattoo Shop	4909 Mobile Hwy.	Palatka	386-325-TAT2	
Hula Moon Tattoo	473 N. Pace Blvd.	Pensacola	850-453-3927	
Living Art Tattoos	6707 Plantation Road B-3	Pensacola	850-470-0454	
Marks of Desire	6505 North "W" Street	Pensacola	850-471-2787	APT
Tattoo Fever	1501 W. Garden Street	Pensacola	850-484-3554	
	6933 Kitty Hawk Dr.	Pensacola	850-712-0833	
The Psychedelic Shack	W. 25a Navy Blvd.	Pensacola	850-453-3166	APT
The Psychedelic Shack	6707 Plantation Road A-2	Pensacola	850-479-9007	APP
Funhouse Tattoos	1304-B E. Atlantic Blvd.	Pompano Beach	954-788-9500	www.psyshack.com
Tattoos By Lisa	2320 Tamiami Trl., Unit 7	Port Charlotte	941-255-0505	APT
Beyond Reality Tattoo	8581 S. Federal Hwy.	Port Saint Lucie	561-878-2886	www.tattoosbylisa.com
Mighty Mike's Tattoos	1762 S.E. P.S.L. Blvd.	Pt. St. Lucie	772-337-7691	APT, NTA
Central Florida Tattooing Co.	Sanford Flea Market	Sanford	407-302-9523	
Gothic Moon Tattoo	7119 S. Tamiami Trail, Suite L	Sarasota	941-921-8116	
Stoney's Ink Slab	2550 S. Nova Road #10	South Daytona	386-763-1988	
Tattoos by Lou South Beach	231 14th Street	South Miami Beach	305-532-7300	APT, NTA
Pleasure Points	11041 Spring Hill Drive	Spring Hill	352-666-6802	www.tattoosbylou.com
Armadillo Red's Kissimmee Tattoo	4499 W. Vine Street	St. Cloud	407-396-2700	APT
Ms Deborah's Fountain of Youth	78 Lemon Street	St. Augustine	904-825-0108	www.armadillored.com
Balls of Steel	3000 34th Street., #33 So.	St. Petersburg	727-866-6300	NTA www.msdeborahtattoo.com
Inkjectdead Ink	515 9th Street N.	St. Petersburg	727-560-3126	APP www.ballsofsteel.com

Name	Address	City	Phone	Notes
Scorpiontattoos	1640 S. Walnut Street	Starke	352-318-3205	
Ink Addiction Tattoos	415 S.E. Monterey Road	Stuart	561-220-8534	NTA
Body Piercing By Bink	739 N. Monroe Street	Tallahassee	850-681-0060	www.binkstudio.net APP
Double D Tattoo	111 Ocala Road	Tallahassee	850-504-1440	
Blue Devil Tattoo Gallery	1717 E. 7th Ave.	Tampa	813-241-6824	NTA
Colorama Tattooing	902 W. Busch Blvd.	Tampa	813-931-0685	
Concrete Ink	112 N. Dale Mabry	Tampa	813-414-9766	
Dreamland Tatttoos & Body Piercings	4127 W. Waters Ave.	Tampa	813-882-3676	
Mean Machine Tattoo	3415 S. Dale Mabry	Tampa	813-831-1106	
Kuda Tattoo	7555 S. U.S. Hwy. 1	Titusville	321-267-1137	
Ace Tattoo Co.	725-B 27th Ave. S.W.	Vero Beach	772-770-6666	
Baby Blues Tattoo's	1121 53rd Ave.	West Bradenton	941-739-3738	
Body Effects Tattoo & Body Piercing	4530 14th Street	West Bradenton	941-756-2666	
Crystal's Tattoos & Boby Piercing	3237 14th Street	West Bradenton	941-708-5322	
Outrageous Tattoos	4551 Summit Blvd.	West Palm Beach	561-683-4134	
Screaming Ink Tattoo	1206 S. Dixie Hwy. 45	West Palm Beach	561-383-2820	

Georgia

Name	Address	City	Phone	Notes
Stone Age Tattoos	6009 Hwy. 92	Acworth	770-517-9368	
Asylum Professional Body Art	1301-C N. Slappey Blvd.	Albany	229-430-9007	
Hatstats	1510 N. Slappey	Albany	229-446-9408	
Permanently Inked Tattooing & Body Piercing	1420 Radium Springs Road, Suite #205	Albany	229-439-2500	
The Tattoo Shop	2219 N. Slappey Blvd	Albary	229-439-9494	
Eternal Images Tattooing	1277 Oconee Street	Athens	706-227-0047	
Midnight Iguana Tattooing, Inc.	2173 W. Broad Street	Athens	706-549-0190	www.midnightiguana.com APT, NTA
Timebomb Tattoo	1035-A Baxter Street	Athens	706-316-2223	
Timeless Tattoo Inc.	285 W. Washington Street	Athens	706-208-9588	www.timeless-tattoo.com APP, NTA
East Atlanta Tattoo	1188-C Glenwood Ave.	Atlanta	404-622-5688	
Kolo Body Arts	1144 Euclid Ave.	Atlanta	404-523-1098	APP
Piercing Experience	1654 Mclendon Ave.	Atlanta	404-378-9100	www.piercing.org APP

Business	Address	City	Phone	Website	Certifications
Prophet Art & Tattoo Studio	105 Peachtree Street	Atlanta	404-688-8287		
Psycho Tattoo	6214 Roswell Road	Atlanta	404-255-TAT2 (8282)	www.psychotats.com	APT, NTA
Sacred Heart Tattoo, Inc.	483 Moreland Ave. #5	Atlanta	404-222-8385	www.sacredhearttattoo.com	NTA
Timeless Tattoo	2271 Cheshire Bridge Road	Atlanta	404-315-6900	www.timeless-tattoo.com	APP, NTA
Vantage Pointe Studios	1606 Hosea L. Williams Dr., Suite-H	Atlanta	404-371-9388		
Virtue & Vice	2271 Cheshire Bridge Road	Atlanta	404-315-6925	www.virtueandvice.com	APP
A Dermagraphic Production	3218 Wrightsboro Road	Augusta	706-736-8286		
Alter Ego Tattoo and Art Studio	127-129 9th Street	Augusta	706-722-1EGO		
Cherokee Tattoo	3705 Washington Road	Augusta	800-738-9805	www.cherokeetattoo.com	APT
Rage Tattoos	1889a Gordon Hwy.	Augusta	706-733-8188		
Tribal Urge Tattoos	523 Broad Street	Augusta	706-823-0022		
House of Color Tattoos	2945 Canton Hwy.	Ball Ground	770-735-7585		
Blindsight Tattoo	312 N. Broad Street	Bewman	706-310-0354	www.blndsght.com	
Uncle Freddie's Tattoo & Body Piercing	4140 South Lee Street	Buford	678-482-8300		
Friends' Custom Tattoos	364 Columbia Dr.	Carrollton	770-838-0058		
Falcons On Broad	1014 Broadway	Columbus	706-653-2207		
Skullz Workshop	PO Box 4790	Columbus	706-325-6906		
Superior Skin Art	3411 Victory Drive	Columbus	706-685-1444 or 706-687-4929		
Exotic Ink Tattoo	2221 Salem Road, Suite C	Conyers	770-483-0900		
The Illustrator Tattoo	211 Main Street	Dallas	770-445-8000	www.debiillustratortattoo.com	APT, NTA
Psycho Tattoo 3	3371 Hwy. 5, Suite A	Douglasville	678-838-TAT3 (8283)	www.psychotats.com	APT, NTA
The Tattoo Factory Ink	8390 Grady Street, Suite D	Douglasville	770-577-1787	www.thetattoofactoryink.com	APT
Burning Desires	314b Elbert Street	Elberton	706-213-8133		
Ink Addiction Tattoos	21 N. Mcintosh Street	Elberton	706-283-1733		
Ink Wizard Tattoos	827 Main Street	Forest Park	404-361-2111	www.inkwizard.com	NTA
Magick Dragon Tattoo	237 John Morrow Jr. Pkwy., Suite 1010	Gainesville	770-287-9545	www.magickdragontattoo.com	APT
Lucky Dragon Tattoo Co.	454 West Solomon Street	Griffin	770-227-8003		
Ink Wizard Tattoos	350 N. Expressway	Griffin	770-227-4994	www.inkwizard.com	NTA
To The Point	Hwy. 138 Booth D-9	Jonesboro	770-778-4896		
Emerald City Tattoo	2272 Westpoint Road, Suite#2	Lagrange	706-812-8288		
Good Clean Fun	2349 Hwy. 29, Suite B	Lawrenceville	770-237-0422		

Name	Address	City	Phone	Website	
Lady Luck Tattoos	11 Cypress Street	Ludowici	912-545-2015		
Tattoos By Drew	Cnr. of 12 Liberty Street & Church Street	Ludowici	912-545-3111		
Beyond Taboo	3457 Pio Nono Ave. #106	Macon	478-785-8080	www.beyondtabootattoo.com	APP
Ink Wizard Tattoos II	3457 Pio Nono Ave.	Macon	478-784-1882	www.inkwizard.com	NTA
The Illustrator Tattoo	3020 Canton Road	Marietta	770-794-0818	www.debiillustratortattoo.com	APT, NTA
Psycho Tattoo	1289 Roswell Road, Suite 430	Marietta	770-977-TATS (8287)	www.psychotats.com	APT, NTA
Skin Grafix Tattoos & Piercings	3867 Washington Road	Martinez	706-869-8288		
Pair O Dice Tattoo	757 N. Columbia Street	Milledgeville	478-414-1133	www.pairodice-tattoo.com	APT
Sacred Heart	1241 Indian Trl, Suite A	Norcross	770-806-0054	www.sacredhearttattoo.com	NTA
Rising Alliance	243 Valley Ridge Dr.	Roswell	678-754-8787		APP
Alien Arts Tattoo	17 E. Bay Street	Savannah	912-236-9611		
Planet 3 Piercing	218 W. Brought Street	Savannah	912-236-7772	www.planetthree.com	APP
Planet Three Tattoo & Piercing Studios	14 E. 73rd Street	Savannah	912-355-5100		
Smiling Buddha Tattoo Studio	6608 White Bluff Road, Suite 38	Savannah	912-352-7880		NTA
Kings Bay Tattoo Shop	911 Osborne Street	St. Marys	912-882-8007		
Ivory Tower Tattoo Studio	406 Fair Road # 9	Statesboro	912-764-5048	www.ivorytowertattoo.com	APT, APP
Smiling Buddha of Statesboro Tattoo	408 S. Main Street	Statesboro	912-764-2788		APT
Ink Wizard Tattoos IV	5531 N. Henry Blvd.	Stockbridge	770-507-9622	www.inkwizard.com	NTA
Flowstyle Tattoos	5062 Memorial Dr.	Stone Mountain	404-294-5323	flowstyl@fdn.com	
Ink Jammers Tattoos & Body Piercings	1003 N. Ashley Street	Valdosta	229-247-4778	jammer@inkjammerstattoos.com	
All American Tattoo	409 Belmont Dr.	Warner Robins	478-329-1901		
Electric Crayon Tattoo	2072 Watson Blvd.	Warner Robins	478-923-1368		
Electric Crayon Tattoo & Body Piercing	409 Belmont Dr.	Warner Robins	478-954-1092		
Lyon Studios	2072 Watson Blvd.	Warner Robins	478-923-1368		
Epic Tattoo Studio	10350 Main Street, Suite 120	Woodstock	770-517-7200		

Hawaii

Name	Address	City	Phone	Website	Code
Rainbow Tattoo	11 Furneaux Lane, #210	Hilo	808-961-2621		NTA
A Tiki Tattoo	2229 Kuhio Ave.	Honolulu	808-923-4100		NTA
Big Fat Tatts	1095 Dillingham Blvd.	Honolulu	808-843-2644		
Fat Duk Studio	PO Box 37143	Honolulu	808-371-2666		
Paragon Body Piercing	1667 Kapiolani Blvd.	Honolulu	808-949-2800		APP
Sharkys Tattoo	1038 Nuuanu Ave.	Honolulu	808-585-0076		
South Pacific Tattoo Co.	345 Saratoga Road	Honolulu	808-924-2198		NTA
Gunpoint Tattoo	438 A Uluniu Street	Kailua	808-263-848		APT
Rainbow Falls Tattoo	75-5799 Alii Dr. #B-7	Kailua-Kona	808-326-7427		NTA
Human Rites	PO Box 566 4424 Papalina Road	Kalaheo	808-332-0330		
Skin F/X Tattoo	45-1117 Kam Hwy.	Kaneohe	808-235-8286		
Atomic Tattoo	193 Lahainaluna Road	Lahaina	808-667-2156		
Dragon Tattoo	10 N. Kamehameha Hwy.	Wahiawa	808-622-5924		NTA
New Tribal Tatau	2310 Kuhio	Waikiki Market Place	808-926-8288		

Idaho

Name	Address	City	Phone	Website	Code
Black Cat Tattoo & Piercing	3115 W. State Street	Boise	208-368 9960	www.blackcat-tattoo.com	APT
Imperial Body Art	610 N. Orchard Street	Boise	208-344-TATS		
Inkvision Tattoo	1736 Main Street	Boise	208-383-0912		
Krahnic Body Art	3703 Overland Road	Boise	208 424-1INK	www.boisetattoo.com	APT, APP
Nobody's Hero	1505 Liberty Street	Boise	208-377-9300		APP
Skin City Tattooing	6805 Fairview Ave.	Boise			APT, NTA
Express Yourself Tattoo	4807 Yellowstone Ave.	Chubbuck	208-237-8288		
Dan's Tattoo Shop	8761 N. Government Way	Hayden	208-762-3999		
Pirate Custom Tattoo & Exotic Body Piercing	9439 N. Government Way	Hayden	208-762-3337		
Falling Moon Tattoo	520 S. Main Street	Moscow	208-882-4257		NTA
Little City Tattoo	230 W. 3rd Street	Moscow	208-882-8668		APT
Skinny Boy Tattoo	5250 E. Seltice Way #C	Past Falls	208-457-9500		APT
Lake City's Tattooland	704 Cavalry Lane	Post Falls	208-667-8286	www.lakecitytattooland.com	APT
Slavedragon Tattoo & Piercing	1688 Kimberly Road, Suite 6	Twin Falls	208-737-0680		APT

Illinois

Name	Address	City	Phone	Website	Codes
Rising Phoenix	9 W. 330 Lake Street	Addison	630-458-8800		NTA
Body Treasures Tattooing & Piercing	4111 Alby Street	Alton	618-462-0006	www.bodytreasures.com	APT, NTA
Digital Tattoos	815 Charles	Aurora	630-897-6772		
Ronin Tattoo & Body Piercing Studio	1161 B. Farnsworth Ave.	Aurora	630-585-7011	www.ronintattoo.com	APT
World Class Body Customizing	3263 Harlem Ave.	Berwyn	708-788-8288		NTA
Sacred Art Studios	586 Torrence Ave.	Calumet City	708-862-2666		
Golgotha Tattoos & Piercing	709 South Illinois Ave.	Carbondale	618-529-4809		NTA
18 Story Tattoo	101 E. Healey	Champaign	217-239-2383		
Mark Of Cain Tattoos	207 W. Green Street	Champaign	217-355-3876	www.markofcaintattoos.com	
Ageless Arts Tattoo & Body Piercing Studio	6743 W. North Ave.	Chicago	708-358-0526		
Chicago Tattoo & Piercing Company	922 W. Belmont Ave.	Chicago	773-528-6969	www.chicagotattoo.com	APT, NTA
Deluxe Tattoo	1459 W. Irving Park Road	Chicago	773-549-1594	www.deluxetattoo.com	
Ink & Iron Custom Tattoo	4206 N. Milwaukee Ave.	Chicago	773-777-2INK		
Jade Dragon Tattoo & Body Piercing	5331 W. Belmont Ave.	Chicago	773-736-6960		NTA
No Hope No Fear	1579 N. Milwaukee Ave., Suite 30	Chicago	773-772-1960		
Shred's Inferno	4304 W. 63rd Street	Chicago	773-585-2653		
Tattoo Factory	4408 N. Broadway	Chicago	773-989-4077	www.tattoofactory.com	NTA
Tatu Tattoo Inc.	1754 W. North Ave.	Chicago	773-772-8288	www.tatutattoo.com	APT
The Native Soul Tattoos	1004 W. 18th Street	Chicago	866-666-1950		
Toria's Gallery	10853 S. Western Ave.	Chicago	773-238-8375		NTA
Prairie Tattoo	172 S. Halsted Street	Chicago Heights	708-709-0103		APT, NTA
American Standard Tattoo	416 E. Main Street	Collinsville	618-345-TAT2	www.americanstandardtattoo.com	APT
Fantasy Skin Tattoo	4755 W. 137th Street	Crestwood	708-597-8245		
Area 51 Tattoos & Body Piercing	60 N. Williams Street	Crystal Lake	815-455-1199		
Lunch Box Tattoo	By appointment only	Crystal Lake	815-790-8822	www.lunchboxtattoo.com	APT
Fox Valley Tattoo	426 North Virginia Road	Crystal Lake	815-444-0024		NTA
Tattoo U	403 N. 22nd Street	Decatur	217-428-8710		NTA

Name	Address	City	Phone	Website	
Perfection Dermagraphics	69 N. Broadway	Des Plaines	847-635-0335		
Skin Graphics Tattooing	14145 S. Chicago Road	Dolton	708-201-9319		NTA
Downers Grove Tattoo Co	2051 Ogden Ave.	Downers Grove	630-960-1409		NTA
Red-Dawg Tattoo Studio	5 Fivepennies Trl. Ct.	Edinburg	217-623-4485		
Topnotch Tattoos	216e Chicago Street	Elgin	847-695-4906		
Inkwell Tattoo Studio	10227 Lincoln Trl.	Fairview Heights	618-398-1427	www.inkwelltattoos.com	NTA
Dave's Tattoos	604 E. Oak W.	Frankfort	618-932-2511		
Pores Of Color	7825 W. Lincoln Hwy.	Frankfort	815-464-7255		NTA
Gar's Ink Tattoos	135 Lincoln Street Main Floor	Galesburg	309-342-8207		
Dead Serious Designs	7107 Montclair Ave.	Godfrey	618-466-3323	www.deadserioustattoos.com	APT, APP
Flesh Effex	330 E. Raymond Street	Harrisburg	618-252-4358		NTA
Rj's Tattoo Studio	105 W. Front Street	Harvard	815-943-5117		
Westside Tattoo & Body Piercing	815 Plainfield Road	Joliet	815-726-TAT2		
Wolf's Fine Line Tattoo	Pinetree Plaza	Joliet	815-723-5918	www.wolfsfineline.com	APT
	1117 Plainfield Road, Suite 4				
The Abyss	665b N. 5th Ave.	Kankakee	815-932-3600		
Blue Skys Tattoos	125 Joliet Street	La Salle	815-224-8287		APT
Skin Deep Custom Tattoos	15 Main Street	Leaf River	815-738-2953		
Art W/ Atattooed	269 Peterson Road	Libertyville	847-367-1966		NTA
Liberty Tattoos	1023 N. Milwaukee Ave.	Libertyville	847-281-9168		NTA
Lucky Seven Studio	229 Peterson Road	Libertyville	847-680-7679		NTA
Tattoo City - Skin Art Studio	14508 S. Archer Ave.	Lockport	815-836-8282	www.tattoocityskinart.com	APT
Altered Images	3279 Glenwood-Dyer Road	Lynwood	708-758-8282		
Tattoo Blue	102 1/2 W. Jackson Street	Macomb	309-833-1849		NTA
Visionquest Tattoo's & Things	110 N. State Street	Marengo	815-568-9211		NTA
Boulevard Tattoo	208 E. Blvd.	Marion	618-997-5259		NTA
Hyperspace Studios	PO Box 371	Marion		www.hyperspacestudios.com	APT
Unique Ink Custom Tattoos & Body Piercings	1010 W. Main	Marion	618-993-5050		
Living Color Tattoo	1622 Broadway Ave.	Mattoon	217-234-9611		NTA
The Pit Studio	109 W. Main	Ottawa	815-434-4040		
Nick's Tattoos	1020 Derby	Pekin	309-346-TATS		
Hybrid Art Studio	222 E. Washington Street E.	Peoria	309-694-1088		
Mojo Studios	1305 N.E. Adams Street	Peoria	309-637-1313		

Business	Address	City	Phone	Website	Code
Redwood's Wild Side Tattoo	9307 S. Rte. 12, Unit A	Richmond	815-678-4600	www.tattoosbyredwood.com	APT
Flying Tiger Tattoo	118-A Main Street	Round Lake Park	847-201-1298		
New Age Tattoos	2919 S. Macarthur Blvd.	Springfield	217-546-5006		
Integrity Tattoos	324 N. Illinois	St. Belleville	618-257-2321		
Artistic Skinpressions	3331 Chicago Road	Steger	708-755-0893		
Wildest Dreams Body Art	1205 W. Edwards Street	Vandalia	618-283-2698		
Underground Tattoo Co.	4808 E. Lake Shore Dr.	Wonder Lake	815-728-0196		NTA

Indiana

Business	Address	City	Phone	Website	Code
Orgasmic Ink Tattoos & Body Piercing	2040 Broadway	Anderson	765-642-2828		
Poppies Tattoo Club	3705 Main Street	Anderson	765-643-8229		
Body Enhancements	121 E. Main Street PO Box 5	Atwood	219-858-0553		
Marked 4 Life Tattoo	129 W. 8th Street	Auburn	260-925-2113		
Eternal Image	113 E. Van Buren Street	Columbia City	219-244-4263		
The House of Pain	647 N. Main Street, Suite C	Columbia City	260-244-3361		
Full Moon Studio	2612 Virginia Ave.	Connersville	765-825-2404		
The Mind's Eye Tattoo	110 S. Green Street	Crawfordsville	765-361-1051	www.geocities.com/tatumark	APT
Legendary Ink Tattoo Studio	12025 Blake Road	Deput	812-873-5050		
Elegant Art	8378 S.R. 18	E. Montpelier	765-728-9334		
Cain's Grafik Dragon Tattoo	602D W. Vine Street	Ellettsville	812-935-6556		
Everlasting Impression	3821 E. Morgan Ave.	Evansville	812-428-3057		
Grade A Tattoo & Body Piercing	5719 St. Joe Road	Fort Wayne	219-485-8258	www.gradeatattoos.com	APP
Modern Primitive	2034 Broadway	Fort Wayne	260-423-2130	www.themodernprimitive.com	APP
Bugaboo Tattoo	7014 Kennedy Ave.	Hammond	219-844-4343		
Artistic Skin Designs	4955 W. Washington Street	Indianapolis	317-244-8282		NTA
Freedom Tattoos	423 E. Lincoln Road	Kokomo	765-455-8548		
Black Rose Tattoos	1192 A. Street, N.E. Hwy. 54	Linton	812-847-4588		
Renegades Tattoos	708 W. Curry Street	Mitchell	812-849-0795		
Dragon Slayer Tattoo	2801 N. Wheeling Ave.	Muncie	765-288-7153		
The OUCH! Gallery	506 1/2 North Martin Street	Muncie	765-287-1090		
Artistry In Motion	223 E. Walnut Street	North Vernon	812-346-0057		
Seal Of The Living God Tattoos	2290 St Road 67 S.	Paragon	765-537-3039		

Name	Address	City	Phone		
No Regrets Tattoo Studio	5478 Central Ave.	Portage	219-762-1441		
Tat Shop Tattoo Studio	14 S. 9th Street	Richmond	765-935-4689		
Artisan Tattoo Co	10005 Lower Huntington Road	Roanoke	219-672-3809		APT
Artistry In Motion	165 S. Gardner Street	Scottsburg	812-752-1000		
A Spot of Ink & A Taste of Steel	1600 S. Third Street	Terre Haute	812-232-0818		APT
Artistic Skin Expressions	1617 S. 7th Street	Terre Haute	812-299-SKIN		
Bullet Tooth	908 N. Washington	Valparaiso	219-928-0574		
A Spot of Ink & A Taste of Steel	19 S. Third Street	Vincennes	812-895-1224		APT
Altered Image	417 College Ave.	Vincennes	812-882-8288		
Blue Dragon Tattoos & A Taste of Steel	1503 N. 2nd Street	Vincennes	812-886-3786		APT
Purple Cow Tattoo Emporium	13 S.E. 3rd Street	Washington	812-257-8982		

Iowa

Name	Address	City	Phone	Website	
Omega Red	510 State Street	Cedar Falls	319-277-8780		
Appetite For Ink	812 Ellis Blvd. N.W.	Cedar Rapids	319-364-7558		
Chinese Symbol For Tattoo Design	705 2nd Street #2	Coralville	319-430-1689		
Crossroads Tattoo	508 2nd Ave.	Coralville	319-388-8500	www.crossroadstattoo.com	NTA
Creative Images	4817 University Ave.	Des Moines	515-277-8288		NTA
Sacred Skin	4400 S.W. 9th Street	Des Moines	515-953-6902		NTA
Mid Air and Ink	206 4th Street	Des Moines	515-243-0009		
The Axiom @ The Skin Kitchen	2724 Douglas Ave.	Des Moines	515-255-4430		
The Skin Kitchen	2722 Douglas Ave.	Des Moines	515-255-4430		
Apocalypse Tattoos & Body Piercing	1210 Central Ave.	Fort Dodge	515-573-7551		
Kustom Kulture Tattoos	522 S. 22nd Street	Fort Dodge	515-576-7218		
Endorphinden	632 S. Dubuque St.	Iowa City	319-688-5185		
Slingin' Ink Tattoos	403 E. Main Street	Montezuma	641-623-3564		
Starr Asylum	1207 E. Washington Street	Mt. Pleasant	319-385-1997		
Project X Tattoos & Body Piercing	212 1st Street N.	Newton	641-792-2671		
Outlaws Ink Tat-2 Shop	34 S. Hawkeye Ave.	Nora Springs	641-749-2590		
Silver Eagle Tattoo	312 E. Coolbaugh	Red Oak	712-623-5968		
Jolly Roger Tattoo	4508 Morningside Ave. Eastview Plaza	Sioux City	712-274-1095		NTA

Name	Address	City	Phone	Website	Notes
Midwest Wade's Custom Tattoo	4124 Floyd Blvd.	Sioux City	712-239-6600		NTA

Kansas

Name	Address	City	Phone	Website	Notes
Skin Art Creations Tattoo Emporium	105 West Main Street	Independence	620-331-5938		NTA
East Coast Al's Studio	1507 Central Ave.	Kansas City	913-321-1214		APT, NTA
Shane Hart's Studio of Tattooing	832 Iowa Street, Suite B	Lawrence	785-832-9557		APT, NTA
Big Daddy Tattoos & Piercing	5907 Outlook	Mission	913-384-5454		
Electric Tattoo & Piercing	2517 W. 6th Street	Topeka	785-233-9500		
Fine Line Tattoo & Body Piercing	2840 S.E. Massachusetts	Topeka	785-233-8288		NTA
Holier Than Thou	1111 E. Douglas	Wichita	316-266-4100		APP

Kentucky

Name	Address	City	Phone	Website	Notes
Touch of Class Tattooing	8136 U.S. 60 W.	Ashland	606-928-8465		NTA
Body Language Tattoos	503 Knox Street	Barbourville	606-546-7552		
Artistic Encounter	1407-31 W. Bypass	Bowling Green	270-783-8697		
Toppers Fine Line Tattoo	1224 U.S. Hwy. 31-W Bypass	Bowling Green	270-796-3600		NTA
Lost Planet Tattoo	8040 S. Hwy. 27	Burnside	606-561-4040		NTA
Lucky 13 Tattoo Inc.	712 Madison Ave.	Covington	859-431-4400		
New Age Beauty	608 Poplar Street	Georgetown	502-570-9652		
Tattoo You	216 Lovern Street	Hazard	606-436-0458		
Tattoo Express	3143 U.S. 41 N.	Henderson	270-831-2032		
Electric Art Tattoo & Piercing	159C E. Reynolds Road	Lexington	859-272-8989		
Fiery Dragon Tattoo & Body Piercing	1036 New Circle Road N.E. #B	Lexington	606-231-1105		NTA
Always N-2-U	1845 Berry Blvd.	Louisville	502-366-9635	www.tattoocharlies.com	APP
Body Art Emporium	1802 Bardstown Road	Louisville	502-452-1485		NTA
E-Den Studio	1507 Bardstown Road	Louisville	502-473-7400		
Phat Tattoos	1767 Bardstown Road	Louisville	502-719-PHAT		
Streamline Tattoo Studio	1228 Highland Ave.	Louisville	502-561-8638		
Tattoo Charlie's on Dixie	7640 Dixie Hwy.	Louisville	502-995-5635		APT
Tattoo Tavern & Professional Body Piercing	E. Main Street (across from Speedway)	Morehead	606-784-0000		
The Gargoyle Tattoo Studio	508 N. Maysville, Suite B	Mt. Sterling	859-497-9589		

Name	Address	City	Phone	Website	
Castle Of Color	3023A Lexington Road.	Nicholasville	859-881-5353		
Dancing Dragon Tattoo	3906 Hwy. 41A	Oakgrove	502-439-4465	www.dancingdragontattoo.com	NTA
The In Skin Studio	1000 Old Mayfield Road #A	Paducah	502-442-9066		NTA
Topes Puff N Stuff Tattoo Parlor	226 Broadway	Paducah	270-444-9993		
General Lee's Tattoo	1049 N. Dixie Blvd.	Radcliff	502-352-2837		NTA
Tattoos by The Renegade	759 N. Dixie Blvd.	Radcliff	502-351-6767		NTA

Louisiana

Name	Address	City	Phone	Website	
Speakeasy Studio	3221 Masonic Dr.	Alexandria	318-473-4551		
Looking Glass Tattoo	120 W. Madison Ave.	Bastrop	318-283-9145		
The Hole Experience	7106 Antioch Road	Baton Rouge	225-752-2345		
The Hole Experience	4110 Highland Road A-10	Baton Rouge	225-761-HOLE		
The Tattoo Clinic (Body Images Tattoo)	3607 Government Street	Baton Rouge	225-343-1438	www.thetattooclinic.com	APT
Tiger's Claw Tattoos	8525 Greenwell Springs Road	Baton Rouge	225-924-5340		
Skin Works Tattoo	739A Benton Road	Bossier City	318-752-4333		APT
Imperial Tattoo	9031 W. Judge Perez	Chalmette	504-279-4375		
Freaky Tiki Tattoos	2327 Veterans Blvd. "B"	Kenner	504-464-0053		
Mike's Tattoos	12149 Lake Charles Hwy.	Leesville	318-239-0425		NTA
Slingblade's Tattoo & Piercing	116 East Union	Minden	318-371-1866		
Steve's Inkslingers	3223 Louisville Ave.	Monroe	318-388-2833		
Tat2u	2 Louisville Ave.	Monroe	318-324-2111		
Fat Jack's Tattoo Emporium	624 Fourth Street	Natchitoches	318-356-0013		
Original Skin	321 Shoreline Dr.	Natchitoches	318-357-8566		
Aart Accent Tat 2-Voo Doo	5727 Saint Claude Ave.	New Orleans	504-949-5377		APT, NTA
Electric Ladyland	8106 Earhart Blvd.	New Orleans	504-866-3859		NTA
Eye Candy Tattoo	1578 Magazine Street	New Orleans	504-299-8222		
Lucky U Tattoo Studio	902 Poydras	New Orleans	504-566-0062		
Pure Black Tattoo	3711 Cadiz Street	New Orleans	504-822-8763		
Rings of Desire Body Piercing	1128 Decatur Street	New Orleans	504-524-6147	www.ringsofdesire.com	APP
Viper's Custom Ink	7502 Chef Menteur Hwy.	New Orleans	504-244-8985		
Skin Expressions	208 E. Jefferson Street	Oak Grove	318-428-1800		
Tattoo Paradise	6105 Youree Dr.	Shreveport	318-865-3191	www.tattooparadise.8k.com	NTA
Bayou Tattoo	2211 Gause Blvd. E.	Slidell	985-643-3339		

Name	City	Address	Phone	Website	
The Body Shop	Slidell	2146 E. Gause	985-646-6075		
Studio Ink	Vanville	1324 Hustonville Road	859-936-2009		

Maine

Name	City	Address	Phone	Website	
Tattoo's 4 U	Augusta	Rt. 17 264 Eastern Ave.	207-626-9232		
Ramtattoo	Bangor	182 Essex Street	207-942-8038		
Bar Harbor Tattoo	Bar Harbor	40 Rodick Place	207-288-9722		
House Of Ink	Benton	Unit 26 Benton Plaza, Benton Neck Road	207-453-7731		
Mystic Impressions Tattoo Studio	Caribou	Center Street	207-498-2128		
Bad Girl Body Art Studio	East Millinocket	73C Main Street	207-746-9950		NTA
Absolute Pride Tattoo	East Orland	Rt. 1 Acadia Hwy.	207-469-2840		
Altered Image Tattoo	Lewiston	1384 Lisbon Street	207-786-7005		
Madhatter's Tattoo	Old Orchard	716 Main Street	207-934-4090		NTA
Tattoo's 4 U	Pittsfield	14 Easy Street	207-487-3013		
Sanctuary Tattoo	Portland	20-36 Danforth Street, Suite 213	207-828-8866		
Tsunami Tattoo	Portland	9 Union Street	207-756-6766	www.tsunamitattoo.com	APT
Dragon Guy Tattoo	Presque Isle	12 Church Street	207-760-8282		
Great Northern Tattoo Co.	Presque Isle	1 Academy Street	207-768-5822		
Rosebud Tattoo Studio	Saco	5 Elm Street	207-283-9632		NTA
Forever Ink Tattoo	Sanford	36 Winter Street	207-324-2379		

Maryland

Name	City	Address	Phone	Website	
Full Color Coverage	Annapolis	24-B Defense Street	410-224-0992	www.fullcolorcoverage.com	APT
Great Southern Tattoo Co.	College Park	9403 Baltimore Ave.	301-474-8820		NTA
Personal Art Studio	Cumberland	13404 McMullen Hwy. S.W.	301-729-8282		APT
Body Fx Tattoo Studio	Elkridge	6240 Washington Blvd.	410-796-9396		NTA
Tidewater Tattoo Studios	Elkton	113 W. Main Street	800-274-5921 or 410-398-1202	www.tidewatertattoo.com	APT, NTA
Marks of the Spark Tattoo	Frederick	323 E. Patrick Street	301-662-7200		APT, NTA
Dragon Moon Tattoo Studio	Glen Burnie	208 North Crain Hwy.	410-768-6471	www.dragon-moon.com	NTA
Tux's Tattoo Studio	Glen Burnie	7231 Ritchie Hwy.	410-761-7231		NTA
Inkers Tattoo	Rockville	15877 Redland Road	301-977-0094		NTA

Name	Address	City	Phone	Website	Code
Explosive Tattoo	28772 Ocean Gateway #D	Salisbury	410-548-9887	www.explosivetattoo.com	APT
Capitol Tattoo	7920 Georgia Ave.	Silver Spring	301-585-3483		NTA
Mr. Natural's Tattoo Studio	414 S. Conococheague	Williamsport	301-223-6014	www.mrnaturals.com	APT, NTA

Massachusetts

Name	Address	City	Phone	Website	Code
Mom's Tattoo Studio	15 North Pleasant Street, #2S	Amherst	413-256-3900	www.momstattoostudio.com	APT, NTA
Tribal Ways Inc.	93 Massachusetts Ave., 2nd Floor	Boston	617-536-0445		
13 Moons Tattoo & Piercing Studio	2374 Massachusetts Ave.	Cambridge	617-354-4477		
Chameleon Tattoo & Body Piercing	36 JFK Street	Cambridge	617-491-4335		
Kruger Tattoos	167 Church Street	Clinton	603-770-6963		
What It Is!	167 Church Street	Clinton	978-368-7299		
Mass-Ink	55 N. Bedford Rte. 18	E. Bridgewater	508-378-4311	www.massinkonline.com	APT
Man's Ruin Tattoo	407 S. Main Street	Fall River	508-675-3111		
Classic Tattoo	440 N. Ave #134	Haverhill	978-373-6415		
Fat Ram's Pumpkin Tattoo	380 Centre Street	Jamaica Plain	617-522-6444	www.fatramtattoo.com	APT
Milk Made Art	380 Centre Street	Jamaica Plain	617-522-6444		
Stinky Monkey Tattoos	70C Summer Street	Kingston	781-585-9393		
Tattooed Dragon	596 Western Ave.	Lynn	781-593-7600		
Bodyart	468A Salem Street	Medford	781-350-0120		
Lucky's Tattoo & Piercing Emporium	37 Main Street	Northampton	413-587-0004		
The Living Art Studio	219 Main Street	Northampton	413-584-3758	www.thelivingartstudio.com.	NTA
The Shining Star	59 Central Street	Peabody	978-538-9783		
A Crazy Chameleon Body Piercing & Tattooing	56 Elm Street	Pittsfield	413-442-7723		
Peter Tat-2	317 North Street	Pittsfield	413-442-9490		NTA
Canman Creations at Cobra Custom	26 Main Street	Plymouth	508-747-8135	www.canmancreations.com	
Clean & Sober Tattooing	By appointment only	Plymouth	508-888-9026		APT
Cobra Custom Tattoo	26 Main Street	Plymouth	508-747-8135	www.cobracustomtattoo.com or www.canmancreations.com	APT
Darkwave Tattoos	2129 Washington Street	Roxbury	617-445-9090		APT
Mongo's Tattoo Madness	149 Washington Street	Somerville	617-666-4213		
Nuclear Crayon	648 Page Blvd.	Springfield	413-205-2840		

Name	Address	City	Phone	Notes
Action Ink Tattoo & Body Piercing	295 Broadway (Rte. 138)	Taunton	508-822-6775	www.actioninktattoo.com
Pleasure in Pain Tattoo	184 Broadway	Taunton	508-824-0302	
Art Gecko Tattoos	195 West Boylston Street	West Boylston	508-835-3838	
Nitemare Tattoo & Body Mods	297 Elm Street	Westfield	413-572-0437	
Golden Needle Tattoo Studio	245 Bedford Street	Whitman	781-447-6022	
Inkslingers Traveling Tattoo & Piercing	36 Locust Street	Woburn	339-927-3224	
Mass Tattoos	34 Cambridge Street	Worcester	508-755-2228	
Piercing Emporium	400 Shrewsbury Street	Worcester	508-754-0564	APP

Michigan

Name	Address	City	Phone	Notes
Creative Tattoos	819 W. Chisholm	Alpena	989-354-6727	
Lucky Monkey Tattoo Parlour	308 S. Ashley Street	Ann Arbor	734-623-8200	
Name Brand Tattoo	621 Church Street, 2nd Floor	Ann Arbor	734-623-0553	
S.C. Tattoo & Body Piercing	6834 Jackson Road	Ann Arbor	734-327-4311	APT
Tattoo Paradise	340 S. State Street	Ann Arbor	734-669-TATU	
Electric Superstition	27815 Woodward Ave.	Berkley	248-548-4637	
American Graffiti Tattoos Inc.	630 E. Grand River Ave.	Brighton	810-220-0266	NTA
Lucky-U-Tattoo	3273 S. Dort Hwy	Burton	810-743-7649	
Ink Slingers	25543 Van Dyke Ave.	Center Line	810-759-5510	NTA
Wild Things Tattoo	48828 Gratiot Ave.	Chesterfield Twp	586-948-2595	
Inkslingers Tattooing	25534 21 Mile Road.	Chesterfield	586-948-2800	NTA
Finest Touch Tattoos	237 N. River Road	Clements	586-783-9906	
Scooters Tattoo & Body Piercing	455 Marshall Street	Coldwater	517-279-1666	
Ink Slingers Tattooing Inc.	8602 N. Telegraph Road	Dearborn Heights	313-565-7776	NTA
Detroit Tattoo Inc.	6535 Michigan Ave.	Detroit	313-898-2237	APT
T.N.T. Tattoo & Piercing	24251 McNichols	Detroit	313-414-TATS	
A Splash of Color Tattooing	515 E. Grand River Ave., Suite F	East Lansing	517-394-2120	APT, APP www.splashtattoos.com
Glen Art Studios	213 E. Grand River Ave.	East Lansing	517-337-9014	APT, NTA
The Electric Needle Hut	6885 Cass Street	Edwardsburg	269-663-6804	
Higgy's Tattoo Studio	1450 Dick Road	Fenwick	989-248-3142	
Michigan Tattoo	2069 N. Dort	Flint	810-235-0517	
Doctor John's Body Art Studio	33160 Groesbeck	Fraser	586-415-5903	NTA

Business	Address	City	Phone	Website	Notes
Nice Guys Custom Tattooing	122 44th Street S.E.	Grand Rapids	616-530-3287		
Magnum Tattooing Inc.	2317 S. Division Ave.	Grand Rapids	616-245-1880		
The Edge Tattoo & Body Piercing	422 Quincy Street	Hancock	906-482-8999	www.edgetattoos.com	APT
Sink the Ink	380 Central, Suite 5	Holland	616-395-8288		
Impaled Body Piercing & Tattoo	509 Sheldon Ave.	Houghton	906-482-7653		
River House Tattoo	9702 U.S. 31 S.	Interlochen	231-275-6457		
House of Stiles	1621 W. Michigan Ave.	Jackson	517-817-5467		
Precision Tattoo Inc.	1008 E. Ganson	Jackson	517-782-7274		APT
Old Anchor Tattoo	1414 Portage Road	Kalamazoo	616-345-9490		
Lost Tiger Tattoos	4123 W. Saginaw Hwy.	Lansing	517-327-2992	www.losttigertattoos.com	APT
Tribal Image	55 W. Nepessing Street	Lapeer	810-667-3292		APT
Eternal Tattoos	27590 Plymouth Road	Livonia	734-425-4428		NTA
Karma Body Art	750 S. Telegraph	Monroe	734-241-3260		
Artistic Edge Custom Tattooing & Piercing Salon	1350 S. Getty Street	Muskegon	616-777-7450	www.artisticedgetattoo.com	APT
Creation Station Tattoo Studio	8140#C Mason Dr.	Newaygo	231-652-8282		
Michiana Tattoo Emporium Service	116 S. 11th Street	Niles	269-683-3383		APT, NTA
Ambrosia Tattoo Gallery LLC	22175 Coolidge Hwy.	Oak Park	248-890-3612		NTA
Creative Tattoos	101 Bank Ave., Suite 104	Oscoda	989-739-2533		
Tattoos by Raven	M-89 downtown	Otsego	616-694 4278	www.tattoosbyraven.com	APT
Nailed Promise Tattoos	Glen's Plaza North	Petoskey	231-348-8778		
Fast Freddie's Tattooing	3521 Pine Grove Ave.	Port Huron	810-984-8118		NTA
Ink Slingers Tattooing	710 Huron Ave.	Port Huron	810-989-6000		NTA
Eternal Tattoos	26065 Gratiot Ave.	Roseville	586-779-4770		NTA
Ink Slingers Tattooing	29323 Gratiot Ave.	Roseville	810-777-6390		NTA
Royal Oak Tattoo Inc	820 S. Washington	Royal Oak	248-398-0052	www.royaloaktattoo.com	NTA
Old Town Tattoo	203 N. Hamilton	Saginaw	989-799-3972		
Superior Lines Tattoo	225 Ashmun Street	Sault Sainte Marie	906-632-8282	www.tattuz.com	APT
Northern Lights Tattoo Company	212 Ashmun Street	Sault Sainte Marie	906-253-SKIN		
Deep Image	129 W. Lake Street, Suite B	South Lyon	248-437-5399		
Wonderland Tattoo Studio	23531 Little Mack Ave.	St. Clair Shores	586-774-8288		NTA
Detroit Hardcore Tattoo's & Piercing	43727 Van Dyke	Sterling Heights	586-709-5190		
Inkslingers Tattooing	43911 Van Dyke	Sterling Heights	586-323-1279		

Business	Address	City	Phone	Website	Codes
Sturgis Tattoo Co. & Body Piercing	67659 M-66 N.	Sturgis	616-651-8860		APT, NTA
Glen Art Studios	320 West Street	Sutton's Bay	231-271-3253		APT, NTA
Ink Slingers Tattooing	15525 Racho Blvd.	Taylor	734-287-3080		APT, APP
Johnson Tattoo	25119 Ecorse Road	Taylor	313-292-5296	www.johnsontat.com	APP
Damage	140 E. Front Street, #11	Traverse City	231-946-9494		
Pour Boiz Tattooz Ink	1557 Premier Street	Traverse City	231-929-9190		
Sin Tattoo	212 E. Front Street	Traverse City	231-932-2382		
Bluz Tattooz & Body Piercing	5720 Highland Road, Suite E	Waterford	248-674-2300		
Lady Luck Inc.	5310 Highland Road (M-59)	Waterford	248-673-0670		APT

Minnesota

Business	Address	City	Phone	Website	Codes
Forever Yours Tattoos	201 E. Main Street	Anoka	763-576-0518		
Black Cat Tattoo Inc.	212 Minnesota Ave. N.W.	Bemidji	218-751-4851		NTA
Spellbound	217 Milky Way S.	Cosmos	320-877-7555		
Big Jeff's Tattoo	7 3rd Street N.W.	Faribault	507-334-8184		
Electric Dragonland	923 Main Street	Hopkins	952-933-2097	www.electricdragonland.com	APT, NTA
Cactus Tattoo	307 N. Riverfront Dr.	Mankato	507-387-6601 or 877-844-2895	www.cactustattoo.com	APT
Ace Tattoo	2504 Hillsboro Ave. N.	Minneapolis	612-595-8484		
Art with a Point Custom Tattoo Studio	711 W. Lake Street	Minneapolis	612-823-1254	www.artwithapoint.com	APT, NTA
Ink Lab Tattoos	919 W. Lake Street	Minneapolis	612-823-2969		
Saint Sabrina's Parlor in Purgatory	2751 Hennepin Ave. S.	Minneapolis	612-874-7360	www.saintsabrinas.com	APP
Sin & Ink Tattoo and Body Piercing Studio	241 2nd Ave. N.	Minneapolis	612-339-1461		
Steady Tattoo	714 Washington Ave. S.E.	Minneapolis	612-379-4455		
Tattooing by Yurkew	3131 Nicollet Ave.	Minneapolis	612-825-6161		NTA
Tatus by Kore	611 W. Lake Street, Suite C	Minneapolis	612-824-2295	www.tatusbykore.com	APT, NTA
Golden Needle Tattoo	210 11th Street S.	Moorhead	218-236-8560		NTA
Nuworld Tattoos & Body Piercing	529 Central Ave.	Osseo	763-493-2422		
Jeff's Tattoo & Body Piercing	60 Main Street E.	Rice	320-393-2654		NTA
Infinity Tattooing & Body Piercing	1006 N. Broadway	Rochester	507-281-1296		
Tattoos Unlimited	490 Asbury Street	St Paul	651-647-9251		NTA

Name	Address	City	Phone	Website	
Cloud 9 Tattoo	714 W. St. Germain Street	St. Cloud	320-251-3888		
Rising Phoenix Tattoo	16 21st Avenue S.	St. Cloud	320-255-7305 or 800-340-7305	www.rising-phoenix.com	APT
Twisted Tattoo & Body Piercing	805 W. St. Germain Street	St. Cloud	320-240-6966		
Acme Tattoo Co. Inc.	1045 Arcade Street	St. Paul	651-771-0471 or 651-771-1377	www.acmetattoo.com	APT, NTA
Tatts by Zapp	235 1/2 East Chestnut Street	Stillwater	651-439-4974		
Cherry Creek Studio	200 S.W. 6th Street	Willmar	320-231-0501		NTA

Mississippi

Name	Address	City	Phone	Website	
Bayside Tattoo & Body Piercing	1060A Hwy. 90	Bay St. Louis	228-463-0026		
King Pin Tattoo & Piercing	4085 Popp's Ferry Road	D'iberville	228-396-0309	www.kingpintattoo.com	NTA
King Pin Tattoo & Piercing	2416 Government Street	Ocean Springs	228-818-555	www.kingpintattoo.com	NTA
Jack & Diane's Tattoo	1630 Pass Road	Biloxi	228-436-9726	www.jackanddianes.com	APT, NTA
Poison Pen Tattoos	Brookway Plaza, Suite 14	Brookhaven	601-823-4498		
Skin Graffiti Tattoo	1359 Lakeview Dr.	Grenada	662-226-7001		
Jack & Diane's Tattoo	510 Broad Ave.	Gulfport	228-864-4764	www.jackanddianes.com	APT, NTA
Squench's Tattoos	3780 I-55 S.	Jackson	601-372-2800		
Spacey Tattoo	3500 8th Street	Meridian	601-482-8287		
Tattoo Art	2006 W. Main Street	Tupelo	662-840-1783		
Tattoo Art	1013 W. Main Street	Tupelo	662-680-4771		NTA
TCB Tattoo Studio	618 N. Gloster Street, #5	Tupelo	662-620-5400		

Missouri

Name	Address	City	Phone	Website	
Airstream Tattooing & Body Piercing	910 Center Street	Bismarck	573-734-9097		
A Different Drummer Tattoo Studio	405 Broadway	Cape Girardeau	573-651-8688		NTA
The Tattoo Spot	1209 Broadway	Cape Girardeau	573-332-1003		NTA
Ink Addiction Tattooz	120 W. Liberty	Farmington	573-756-7672		
Artistic Edge Inc.	1067 Gravois Road	Fenton	314-305-1278		
Ink Illustrations Tattoo Gallery	831 S. Main Street.	Joplin	417-206-4080		
Punkteur	1312 S. Main Street	Joplin	417-626-0500		APP

Name	Address	City	Phone	Website	Code
Alternative Creations	4240 N. Oak Trafficway	Kansas City	816-452-0393		
Lady Hawke Ink	1215 1/2 Grand Blvd.	Kansas City	816-471-7405		
Smokerrs Tattoos	3201 Oakland	Kansas City	816-923-0761		
Tattoos by Matthew	PO Box 46751	Kansas City	816-330-3689		
Tattitude	9 E. St. Maries Street	Perryville	573-547-9310		
Ink Illustrations Tattoo Gallery 2	723 Pine Street Corner	Rolla	573-368-3200		
Soul Expressions	903 Pine Street	Rolla	573-368-4123		
A.2.4.U. Tattoo & Body Piercing	7220 S. Broadway	Saint Louis	314-351-1077		
Skin Thieves Tattoo Studio	1703 1/2 W. 9th	Sedalia	660-826-0883	www.skinthievestattoos.com	APT
Hearts of Fire Tattoo & Body Piercing	1851 E. Bennett	Springfield	417-889-3473		NTA
Little's Tattoo	302 Park Central E.	Springfield	417-865-6672	www.littletattoo.com	APT NTA
Miller Cottons Tattoos	1445 S. Glenstone	Springfield	417-889-8287		
Art of Illusion	1339 Harvestowne Ind. Dr.	St. Charles	636-441-8246		
Midwest Kustom Tattoo	Box 705	St. Charles	314-422-4328		
Threshold Body Art Studio	4500 Central School Road	St. Charles			NTA
Body Expressions	617 Francis Street	St. Joseph	816-232-0327		
Kansas City Tattoo Co.	611 Edmond Street	St. Joseph	816-232-4484		
Painted Angel Studios	2104 St. Joseph Ave. 3710 N. Belt Hwy.	St. Joseph	816-390-8443		
Black Pearl Tattoos	2008 Olive Street	St. Louis	314-621-1020		
Cheap TRX	3211 S. Grand	St. Louis	314-664-4011	www.cheapTRX.com	APP
Craig's Tattoo Studio	341 Lemay Ferry Road	St. Louis	314-638-2503		NTA
Goldenlands	8768 St. Charles Rock Road	St. Louis	314-423-0530	www.goldenlands.com	NTA
A Living Color Tattoo	945 E. Missouri Ave.	St. Robert	573-336-7841		
The Electric Krayon	357 Z Hwy, Suite 10	St. Robert	573-336-0012		
Firehouse Tattoos & Body Piercing	140 Marshall Dr.	St. Robert	573-336-5336		NTA
Silent Warrior Tattoo Co.	481 Missouri Ave., Suite E.	St. Robert	573-336-3333		
Full Spectrum	21 Vance Road	Valley Park	636-825-2500		
Skin Thieves Tattoo Studio	1104 S. Maguire	Warrensburg	660-747-0804	www.skinthievestattoos.com	APT
The Zone	417 N. Maguire Street, Suite A	Warrensburg	660-429-4103		APP
The Ultimate Art Form	#2 E. Main Street	Wentzville	636-639-5415		NTA

Montana

Body Works Tattoo & Piercing	406 Grand Ave.	Billings	406-252-7899		NTA
Tattoo Art	16 N. 35th Street	Billings	406-245-0851		APT
Twin Dragon Tattoo & Body Piercing	1833 Grand Ave.	Billings	406-896-0457		
Bozeman Dermagraphics	19 S. Tracy Street	Bozeman	406-585-0034		NTA
Big Sky Tattoo & Body Piercing	443 Main Street	Kalispell	406-755-0129		NTA
Altered Skin Tattoos & Body Piercing	103 Brooks	Missoula	406-549-8544 or 888-549-8544	www.alteredskin.com	NTA
Painless Steel Tattoo	1701 1/2 S. 5th Street W.	Missoula	406-728-1191		NTA
Tnt Tattoo & Body Piercing	(Mobile Studio) PO Box 310	Red Lodge	406-446-9124	www.users.qwest.net/~kk7dw	APT, NTA

Nebraska

Aardvarx Tattoo	3233 S. 13th Street	Lincoln	402-423-7546		
Iron Brush Tattoo	1024 'O' Street	Lincoln	402474-5151	www.ironbrush.com	APT
American Tattoo	4452 S. 84th Street	Omaha	402-339-9000		NTA
Big Brain Productions	1123 Jackson Street	Omaha	402-342-2885		NTA
Body Mods	6110 Maple Street	Omaha	402-551-8801		
Grinn & Barrett Tattoo Studio	5002 Center Street #3	Omaha	402-553-7714		APT
Liquid Courage Custom Tattoo	2936 S. 84th Street	Omaha	402-926-4968		
Nuclear Ink	159 N. 72nd Street	Omaha	402-556-8500		APT

Nevada

Skin Deep Tattoo & Body Piercing	40 E. Williams	Fallon	775-423-1017		
Buffy's Body Art	485 Truck Inn #23	Fernley	775-575-5021		
Insane Tattoos	6000 S. Eastern Ave.	Las Vegas	702-324-6026		
Tatlantis Tattoo & Design Studio	6000 S. Eastern Ave., Suite 12E	Las Vegas	702-798-8288		
Tattoo Art	6200 Spring Mountain Road	Las Vegas	702-726-3151		NTA
Precious Slut	2050 N. Hwy. 160	Pahrump	775-751-2268		
Body Graphics	460 S. Wells Ave.	Reno	775-322-8623		NTA
Piercing USA	1155 W. 4th Street #105	Reno	775-329-2969		APP

New Hampshire

Name	Address	City	Phone	Website	Code
Underground Dragons	6 Ferry Street	Allenstown	603-485-4696		
Electric Angle Tattoo	Rte. 13	Brookline	603-672-5722		APT
Midnight Moon Tattoo	320 Dover Road, Rte. 4	Chichester	603-798-3344		
White Mountain Tattoo & Body Piercing	505 White Mountain Hwy.	Conway	603-447-3232	www.whitemountaintattoo.com	APT
Blue Heron Tattoo	45 Birch Street	Derry	603-421-0265	www.blueherontattoo.com	APT
Maggots Delight	7 Fairway Dr.	Derry	603-560-4301		
Scorpion Tattooing	127 Rockingham Road	Derry	603-434-4798	www.hometown.aol.com/scorpiontatu	
Skullduggery Tattoo	45 Birch Street	Derry	603-421-0265		
Tattoo Palace	30 Crystal Ave.	Derry	603-434-6608		
Hazel'z Inkwell Tattoo & Piercing Studio	5 Jenkins Ct.	Durham	603-969-2842		
Mom's Tattoo Studio	17 Roxburt Street, Suite #3	Keene	603-352-4422	www.momstattoostudio.com	APT
Hollywood Ink Tattoo	Lakeside Ave., Weirs Beach	Laconia	603-366-2425		
LA East Studio of Tattoo	49 Elm Street	Laconia	603-524-6908		NTA
Magic Needle Tattoo Studio	273 Derry Road	Litchfield	603-598-6911		
Tatunka Tattoo	97 N. Thetford Road	Lyme	603-795-4020		APT, NTA
Precision Body Arts	109 W. Pearl Street	Nashua	603-889-5788		
Tattoo America	60 Canal St.	Nashua	603-595-4994		NTA
Xtreme Ink	2399 White Mountain Hwy.	North Conway	603-356-0200		
Screaming Needles Tattoo & Piercing Studio	40 Main Street	Plymouth	603-536-8282		
Bold Will Hold	113 Daniel Street	Portsmouth	603-498-1720		
Body Creations	4 N. Main Street	Rochester	603-332-1799		
Mark Herlehy's Tatu Studio	174 N. Broadway	Salem	603-890-6105		NTA
Tony's Tattoo & Piercing	349 S. Broadway	Salem	603-893-5114		NTA
Bob's Tattoo Paradise	55 Rte. 27	Seabrook	603-895-1411		NTA
Juli Moon Designs	255 Lafayette Road, Rte. 1	Seabrook	603-474-2250 or 877-585-4828	www.julimoon.com	APT, NTA
Freehill Trading Co.	307 Main Street	Tilton	603-286-8813		

New Jersey

Name	Address	City	Phone	Website	
Body Art World I	615 Main Street	Asbury Park	732-988-9875	www.bodytattoos.com	APT
Backstage Tattoos	539 White Horse Pike, Rte. 30	Atco	856-753-5799	www.backstagetattoos.com	NTA
Screamin' Ink	34-07 Broadway	Fair Lawn	201-797-7858	www.screaminink.com	
Starlight Tattoo	472 Washington Ave.	Belleville	973-751-8511	www.starlighttattoo.com	
Evolve	117 E. Main Street	Bogota	201-488-3234		
Lola's Hot and Flying Tattoo Studio	117 E. Main Street	Bogota	201-488-3234		NTA
Electric Lotus Tattoo	912 Main Street	Boonton	973-402-2777	www.electriclotustattoo.com	
4130 Tattoo	125 Rte. 130, S. #7	Burlington	609-747-1900		
Tattoo Shoppe	309 Hackensack Street	Carlstadt	201-933-0037		NTA
Immortal Ink	2004 Rte. 31	Clinton	908-638-9400	www.immortalink.com	APT
Immortal Ink Tattoo	2004 Rte. 31, Unit #1	Clinton	908-638-9400	www.immortalink.com	
Sinister Ink I	290 Rte. 18 Indoor Market	East Brunswick	732-698-2411		
Al's Tattooing	246 Philadelphia Ave.	Egg Harbor City	609-965-3660		APT
Ron's Tattooing Inc.	607 Westfield Ave.	Elizabeth	908-289-7876		NTA
Body Graphics Tattoo	193 U.S. Hwy. 206 Bl 3	Flanders	973-927-7315		NTA
Immortal Ink	9-15 Central Ave.	Flemington	908-284-9401	www.immortalink.com	APT
Studio 9 Tattoo	399 Rte. 9 N.	Freehold	732-780-4800	www.studio9tattoos.com	APT
Body Art Tattoo II	2 W. Evesham Road	Glendora	856-939-TATS or 856-939-8287		
Ink Spot West	60 Rte. 22 W.	Greenbrook	908-752-4022		NTA
Ground Zero Studios	334 Belmont Ave.	Haledon	973-904-3030		
Pleasurable Piercings	417 Lafayette Ave.	Hawthorne	973-238-0305	www.pleasurable.com	APP
Silk City Tattoo	7 Garfield Ave.	Hawthorne	973-238-9167		
Blood Sweat & Ink	2958 Rte. 9 S.	Howell	732-901-5200		
Modern Electric	By appointment only	Jersey City	201-333-5443	www.chicksdigtattoos.com	
Butch's Tattoo Studio	5 E. Front Street	Keyport	201-203-0269		APT
Taboo Tattoos	242 Broad Street	Keyport	732-739-9852		
Eternal Image Tattooing Studio	629 Main Street, Unit 7	Lanoka Harbor	609-971-8282		APT
Blackwork Tattoos	69B Rte. 23 S.	Little Falls	973-812-9500	www.blackworktattoos.com	APT
Body Art World II	555 Broadway	Long Branch	732-222-9740	www.bodytattoos.com	APT

Name	Address	City	Phone	Website	
Fusion of Styles Tattooing & Piercing	113 Malaga Park Dr. U.S. Hwy. 40 & State Hwy. 47	Malaga	609-694-3699	www.fusionofstylestattoo.com	APT, NTA
Evolution Tattoo Studio	570 Bridgton Pike S1	Mantua	856-415-7555		
Powerhouse Tattoo	545 Bloomfield Ave.	Montclair	973-744-8788	www.powerhousetatto.com	NTA
Powerhouse Tattoo	545 Bloomfield Ave.	Montclair	973-744-8788	www.powerhousetattoo.com	APT
Sinister Ink II	43-B Easton Ave.	New Brunswick	732-247-8666		
Shotsies Tattoo II	2915 Rte. 23 S.	Newfoundland/West Milford	973-697-0032	www.shotsiestattoo.com	APT, NTA
Starlight Tattoo	167 Union Ave.	Paterson	973-389-0100	www.starlighttattoo.com	
Bingo's Custom Body Art	2100 Haddonfield Road	Pennsauken	609-662-2557		NTA
Body Graphic Tattoo Studios	5303 Rte. 70 W.	Pennsauken	609-662-4747	www.bodygraphics.com	APT, NTA
Lucky 13 Boy Shop	42 Leigh Ave.	Princeton	609-430-8282		
Body Art World III	406 Richmond Ave.	Pt. Pleasant Beach	732-892-9776	www.bodytattoos.com	APT
Rebel Image Tattooing	1071 Rte. 47 S.	Rio Grande	609-889-2422		APT, NTA
Starlight Tattoo	215 Rte. 17 S.	Rochelle Park	201-556-1478	www.starlighttattoo.com	
Body Art World IV	613 Boulevard	Seaside Heights	732-830-2685	www.bodytattoos.com	APT
Underground Tattooing	1248 Paterson Plank Road	Secaucus	201-866-5544		
Eternal Image Tattoo Studio	2709 Long Beach Blvd.	Ship Bottom	609-361-8380		APT
Body Art Tattoo I	205 S. White Horse Pike	Stratford	856-7-TATTOO or 856-782-8866		
Body Art World V	2918 Rte. 37 E.	Toms River	732-270-3295	www.bodytattoos.com	APT
Dark Star Tattoos	1830 Rte. 9 S.	Toms River	732-240-0550	www.darkstartattoos.com	APT
Gina's Tattoo Connection	918 Rte. 37 E	Toms River	732-929-9805		NTA
Lucky's Tattoo	406 37th Street	Union City	201-617-4545		
Eternal Etchings Body Art Studio	1705 Bayshore Road	Villas	609-886-6488	www.eternaletchings.com	APT
Custom Tattoo	700 Somerset Street	Watchung	908-561-0505	www.snookiescustomtattoo.com	APT
Shotsies Tattoo	1275 Rte. 23 S.	Wayne	973-633-1411	www.shotsiestattoo.com	APT, NTA
Eagle Tattooing	1600a Union Valley Road	West Milford	973-728-3260		
Headlight Tattoo	1086 N. Delsea Dr.	Westville	856-848-8223	www.headlighttattoo.com	APT

New Mexico

Name	Address	City	Phone	Website	
Route 66 Tattoo	5511 Central Ave. N.E.	Albuqerque	505-255-3784	www.route66tattoo.com	NTA
Route 66 Tattoo	3409 Central Ave. N.E.	Albuqerque	505-255-3784	www.route66tattoo.com	NTA
Addictive Ink	6904 Central Ave.	Albuquerque	505-268-5006		NTA

Name	Address	City	Phone	Code
Evolution	4517 Central Ave. N.E.	Albuquerque	505-255-4567	APP
Independent Ink Tattoos & Body Modifications	111 7th Street N.W.	Albuquerque	505-842-8239	
Star Tattoo	10200 Corrales N.W., Suite E4	Albuquerque	505-922-6217	APP
Tinta Cantina Tattoo	3902 Central Ave. S.E.	Albuquerque	505-265-9606	
Eternal Tattoo	1406 Forrest Dr. #22	Carlsbad	505-628-8863	
Got Ink? Tattoo & Body Piercing	1724 S. Canal	Carlsbad	505-887-TAT2	
Sawbones' Fallen Angel Tattoo	201 Riverside Dr.	Espanola	505-753-7566	
Aware	1430 Cerrillos Road	Santa Fe	505-986-0013	APP

New York

Name	Address	City	Phone	Code
Lark Street Tattoo	274 Lark Street	Albany	518-432-1905	NTA
Body Designs	137 Sunrise Hwy.	Amityville	631-842-9777	
Fat Cat Designs	28 09 Ditmars Blvd.	Astoria	718-267-1326	
Studio Enigma Tattoo	25-63 Steinway Street	Astoria	718-777-8141	
Dream Weaver Tattooz & Body Piercing	12 South Street	Auburn	315-258-TATU	
Avon Tattooing Studio	257 E. Main Street	Avon	585-226-3860	NTA
Artistic Creations	256 Milton Ave.	Ballston Spa	518-885-0636	APT
Body Designs	1746 Sunrise Hwy.	Bay Shore	631-968-0141	
Murder Ink	25-65 Francis Lewis Blvd.	Bayside	718-352-7312	
Zahra's Studio Tattoo and Gallery	496 Main Street	Beacon	845-838-6311	APT
Lonewolf Tattoo	211 Bedford Ave.	Bellmore	516-221-9085	
Matts Tribal Dragon Tattoo	4074 Hempstead Turnpike	Bethpage	516-735-1614	NTA
Colortech	1139 Front Street	Binghamton	607-771-8672	APT, NTA
Colortech Tattooing	1139 Upper Front Street	Binghamton	607-771-8672	
Artful Ink Tattoo Studio	1112 Smithtown Ave.	Bohemia	631-589-7399	NTA
Tattoo Lou's	4764 Sunrise Hwy.	Bohemia	631-563-8822	
Dark Child Tattoo	1224 Suffolk Ave.	Brentwood	631-952-1928	
Champion Tattooing	5606 Broadway	Bronx	718-549-8253	
Deno's Tattoo & Body Piercing	552 Melrose Ave. 2855 3rd Ave.	Bronx	718-882-1046	
Inkzone Tattooz	1353 White Plains Road	Bronx	718-823-7406	
Studio Enigma Tattoo	236 W. 231st Street	Bronx	718-239-2470	

www.evolutionpiercing.com
www.startattoo.com
www.awarebodyart.com
www.studioenigma.com
www.artisticcreationz.com
www.mattstribaldragontattoo.com
www.colortechtattoo.com
www.studioenigma.com

Name	Address	City	Phone	Website	Code
Brooklyn Hardcore Tattoos	712 Broadway	Brooklyn	718-218-8035		
Cari Ann Creations	1901 Emmons Ave.	Brooklyn	718-368-2786		
Divine Ink Tattooing & Body Piercing	1871 Flatbush	Brooklyn	718-677-0950		
Fly Rite	500a Metropolitan Ave.	Brooklyn	718-599-9443		APT
Forbidden Art Tattoo Studio	7606 18th Ave.	Brooklyn	718-234-6300		
Gallery 33	82 Havemeyer #2	Brooklyn	917-374-3330		
Studio Enigma Tattoo	70 Ave. "U"	Brooklyn	718-266-6612	www.studioenigma.com	
Studio Enigma Tattoo	1767 Union Street	Brooklyn	718-773-1415	www.studioenigma.com	
Shanghai Kate's Tattoo	1162 Hertel Ave.	Buffalo	716-876-6200		NTA
Renaissance Tattoo	3223 Main Street	Buffalo	716-831-0588		
Lady Luck Tattoo	211 S. Main Street	Canandaigua	716-394-1980		
Mackenzie's Forever Ink	5 Seminary Hill Road	Carmel	845-225-4147		APT, NTA
Flying Eagles Tatooing	468 Main Street	Catskil	518-943-5246		
Cliff's Tattoo	1446 Middle Country Road	Centereach	531-732-1957	www.cliffstattoos.org	APT
Skin Funk Tattoo	8140 Brewerton Road (Rte. 11)	Cicero	315-698 0088	www.skinfunk.com	APT
Cork's Dermagraphics	#1 Cole Road N.	Clymer	716-355-6621		
Dramatic Pawz Tattoos	2 S. Grand Street	Cobleskill	518-234-0253		
Alternativxpressions	122-05 15th Ave.	College Point	718-661-9396		
Distinctive Image Tattoo Studio	180 S. Main Street	Cortland	507-758-1183		
Tattoos Forever	26304 Rte. 11	Evans Mills	315-629-0311	www.tattoos-forever.com	
Uprize Ink	21 E. Main Street	Fredonia	716-679-4465 (4INK)		
Vajra Body-Arts	45 Temple Street	Fredonia	716-672-8955		
Extreme Graphix	43 Main Street	Genesee	585-243-9270		
Drew's Tattoo Studio	112 Bertrand Road	Gloversville	518-661-5896		NTA
City Lights Tattoo Studio	2566 Rte. 17M	Goshen	845-294-6484		NTA
Sacred Angel Tattoo	273 N. Main Street	Herkimer	315-717-0078	www.sacredeagletattoos.net	APT
Body Designs	4 Jerusalem Ave.	Hicksville	516-932-5797		
New View Tattoo	743 Rte. 9W	Highland	845-691-TAT2		
Peter Tat-2	Main Street	Hillsdale	518-325-4667		NTA
Sacred Art	6 Wall Street	Homer	607-749-4872		
Lasting Impressions	1027 Rte. #82	Hopewell	845-227-7040		
Tattoo Lou's	248e Rte. 25	Huntington	631-425-0444		
Cliff's Tattoo	394 New York Ave.	Huntington Village	631-425-1556	www.cliffstattoos.org	APT
Studio 69 Tattoo	2311 Union Blvd.	Islip	631-277-9181		

Name	Address	City	Phone	Notes	Website
Sfumato Tattoo	312 E. Seneca Street	Ithaca	607-216-0406		
Omegatattoos	81-09 Roosevelt Ave., 2nd floor	Jackson Heights	718-397-8723		
Tattoo Spot	89-10 Roosevelt Ave., 2nd floor	Jackson Heights	718-505-3296		
Murda Ink Tattoos	168-30 Jamaica Ave., 2nd floor.	Jamaica	718-298-6800		
Almighty Studios	320 Cherry Street	Jamestown	716-487-1243		
Tormented Souls	54 Main Street	Kings Park	631-269-6137		
Pat's Tats	948 Rte. 28W	Kingston	845-338-TAT2	NTA	www.patstats.com
Art & Soul Tattoo Parlor	30 Central Ave.	Lancaster	716-651-0254		
Impulse Tattoo	644 Loudon Road	Latham	518-783-8282	NTA	
Tattoo Depot	209 Oswego Street	Liverpool	315-457-6220		
Drew's Tattoo Studio	112 Bradt Road	Mayfield	518-661-5896		
Class Act Tattoo Studio	263 E. Main Street	Middletown	845-343-2471		
Euphoric Body Art Tattoo & Piercing	741 Rte. 211 E.	Middletown	845-692-5140		
Paris Rain Designs	Stockbridge Falls Road	Munnsville	315-495-6736		
Modern Age Tattoos	183 Main Street	Nanuet	845-627-1086	NTA	
Express Yourself Tattoo	2 S. Chest Street	New Paltz	845-256-9658		
Aces High Tattoo	61 Quassaick Ave.	New Windsor	845-561-8380		
Skin City Tattoo	412 Windsor Hwy.	New Windsor	845-565-7252	APT	www.fetafrommynuts.com
334 Bowery Tattoo	334 Bowery	New York City	212-253-7899		
Big Joe's Tattoo	27 Mount Vernon	New York City	212-768-4422		
Caliente's Tattoos	559 W. 207th Street	New York City	212-942-2238		
Canal Street Tattoo	365 Canal Street	New York City	212-274-8006		
Daredevil Studios	174 Ludlow Street	New York City	212-533-8303		
Fineline Tattoo	21 1st Ave.	New York City	212-673-5154		www.finelinetattoo.com
Fun City Tattoo	94 St. Marks Place	New York City	212-353-8282		www.funcitytattoo.com
Last Rites Tattoo	215 East 4th Street	New York City	212-529-0666	NTA	www.darkimages.com
NY Hardcore Tattoos	127 Stanton Street	New York City	212-979-0350		
Rising Dragon Tattoo	230 West 23rd. Street	New York City	212-255-TATU	NTA	www.risingdragon.com
Sacred Tattoo	276 Canal Street	New York City	212-226-4286		
Studio Enigma Tattoo	115 St. Marks Place	New York City	212-598-0538		www.studioenigma.com
Body Designs	227 Merrick Road	Oceanside	516-255-0471		
Inedible Ink	147 Main Street	Oneonta	606-432-6854	APT	
Screamin' Demon Ink	77 E. 2nd Street	Oswego	315-343-6830	APT	www.oswegotattoo.com

Name	Address	City	Phone	Website	NTA
Pete & Cubo's Tattooing & Body Piercing	88-09 101st Ave., 2nd Floor	Ozone Park	718-323-2111		
Cliff's Tattoo	288 E. Main Street	Patchogue	447-2253	www.cliffstattoos.org	APT
Body Piercing & Tatooing By Vincent & Co.	39 Clinton Street	Plattsburgh	518-562-5825		
Feel the Steel Tattoo & Piercing	6 Market Street	Potsdam	315-265-1900		
Thunder Express Tattoo	309 South Ave., Suite C	Poughkeepsie	845-473-0515		
Angelina's Image City Tattoo & Piercing	976 Monroe Ave.	Rochester	716-262-6219		
Butch Comer	By appointment only	Rochester	585-330-5299	www.butchcome.com	
Grinder Tattoo	2933 W. Henrietta Road	Rochester	585-424-1430		
Junkbot	976 Monroe Ave.	Rochester	585-262-6219		
Love Hate Tattoo	217 1/2 Alexander Street	Rochester	585-262-6440		
Lucky Lotus Tattoo	633 Monroe Ave.	Rochester	585-271-5880		
Physical Graffiti	583 E. Main	Rochester	585-262-4444	www.physicalgraffiti.com	NTA
White Tiger Tattoo	466 Ridge Road	Rochester	585-621-4460	www.whitetigertattoo.com	APT, NTA
Cliff's Tattoo	678 Rte. 25a	Rocky Point	631-821-1959	www.cliffstattoos.org	APT
Ink Alternative Professional Tattooing & Body Piercing	2 Warren Ave.	Ronkorkoma	631-698-3656		
Spirit Art Tattoos	17532 County Rte. 75	Sackets Harbor	315-646-2789		
Hippy's Custom Tattoo	5844 Buffalo Street	Sanborn	716-731-3165		NTA
Feel the Steel Too	84 Market Street	Saranac Lake	518-891-5117		
Marky Mark's Tattoo Works	262 Main Street	Saugerties	845-246-0100		
Lotus Tattoo	291 W. Main Street	Sayville	631-244-8288	www.lotustattoo.com	
E-Z Tattoo	1035 Helderberg Ave.	Schenectady	518-372-6254		
Tattoo Lou's	262 Rte. 25	Seldon	516-732-9585	www.tattoolous.com	
Bob's Crystal Blue Tatoo	921 Montauk Hwy.	Shirley	631-395-0393		
Hickory Street Tattoo Studio	274 Central Ave.	Silver Creek	716-934-0052		
NY Inkslinger	20 Conference Ct.	Staten Island	718-781-8655		
Ron & Dave's Tattooing	603 Manor Road	Staten Island	718-982-0100		NTA
Omegatattoos II	42-16 Greepoint Ave.	Sunnyside	718-729-9801		
Electric Circus Tattoo Shop	2828 Lemoyne Ave.	Syracuse	315-454-9370		
Halo Tattoos	171 Marshall Street	Syracuse	315-472-0854		
Bruce Bart Tattooing	Main Street	Tannersville	518-589-5069		NTA

American Skin Art by Dead Ed	16 Webster Street N.	Tonawanda	716-694-9185		
Eternal Images Tattoo	644 Varick Street	Utica	315-798-9386		
Jones Custom	2539 Vestal Pkwy. E.	Vestal	607-798-0264	www.jonescustom.com	APP
Rite of Passage Tattoo	260 W.Main Street	Victor	585-742-2280		
Peter Tat-2 Studio	223 Hempstead Turnpike	W. Hempstead	516-292-8622		NTA
Tattoo Lou's	579 Sunrise Hwy.	W. Babylon	631-752-3622		
Look Sharp Tattoo	3 Main Street	Walden	845-778-5340		
Da Vinci Tattoo	3253 Sunrise Hwy.	Wantagh	516-781-5030		NTA
Extreme Ink Tattoos	255 Martin Luther King Blvd.	White Plains	914-682-7060		
Big Joe & Sons Tattooing	2150 Central Pk. Ave.	Yonkers	914-337-1600		
Hard Knox Tattoo	885d Kimball Ave.	Yonkers	914-803-0387		
Scorpion Images Skin Art	12241 Olean Road	Yorkshire	716-496-2037		NTA
Apocalypse Tattoo	619 Oriskany Blvd.	Yorkville	315-768-2482		NTA

North Carolina

Straight A Tattoo	Church Street	Asheboro	336-328-0579		
Empire Tattooing	83 Tatton Ave.	Asheville	828-252-8282		
Mans Ruin Tattoo & Piercing	857 Merrimon Ave.	Asheville	828-253-6660		
Pitbull Piercing & Tattoo	103 Broadway	Asheville	828-252-1991		
Glenn's Tattoo Service	110 W. Main Street, Suite A	Carrboro	919-933-TATU		
Tattoo Zoo Inc.	598 E. Chatham Street # 139	Cary	919-469-0770	www.kevinstattoozoo.com	NTA
Cosmic Tattoos	3927 Monroe Road	Charlotte	704-334-2707		
Fu's Custom Tattoos	901-D N. Tryon Street	Charlotte	704-376-4556	www.fustattoos.com	APT
The Ink Lounge	919 Central Ave.	Charlotte	704-332-9228		
Indian Ink Tattoo	Hwy. 19 N.	Cherokee	828-497-4723		
Krazy Kat Tattoo	10382 U.S. 70 W.	Clayton	919-553-0573		
Fatty's Tattooin'	2826 Old Cullowhee Road	Cullowhee	828-293-0834		
Redskull Tattoos	2829 Old Cullowhee Road	Cullowhee	828-293-2300		
Dogstar Tattoo Co.	730 Ninth Street	Durham	919-286-5443		
Tattoo Asylum & Body Piercing	4422 N. Roxboro Street	Durham	919-479-5058		
Dreamcatchers Tattoo	911 W. Ehringhaus Street	Elizabeth City	252-335-9696		
Wolf's Den Tattoo	305 S. Hughes Blvd.	Elizabeth City	252-335-5190	www.wolfsdentattoo.com	APT
Bill Claydon's Tattoo World	5955 Yadkin Road	Fayetteville	910-867-9792		NTA

Name	Address	City	Phone	Website	Code
Chop Shop Tattoo & Body Piercing	2945 Hope Mills Road, Suite 108	Fayetteville	910-426-INKS		NTA
Custom Skin Fantasies	4945 Bragg Blvd.	Fayetteville	910-487-6611		
Fallen Studios	2580 Gotts Lane	Fayetteville	910-424-1372		NTA
Smoking Guns Tattooing	6109 Yadkin Road # B	Fayetteville	910-864-8282		
Little John's Tattoo	1225 W. Lee Street	Greensboro	336-275-7161	www.littlejohnstattoo.com	APT, NTA
Kingpin	836 W. Lee Street	Greensboro	336-272-2725	www.earthsedgetattoo.com	APT
Garry's Skin Grafix Tattoo	4685 Hwy. 13 S.	Greenville	252-756-0600	www.skingrafix.com	NTA
Imagination's Unlimited	700 Ray Ave., Suite A	Hendersonville	800-935-8288		
Groovytoos	2129 North Center Street	Hickory	828-326-9737		
Tattoo Hugh	127 Main Street	Hudson	828-728-7715		
Skin Art Tattoo Studio	2101 Lejeune Blvd.	Jacksonville	910-577-0533		NTA
Skin Art Tattoo Studios 2	331 Western Blvd., Suite B	Jacksonville	910-577-1366		NTA
Earth's Edge Too	220 Century Blvd.	Kernersville	336-993-9996	www.earthsedgetattoo.com	APT
Lounge Lizard Tattoos	5625-A Randleman Road	Level Cross	336-676-1606		
Planet X Tattoos	18 Talbert Blvd.	Lexington	336-243-4208		
Vertigo Tattoo & Body Piercing	7594 Shipyard Road.	Manns Harbor	252-475-3541	www.vertigotattoonc.com	APT
Heart & Soul Tattoo	903 E. Union Street	Morganton	828-433-5311		
High Energy Tattoo	7237 Beach Dr. S.W.	Ocean Isle	910-575-8288	www.highenergytattoos.com	APT
Blue Flame Tattoo	3015 Hillsborough Street	Raleigh	919-755-3355		
Warlocks Tattoo Inc.	5535 Western Blvd., Suite 104	Raleigh	919-233-9253	www.warlocks-tattoo.com	APP, NTA
Warlock's Southern Dragon	1924 Stone Rose Dr.	Rocky Mount	919-977-3983		APT
Southern Soul	6673 University Pkwy.	Rural Hall	336-377-3510		
Krazy Kat Tattoo	902 S. Pollock Street	Selma	919-975-0125		
Four Kingz Tattoo Shop	515 Industrial Park Dr.	Smithfield	919-938-4233		
Urban Tactics	1525 Salisbury Hwy.	Statesville	704-872-4424		
Too The Point Tattoo & Piercing Studio	70 White's Crossing Plaza	Whiteville	910-640-1720		
Backwoods Tattoo	5146 McConnell Road	Whitsett	336-697-8201		
Marks Of Distinction	5741A Oleander Dr.	Wilmington	910-392-1123		NTA
Port City Tattoo Co.	1305 S. College Road	Wilmington	910-793-0102		NTA
Earth's Edge	1800 Silas Creek Pkwy.	Winston Salem	336-727-1663	www.earthsedgetattoo.com	
Custom Touch Tattoo	2453 W. Clemmonsville Road	Winston Salem	336-659-1557		NTA

North Dakota

Business	Address	City	Phone	Notes
Derma Design	2700 State Street, Gateway Mall	Bismarck	701-250-8899	www.dermadesign.freeservers.com APT, NTA
Prairie Wynde Tattoo Studios	207 First Street	Ypsilanti	701-489-3539	

Ohio

Business	Address	City	Phone	Notes
Dino's State of the Art Tattooing	929 N. Main Street	Akron	330-726-2333	
Larox Inc. Tattoos & Piercing	138 S. Arlington Street	Akron	330-434-0077	
Tattoos By Sheila	1563 Massillon Road	Akron	330-784-6359	NTA
White Tiger Tattoos	1082 Brown Street	Akron	330-773-7232	NTA
Bad Boy Tattoo & Body Piercing	2371 W. State Street, Suite D	Alliance	330-829-0431	
Mainstreet Tattoos	900 E. Main Street	Ashland	419-207-1178	
Body Art by Gene	148 Columbus Ave.	Bellefontaine	937-599-2711	
Skin Flix Tattooz	2149 Pearl Road	Brunswick	330-220-9511	
Think It Tattoos	1435 Pearl Road	Brunswick	330-273-5250	
Dave's Designs	2615 Rick Road	Cambridge	740-439-3095	
Hammers Tattoo & Body Piercing	3840 Lincoln Street E.	Canton	330-478-1070	NTA
Professional Tattoo & Body Piercing	2707 Fulton Dr. N.W.	Canton	330-452-8044	APT
Ink Incorporated Tattoos & Piercing	3846 Montgomery Road	Cincinnati	513-924-9241	
Lines Unlimited	123 East Galbraith Road	Cincinnati	513-821-5463	
Designs by Dana Inc.	4167 Hamilton Ave.	Cincinnati	513-681-8871	NTA
Body Work Productions	2710 Detroit Ave.	Cleveland	216-623-0744	www.bodyworkprod.com APP
C T & M Tattooing	7552 Pearl Road	Cleveland	440-243-4740	
Dynamic Tattoos & Body Piercing	15225 Lucknow Ave.	Cleveland	216-387-3847	
True Art Tattoos	10230 Joan Street	Cleveland	216-548-7107	
Wicked Tattoos	12222 Lorain Road	Cleveland	216-941-5702	
252 Tattoo	24525 Sprague Road	Columbia Station	440-235-6699	
All City Tattoo	1226 Parsons Ave.	Columbus	614-444-TATS	NTA
Body Art	1878 Tamarack Circle	Columbus	614-848-8220	
Body Language Productions	1101 S. Hamilton Road	Columbus	614-235-9211	www.bodylanguagetattoo.com
Bodystain Tattoo	4410 Cleveland Ave.	Columbus	614-475-1090	

Business	Address	City	Phone	Website	Notes
Evolved	1906 N. High Street	Columbus	614-291-1505	www.evolvedbodyart.com	APP
Fate Tattoo	2202 N. High Street	Columbus	614-299-9930		
Gods & Monsters Productions	1255 N. High Street	Columbus	614-638-4866		
Inspired By Ink	2413 N. High Street	Columbus	614-447-9200		
Koolmetro	2603 Indianola Ave.	Columbus	614-265-8287		
Piercology	872 N. High Street	Columbus	614-297-4743	www.piercology.com	APP
Stained Skin	1255 N. High Street	Columbus	614-297-SKIN		
Viking Studio	1906 N. High Street	Columbus	614-291-1505		
Kustom Kulture	12660 Cleveland Road	Creston	330-242-0417		APT, NTA
East Dayton Tattoo	2700 E. Third Street	Dayton	937-258-3232	www.eastdaytontattoo.com	
Glenn Scott Tattoos	3047 N. Main Street	Dayton	937-276-3061		
Tattoo Tech	5350 Springboro Pike	Dayton	937-298-1966		
Ultimate Tattoo Studio	202 East Second Street.	Defiance	419-782-8946		
Liquid Skin Tattoo	36520 Valley Vista Dr.	Eastlake	888-851-6214	www.liquidskitattoos.com	
Black Star Tattoo	306 N. Barron Street	Eaton	937-472-4131		
Chronic Tattoo	358 Cleveland Street	Elyria	440-323-9656		
Elyria Tattoo	500 Cleveland Street	Elyria	440-365-1979		NTA
Concepts by Chorba—Tattoos	3065 S. Main Street	Findlay	419-427-0800		
Fostoria Tattoo Works	133 E. Center Street	Fostoria	419-436-9107		
Living Color Studio	415 W. State Street	Fremont	419-332-8889		NTA
Temple Tattoo & Body Piercing	250 2nd Ave.	Gallipolis	740-441-8287		
Dragon's Lair Tattoo	120 W. Liberty Street	Girard	330-545-6566		NTA
Roo's Tattoos	118 W. Columbus Street	Kenton	419-673-5248		
Silver Creek Tattoo	737 Bank Street	Lodi	330-948-8511		
Mild To Wild Custom Tattooz	1662 Broadway Ave.	Lorain	440-245-6969		
Hot Rod Tattooing	106 S. 4th Street	Martins Ferry	740-633-1774		NTA
Roy's Art Studio	123 W. Main Street	Mason	513-398-8340		
Art in Motion	415 S. Broadway	Medina	330-725-8282		
Customeyes Ink	6312 Center Street #D	Mentor	440-974-7966		NTA
Inkhouse Tattoo	240 E. Canal Street	Newcomerstown	740-498-5982	www.inkhousetattoo.com	APT
Metal Fix	303 Clark Street	Newcomerstown	740-435-8800	www.inkhousetattoo.com	APT
Stained Skin Second Skin	1022 Mount Vernon Road	Newark	740-366-SKIN		
Medicine Man Tattoos	36020 Center Ridge Road	North Ridgeville	440-327-0880	www.medicinemantats.com	APT
252 Tattoo	51B S. Main	Oberlin	440-776-0095		

Name	Address	City	Phone	Website	
Sharp Images	116 N. Main Street	Orrville	330-683-4658		
Ink It Tattoos	337 E. Main Street #4	Russells Point	937-842-9700		
Pain & Pleasure Tattoo Studio	220 W. Perkins Ave. # 1	Sandusky	419-627-0069		NTA
Crazyhorse Tattoo & Body Piercing Studio	110 Tri-County Hwy.	Sardinia	937-446-1840		
Thin Lizzy's Tattoo & Body Piercing	11 N. Belmont Ave.	Springfield	937-322-9102		
Apocalypse Now	151 N. Michigan Street, Suite 225	Toledo	419-243-5886		
Forbidden Tattoo	2124 Broadway	Toledo	419-245-9811		
Infinite Art Tattoo	3930 Secor Road	Toledo	419-292-1990		
Innovative Ink	312 Main Street.	Toledo	419-690-1004		
Needle Masters Tattoo Studios	535 S. Reynolds Road	Toledo	419-531-4652		APT
Needle Masters Tattoo Studios	5801 Telegraph Road, Suite 6	Toledo	419-476-9015		APT
Otto's Custom Tattooing	811 Starr Ave.	Toledo	419-655-3029		
Pain Divine Tattoo & Gallery	5225 Hill Ave.	Toledo	419-578-9969		
Toledo Tattoo Co Inc	2068 Airport Hwy.	Toledo	419-382-8805		NTA
Thrill Vulture Studio	16 W. College Ave.	Westerville	614-890-6424		APT
Finest Lines Tattoo Studio	28935 Euclid Ave.	Wickliffe	440-943-4008		
G&G Tattoo & Body Piercing	4130 Erie Street	Willoughby	440-942-3567		NTA
Moving Pictures Tattoo Studio	321 E. Liberty Street	Wooster	330-264-8282	www.movingpicturesstudio.com	APT NTA
Art of the Skin	67 W. Second St.	Xenia	937-376-3930		
Lenz's Artistic Dermagraphics	8384 Market St	Youngstown	330-726-6677		NTA
Straightline Tattoo	2209 1/2 Mahoning Ave.	Youngstown	330-799-2208		
Ink Express	1256 Linden Ave.	Zanesville	740-454-9003		

Oklahoma

Name	Address	City	Phone	Website	
Creative Images	By appointment only	Duncan	405-573-9774		NTA
23rd Street Body Piercing	411 N.W. 23rd Street	Oklahoma City	405-524-6824	www.23rdstreetbodypiercing.com	APP
Body Piercing by Nicole Inc.	2727 E. 15th Street	Tulsa	918-712-1122		APP

Oregon

Name	Address	City	Phone	Website	
Galaxy Ink Tattoos	532 N. Main	Ashland	541-201-0438		
Nomad Body Piercing	616 N.W. Arizona	Bend	541-617-8845	www.nomadmuseum.com	APP

Name	Address	City	Phone	Notes
Graveyard Tattoos	9235 S.E. Clackamas Road	Clackamas	503-655-0200	APP
High Priestess	675 Lincoln Road	Eugene	541-342-6586	NTA
Studio Tattoo	1011 W. 6th Ave.	Eugene	541-345-8282	APT, NTA
Tattoo by Design	671 Lincoln Street	Eugene	541-485-5520	
Touch of Taboo	1699 W. 11th	Eugene	541-302-3173	MINTER
Black Market Beauty		Garden Home		
Ink Spot Tattoo & Body Piercing	15 3rd Street	Hood River	541-806-2292	
Custom Body Art	1039 Court Street	Medford	541-857-9866	APT
Graveyard Tattoos	10510 S.E. 42nd Ave.	Milwaukie	503-353-6674	
In Your Face Tattoos	10616 S.E. McLoughlin Blvd.	Milwaukie	503-652-3967	
Tempus Fugit Tattoo	10510 S.E. 42nd Ave.	Milwaukie	503-788-5101	
Wild Lines Tattoo	715 E. Hancock Street	Newberg	503-554-9534	APP
Adorn Body Art	9217 S.W. Bvtn-Hills Hwy.	Portland	503-292-7060	NTA
Deluxe Tattoo Parlor	8333 S.E. Powell Blvd.	Portland	503-774-8477	NTA
Dermigraphics	1017 S.W. Morrison Street #205	Portland	503-224-8416	APT
Infinity Tattoo	7409 N. Knowles Ave.	Portland	503-231-4777	www.infinitytattoo.com APT, NTA
Lady Luck Tattoo & Body Piercing	826 S.E. Belmont Street	Portland	503-236-2833	www.ladylucktattoo.net APT, NTA
Sea Tramp Tattoo Co.	207 S.E. Grand Ave.	Portland	503-231-9784	
Primal Visions	803 S.E. Stephens Street	Roseburg	541-677-9879	
Addictions Body Piercing & Tattoo	176 Liberty Street S.	Salem	503-588-6688	
All American Tattoo	1748 Center Street N.E.	Salem	503-365-8866	
Capitol City Piercing	956 S.E. Commercial Street	Salem	503-566-6727	

Pennsylvania

Name	Address	City	Phone	Notes
Static Ink Tattoo	1118 Indian Mt. Lakes	Albrightsville	570-646-6142	
Al's Gotham City Tattoo	924 W. Walnut Street	Allentown	610-776-0902	
Keystone Tattoo	820 7th Ave., 2nd Floor	Altoona	814-940-5353	
Gargoyle Productions	508 S. Elmira Street	Athens	570-882-1159	
Body Enhancement	106 W. Bishop Street	Bellefonte	814-357-6940	
Mean Street Tattoos	2272 Street Road	Bensalem	215-633-8040	
Skin Designs	217 E. 1st Street	Birdsboro	610-582-4340	NTA
Hero Tattooing	440 N. Duffy Road	Butler	724-283-4531	www.angelfire.com/biz2/tattroom APT, NTA

Business	Address	City	Phone	Website	Code
Mickys Tattoo Studio II	828 New Castle Road	Butler	724-865-2438		
Independent Tattoo Studio	16 W. Pike Street	Canonsburg	724-743-0585		
Animal's Tattoo Emporium	3338 E. Main Street	Carnegie	412-279-2123		
Elite Tattoo	1232 Lincoln Way E.	Chambersburg	800-690-0790	www.elitetattoo.com	APT
Tiny Tim's Boulevard Tattoo	55 Macdade Blvd.	Collingdale	610-583-3534		
Midnite Rider Tattoos	501 Locust Street	Columbia	717-684-0765		NTA
Marc's Tattooing	749 Siniawa Plaza II, Rte 6. Scranton/Carbondale Hwy.	Dickson City	570-344-4744	www.marcstattooing.com	
Tainted Flesh Tattoo Studio	32 S. Brady Street	Dubois	814-375-5570		
Hardcore Tattoo	Suite 15 Village Center	Easton	570-223-1059		NTA
Pleasure & Pain	450 Northampton Street	Easton	610-252-7316		NTA
Angelgate Tattoo	4007 Main Street	Erie	814-897-1452		
Bay City Tattoo & Piercing	759 E. 12th Street	Erie	814-456-7260		
Buddha Tattoo	2757 W. 12th Street	Erie	814-833-0439		NTA
Lil' Nikki's Sinful Art	4307 Buffalo Road	Erie	814-898-2104		
Main Line Tattooing	491 Lancaster Ave.	Frasier	610-889-3345		
Chrome Gardens	147 York Street	Gettysburg	717-337-3725		
Mercury Tattoo	2278 Mt. Carmel Ave.	Glenside	215-517-8833		
Animus Tattoo & Body Piercing	36 W. Second Street	Greensburg	724-836-6233		
Naughty Vibrations Tattooing Inc.	628 S. Main Street	Greensburg	724-600-0962	www.naughtyvibrations.com	APT
Expressions	901 York Street	Hanover	717-630-9564		
Marc's Tattoo Hazleton	32 E. Broad Street	Hazleton	570-454-INKD	www.marcstattooing.com	
Mystical Tattoo Emporium	30 Pierce Street	Kingston	570-714-4163		
Stormi Skin Steel F/X	226 Wyoming Ave.	Kingston	717-288-2595		APP
Willow Street Tattoos	2819 E. Willow Street	Lancaster	717-464-7173		
Hot Spot Tattooing	2303 Ligonier Street	Latrobe	724-532-2419		NTA
Tattoos by Mr. Jim	131 N. First Street	Lehighton	610-377-3292		
Permanent Impressions Inc.	123 S. 3rd Street	Lemoyne	717-731-5411		
Jaybirds Tattoo Studio	7405 Rte. 13	Levittown	215-943-8282		NTA
Moonlite Tattoo	136 W. Market Street	Lewistown	717-242-6765		
Frost Tattoos	1 N. Main Street	Manheim	717-664-2877		
Wicked Ink Underground Tattoo & Body Piercing	122 W. Main Street	Mechanicsburg	717-766-7323		
Custom Fine Line Design	919 W. Main Street #A	Mount Joy	717-653-0864		NTA

Name	Address	City	Phone	Website	Codes
Mad Max Tattoos	215 Brownsville Road	Mt. Oliver	412-481-6250		
Checkered Past	316 Fourth Street, 2nd Floor	New Cumberland	717-774-7180	www.checkeredpastpiercing.com	APP
Skin Flix Tattoz Inc	1216 Main Street	Northampton	610-261-1570		NTA
Studio One Tattoo	234 Chester Pike	Norwood	610-586-4640	www.studio1tattoo.com	NTA
Tophats Tattoo Emporium	129 W. Main Street	Palmyra	717-838-7366		NTA
Gentle Joe's Tattooing	247 S. Belmont Road #A	Paradise	717-687-7909		NTA
World Famous Tattoos	1129 W. Market Street	Perkasie	215-453-0734		NTA
Body Graphics Tattoo Studio	627 S. 4th Street	Philadelphia	215-625-9777	www.bodygraphics.com	APT, NTA
Body Graphics Tattoo Studio	908 Arch Street	Philadelphia	215-922-1313	www.bodygraphics.com	APT, NTA
Dave's Artistic Tattoo	5 N. 63rd Street	Philadelphia	215-471-3113		NTA
Everlasting Art Tattoo	400 S. 43rd Street	Philadelphia	215-386-7720		NTA
Infinite	626 S. 4th Street	Philadelphia	215-923-7335	www.infinitebody.com	APP
Nokaoi Tiki Tattoo	610 S. 4th Street	Philadelphia	267-321-0357	www.nokaoitikitattoo.com	APT, NTA
Olde City Tattoo	44 S. 2nd Street	Philadelphia	215-627-6271		
Pop's Place Tattoos	7935 Frankford Ave.	Philadelphia	215-338-6270	www.popsplace.com	APT
Art & Soul Tattoos	420 Brownsville Road	Pittsburgh	412-481-1376		
Art Fx	9200 Old Perry Hwy.	Pittsburgh	412-364-5522		
Art Fx 2	8 S. Fremont Ave.	Pittsburgh	412-732-0500		
Art Fx 3	3410 Babcock Blvd.	Pittsburgh	412-630-4399		
Gunslingers Tattoo	921 W. Liberty Ave.	Pittsburgh	412-571-0871		
Hot Rod	115 Oakland Ave., 2nd Floor	Pittsburgh	412-687-4320	www.hotrodbodypiercing.com	APP
Inka Dinka Doo	3627 Butler Street	Pittsburgh	412-683-4320		
Jester's Court	812 Western Ave.	Pittsburgh	412-322-8828		NTA
Monster Tattoo	4514 Liberty Ave.	Pittsburgh	412-681-6881		NTA
Raven's Tattoo & Body Piercing	815 Brookline Blvd.	Pittsburgh	412-341-6135		
Tattoo You II	2130 E. Carson Street	Pittsburgh	412-432-2080		
Z Spot Body Art Studio	115 Meyran Ave.	Pittsburgh	412-321-2171	www.zspotstudio.com	APT
Mike's Tattoo & Body Piercing	1427 Lancaster Ave.	Reading	610-775-9676		
Inner Vision Body Art	112 S. Pike Road, Suite 100	Sarver	724-353-1700		
Exotic Body Arts	2019 Boulevard Ave.	Scranton	570-961-6034		
Marc's West Side Tattoo	118 S. Main Street	Scranton	570-343-1176	www.marcstattooing.com	
Totem Tattoo & Piercing	28 S. Susquehanna Trl.	Shamokin Dam	570-743-7830	www.totemtattoo.com	NTA
Totem Tattoo & Piercing	225 W. Beaver Ave.	State College	814-237-1355	www.totemtattoo.com	NTA
The Ink Well	851 Street Road	Southampton	215-953-9453		NTA

Name	Address	City	Phone	Website	Code
Shadow Ink	215 Brusselles Street	St. Marys	814-834-7457		
Ink Inc. Tattooing by Paul	110 Hetzel Street	State College	814-867-4474		
Dreamland Creations	506 Main Street	Stroudsburg	570-421-6313	www.dreamlandcreations.net	APT
Marc's Tattooing Stroudsburg	874 N. 9th Street (Rte. 611)	Stroudsburg	570-420-1442	www.marcstattooing.com	
Funhouse Tattooing	Rte. 611 Pocono Peddlers Village	Tannersville	570-620-2334		
Inside Out Tattoo Studio	107 S. Main Street	Taylor	570-562-4546	www.insideouttattoo.com	APT
Hot Shots Tattooing	3626 Lincoln Hwy.	Thorndale	610-466-9877		
Tattoos by Barbaro	113 McKinley Ave.	Vandergrift	412-610-7641		
Gunslingers Tattoo	150 Allison Hollow Road	Washington	724-745-7735		
C.C. Riders Rocking Tattoos	53 S. Potomac Street	Waynesboro	717-765-4857		
Nightwind Tattoo	33 1/2 Main Street	Wellsboro	570-724-6096	www.nightwindtattoo.com	APT
X-Treme Ink Tattoo & Body Piercing	149 W. Gay Street	West Chester	610-738-7666		
Marc's Tattoo Wilkes-Barre	Rte. 309	Wilkes-Barre	570-820-3465	www.marcstattooing.com	
Mystical Tattoo Emporium	320 S. Pennsylvania Blvd., Suite 311	Wilkes-Barre	570-825-1490		
Tribal Skars Tattoo	724 Wood Street	Wilkinsburg	412-731-5405		
Body Language Boutique	1114-1116 Graham Ave.	Windber	814-467-1649		
Built to Last Tattoo & Body Piercing	315 W. Market Street	York	717-846 1978	www.abuiltrolast.com	APT
Chaotikk Tattooing & Body Piercing	588 W. Market Street	York	717-699-0610		

Rhode Island

Name	Address	City	Phone	Code
Pascoag Tattoo	84 Harrisville Main Street	Pascoag	401-568-7620	NTA
Doors of Perception Tattoo	709 Quaker Lane Quaker Valley Mall	West Warwick	401-826-8282	
Renaissance Tattoo	285 Main Street	Woonsocket	401-769-3384	

South Carolina

Name	Address	City	Phone	Website	Code
Body Rites	2009 Greene Street, Suite 112	Columbia	803-799-2877	www.bodyrites.com	APP
Star Cloud's Tattooing	337-Cl Smith Road	Early Branch	843-726-4631		
Steelroots	417 Piedmont Ave.	Myrtle Beach	843-448-2654		
Body Piercing by Holly	1224 Bacons Bridge Road	Summerville	843-871-6646		APP

South Dakota

Business	Address	City	Phone	Website	Codes
Nosferatu Body Arts	312 N. Main Street	Mitchell	605 996-8811		
Black Hills Tattoo & Piercing Inc.	615 Riley Ave.	Rapid City	605 399-2929 or 800-318-3348	www.blackhillstattooandpiercing.com	APT, NTA
Thrash's Living Art	2050 W. Main	Rapid City	605-343-6372		

Tennessee

Business	Address	City	Phone	Website	Codes
Tye Dye Tattoo	908 Clinch Ave. Hwy. 25W.	Clinton	865-463-8475	www.tyedyetattoo.com	APT
Tye Dye Tattoo Inc.	827 Clinch Ave.	Clinton	865-463-8475		
Alley Cat Studio	715 E. Spring Street	Cookeville	931-526-9790		
Tye Dye Tattoo Inc.	210 W. 4th Street	Crossville	931-707-9432		
New Needle Tattoo	239 Dickson Plaza	Dickson	615-740-0506		
Tattoos by Bryan	518 Walden Street	Harriman	865-882-5935		
Domo's Ancient Art Tattoo Studio	726 N. 22nd Ave.	Humboldt	901-824-3825		NTA
Budo Tattoo Studio	100 Federal Dr.	Jackson	731-660 1311	www.budotattoo.com	APT, APP
Tye Dye Tattoo	470 E. Broadway Blvd.	Jefferson City	855-475-9383	www.tyedyetattoo.com	APT
Tye Dye Tattoo Inc.	1009 U.S. Hwy 11E.	Jefferson City	855-475-9383		
Arsmith Studio	4726 N. Roan Street	Johnson City	423-282-8288		
Hybrid Visuals Studio	1210 N. Roan Street #5	Johnson City	423-928-6500		
Sailor John's Tattoo & Piercing	1506 Lynn Garden Dr., Suite 5	Kingsport	423-230-6380		APT
Imagine That Tattoos	6714-A Central Ave. Pike	Knoxville	865-688-9778		
Tye Dye Tattoo	2608 Sutherland Ave.	Knoxville	865-522-4442	www.tyedyetattoo.com	APT
Tye Dye Tattoo Inc.	3501 Sutherland Ave.	Knoxville	865-522-4442		
Marked Flesh Tattooing	3566 Walker Ave. #2	Memphis	901-323-3883		
Memphis Tattoo Company	3387 Summer Ave.	Memphis	901-324-3848		
Memphis Tattooland	820 S. Cooper	Memphis	901-278-8288		
Icon	115 E. Lytle Street	Murfreesboro	615-217-2929		
Beaver's Dam Tattoos	2803-B Nolensville Road	Nashville	615-244-2930		
Body Language Tattoo & Piercing	451 Bell Road	Nashville	615-367-1200		
Icon	3404 West End Ave. #203	Nashville	615-298-2575		
Lone Wolf Body Art	1602 21st Ave. S.	Nashville	615-321-3111		

Texas

Name	Address	City	Phone	Website	Codes
Strange but True Studios	4021 Beltline Road, Suite 212-B	Addison	972-877-2102	www.jaystrange.com	
Tattoo Gallery	2416 Hobbs Street	Amarillo	806-355-7879	www.tat2gallery.com	APP, NTA
Body Art Tattoo Studio	308 W. Randol Mill Road	Arlington	817-274-6000		NTA
Eldiablo Ink	1902B Baird Farm Road	Arlington	817-548-5725		
Love-N-Hate	2801 E. Pioneer #102	Arlington	817-640-7817		
Nemo's Tattoos & Body Piercing	604 Doug Russell Road, Suite J	Arlington	817-265-8288		
Amillion Tattoos & BP	8556 Research Blvd., B&C	Austin	512-453-8287		APP
Belladonna Tattoo	104B E. 31st Street	Austin	512-469-9966		
Between the Lines Tattoo Studio	707 E. Braker Lane, Suite 201	Austin	512-835-2900		
Body Rites Austin	500B E. 6th Street	Austin	512-472-4804		APP
Capitol City Tattoo	300A E. 6th Street	Austin	512-494-0717	www.capitolcitytattoo.com	APT
Crimson Dragon Tattoo & Body Piercing	2928 Guadalupe #103-B	Austin	512-482-8288	www.crimsondragontattoo.com	APT, APP
Diamond Glenn's River City Tattoo	500B E. 6th Street	Austin	512-476-8282		
Mom's Tattoos	1703 S. Lamar Blvd.	Austin	512-912-8904		
Perfection Tattoo	4205 Guadalupe Street	Austin	512-453-2089	www.jasonbrookstattoo.com	APT
River City Tattoo	500B E. 6th Street	Austin	512-476-8282	www.rivercitytattoo.com	APT, NTA
True Blue Tattoo	607 Red River Street	Austin	512-472-2783		
Chucks' Custom Tattooing	2440 Interstate 10E.	Beaumont	409-898-2075		NTA
Gill Montie's Tattoo Mania	601 Park Street	Beaumont	409-838-2345	161.58.193.124/tattoomania	APT, NTA
Tattoo Consortium	3803 S. Texas Ave.	Bryan	979-846-7084		NTA
Rat A Tat Tat Tattoos	8545-4 FM 2673	Canyon Lake	830-899-2350		
Fat Boyz Tattooing	138 CR 2206	Cleveland	281-592-0639		
Poking You Tattoo	317 Dominik Dr.	College Station	979-764-8898		
Sharp Arts Tatt-2	153 CR 2092	Commerce	903-886-7028		
Skintones Tatto & Body Piercing	1001 Main Street	Commerce	903-886-6748		
Forever Art	6341 S. Padre Island Dr.	Corpus Christi	361-992-3729		APP
Ace in the Hole Piercing	2719 Main Street	Dallas	214-670-9988		
Addictive Body Art	2109 Main Street	Dallas	214-749-7864		
Dare Devil Tattoos	2919 Greenville Ave.	Dallas	214-887-1471		
Fineline Tattoo	9515 Skillman Street	Dallas	214-343-8287		
Obscurities	4000B Cedar Springs	Dallas	214-559-3706	www.obscurities.com	APP

Name	Address	City	Phone	Website	Codes
Skin Art Gallery	4299 Beltline Ave.	Dallas	972-387-1755		
Suffer City Tattoo	9012 Garland Road	Dallas	214-324-3989		
Tears of a Clown Tattoo	4416 Maple Ave.	Dallas	214-208-2696		
Intradermal Designs	2531 W. Prairie Street	Denton	940-381-5006		
Papa Mike's Texas Tattoo	1222 Fort Worth Dr.	Denton	940-387-3585		
Wizard Worx Tattooz	1109 Pine Dr.	Dickinson	713-392-1859		
Tattoo Body Works	316 N. Main Street	Duncanville	972-298-8774		
Magic Needle Tattoo & Body Piercing Studio	5826 FM 1960	East Humble	281-852-1003		
Hyperdermic Dreams	710 Cano Street, Suite 3	Edinburg	956-383-5590		
Dragon's Den Tattoo	6120 Dyer Street	El Paso	915-565-8288		
Renegade Tattoo	6010 1/2 Dyer Street	El Paso	915-562-8288		NTA
Xtreme Tattoo	4022 Montana	El Paso	915-542-0202		
Munkeewrench Tattooz	2903 W. Berry Street	Fort Worth	817-921-5830		
Psycho Clown Tattoo	1307 N.W. 28th Street	Fort Worth	817-626-8287		
Randy Adams Tattoo & Body Piercing	6467 E. Lancaster Ave.	Fort Worth	817-446-0272	www.randyadams.com	APP, NTA
Crossroads Studios	4712 E. Lancaster Ave.	Fort Worth	817-534-6888		
Liberty Electric Tattooing	2304A W. 7th Street	Fort Worth	817-334-0300		
The Ink Pit Tattoo Studio	1104 N. Grand Ave.	Gainesville	940-668-9002		
Chuck's Custom Tattooing	3802 Cove View Blvd.	Galveston	409-740-0262		
Fineline Tattoo	5510 Broadway Blvd.	Garland	972-240-0680		
Living In Skin	472 S. Main Street	Giddings	409-542-5662		
American Illustrators Tattoo Shop	109 Cox Dr., Suite B	Harker Heights	254-680-2929		NTA
China Jack's Tattoo Studio	Studio 202, W. Veterans Memorial Blvd.	Harker Heights	254-699-7227		NTA
Dragon Lady Tattoos	217 W. Veterans Memorial Blvd.	Harker Heights	254-699-2204		NTA
Piercings by KC	109 Cox Dr.	Harker Heights	254-680 2929		APP
Artistic Designs Tattooing & Body	6800 S. (610) Loop East	Houston	713-643-8672		
Electric Chair Tattoos & Body Piercing	6460 Westheimer	Houston	713-780-3500		
Lasting Impressions Custom Tattoos	14245 I-10 E. Frwy.	Houston	713-637-8282		
Red's Timeless Tattoo	1020 W. FM. 1960 #3	Houston	281-580-5454	www.redstimelesstattoos.com	APT, NTA
Sacred Heart Studio Inc.	327 Westheimer Road #3	Houston	713-523-0985	www.sacredheartstudio.com	APP

Name	Address	City	Phone	Website	Code
Scorpion Tattoos	1338B Westheimer Road	Houston	713-528-7904	www.scorpionstudiostattoo.com	APT
Shaws Tattoo Studio	1660 Westheimer Road	Houston	713-528-1255		NTA
Taurian	1505 Westheimer Road	Houston	713-526-2769	www.taurian.com	APP
The Skin Lab	12537 Jones Road	Houston	281-894-2282		
Atomic Body Art	305 N. Story Road	Irving	214-926-9262		
Sacred Art	1630 W. Irving Blvd.	Irving	972-254-4979		
In The Flesh	2590 Junction Hwy. C 1	Kerrville	830-367-3883		NTA
Aztec Soulz	3715 San Bernardo	Laredo	956-717-3777		
Distinctive Tattoo	6202 McPherson Ave., Suite 5	Laredo	956-722-4922		
Good Time Charlies Tattoos	920 S. Zapata Hwy.	Laredo	956-726-2503		
Tattoos by Rob	3609 San Dario	Laredo	956-726-2511		
Studio 13 1/2 Tattoos	1520 E. Main Street	League City	281-332-3265		
Love-N-Hate-Lewisville Studio	2302 S.H. 121 #150	Lewisville	214-488-5884		
Mystic Knight Tattoos	423 N. High Street	Longview	903-553-9727		
Tattoos by Pattie	RR 5 Box 132	Kilgore			NTA
American Eagle Tattoo & Body Piercing	4812 Ave. Q	Lubbock	806-744-5555		
Big Buddha Tattoo	1917 19th Street	Lubbock	806-741-0112		
Inkfluence	1406 Ave. Q	Lubbock	806-744-8282		
Piercecution	1820 19th Street	Lubbock	806-749-8280		
Double Trouble Tattoos— Piney Woods Tattoo	514 North Timber Land	Lufkin	936-634-9736		
Freedom Tattoos & Body Piercings	2805b Hwy. 281 N.	Marble Falls	830-798-8631		
Fineline Tattoo	3801 Gus Thomasson	Mesquite	972-686-9696		
Double Trouble Tattoos / Tat2 Majik	5207 South Street	Nacogdoches	936-462-7707		NTA
Working Man's Tattoo	417 Powell Street	Pampa	806-665-2320		
Smokin Jo's Custom Tattoos	3910 Fairmont Pkwy.	Pasadena	218-998-8730		
Smith's Ink-Slingers Tattoos	609 Houston Street	Queen City	903-796-3342		NTA
Shotgun Tattoos	2385 East Quinlan Pkwy.	Quinlan	903-447-3597		
Art Of Skin	628 South Saint Marys Street	San Antonio	210-227-7673		NTA
Dandyland	1821 B Bandera Road	San Antonio	210-432 5747	www.Dandyland.com	APP
Fine Line Tattoo Studio	5406 Military Dr. W.	San Antonio	210-674-8282		
Jolly Roger Tattoo Company	12253 West Ave., Suite B	San Antonio	210-979-8335		

Name	Address	City	Phone	
Skinjitsu Art Of Skin	2916 Pleasanton Road	San Antonio	210-928-1846	
Tattoo Arcade	519 E. Houston Street	San Antonio	210-225-0782	NTA
Steel Angel	718 E. Hopkins Street	San Marcos	512-396-8288	www.steelangelonline.com APP
Pan American Tattoo	22015 Ih-35 N.	Schertz	830-606-5557	NTA
Sheri's Texas Tattoo	2204 W. Broadway Street	Sweetwater	325-236-6234	www.sheristexastattoo.com APT
Tattoos by Gary	803 W. Moore Ave.	Terrell	972-563-0312	NTA
Dermagraphic Studio	911 New Boston Road	Texarkana	903-793-2276	
Firing-Line Tattoo Piercing	1505 S. Vine Street	Tyler	903-592-6166	NTA
Kelly's Tattoos	2525A E. Fifth Street	Tyler	903-596-8287	
A Different Drummer	4049 Burkburnett Road	Wichita Falls	940-855-4481	NTA
Altered Images Tattoo Studio	4021 Burkburnett Road	Wichita Falls	940-855-6987	NTA
Tattoos by Rev. John	Hwy. 751	Wills Point	903-560-1916	NTA

Utah

Name	Address	City	Phone	
Déjà Vu	3651 Wall Ave., Suite 1230	Ogden	801-399-1376	APP
Heavy Duty Tattoo Studio	3560 Riverdale Road	Ogden	801-627-4900	
Lost Art Tattoo-Studio #2	2618 Washington Blvd.	Ogden	801-393-4901	
Skin Ink	38 E. Main Street	Price	435-637-9078	
Tattootlan Tattoos & Piercing	1500 S. by Main Street #11	Salt Lake City	801-759-7200	NTA
A.S.I. Tattoo	1136 S. State Street	Salt Lake City	801-355-1181	NTA
Burnt Toast Productions	72 W. 400 S.	Salt Lake City	801-363-0908	
Good Times Tattooing	145 E. 900 S. #5	Salt Lake City	801-485-4777	
Koi	1301 S. 900 E. #7	Salt Lake City	801-463 7070	www.koipiercing.com APP
Lost Art Tattoos	348 S. State Street	Salt Lake City	801-537-7858	
A.S.I. Tattoo	2166 Highland Dr.	Salt Lake City	801 484-8700	NTA
Berserk Body Art Tattoo & Piercing	60 S. Main Street	Tooele	435-843-1076	

Vermont

Name	Address	City	Phone	
Jim Cooper's Wicked Sensation	Main Street	Brattleboro	802-258-9082	APT, NTA
Tattoos by Alex	1010 Western Ave.	Brattleboro	802-257-9251	
Counter Culture	132 Church Street	Burlington	802-660-2700	
Yankee Tattoo	198 Pearl Street	Burlington	802-862 3328	www.yankeetattoo.net APT, NTA

Virginia

Name	Address	City	Phone	Website	Notes
Crazy Daizy Tattoo Co.	952 W. Main Street	Abingdon	276-623-2345		
Lbn Tattoo & Piercing	3608 Forest Dr.	Alexandria	703-998-0004		
East Coast Tattoo	4786 Lee Hwy.	Arlington	703-276-2994		NTA
Rick's Tattoos	4818 Lee Hwy.	Arlington	703-527-8377		NTA
Body Art Tattoos	8 Chalmers Ct.	Berryville	540-955-0111		APT, NTA
Blacksburg Tattoo Co.	102B Roanoke Street	Blacksburg	540-552-5500		
Rendezvous	620 N. Main Street	Blacksburg	540-951-7442	www.mysaintjohn.com	
Virginia Tattoo Co. Tribe	Rte. 2, Box 435C	Bluefield	800-650-7721		APP
Sacred Ink	1833 Euclid Ave.	Bristol	276-466-3324		
Vintage Tattoo	2171 Ivy Road	Charolettesville	434-971-8282		
Inner Reflections	928 E. Lee Hwy.	Chilhowie	276-646-3511		
Misty Blue Tattoos	4503 Eaton Ct.	Dale City	703-583-1245		
Harry's Tattoo Shop	620 Westover Dr.	Danville	804-791-1073		APT
Sumoe Productions	313 Wolfe Street	Fredericksburg	540-371-4251	www.SuMoE.com	APT
Colorworks Tattoo Studio	514 N. Royal Ave.	Front Royal	540-636-8282		
Woody's Tattoos & Body Piercing	105 E.Oldtown Street	Galax	336-325-5477		
Abstract Art Tattoo	Plaza Shopping Ctr., Rte. 17 #3	Gloucester	804-642-0028	www.abstractarttattoo.com	APT
Accent Tattoo & Body Piercing	2072 George Washington Mem. Hwy.	Gloucester Point	804-642-7473	www.accent-tattoo.com	APT
138 Tattoo	1429 George Washington Mem. Hwy.	Gloucester Pt.	804-642 6500		
Tj's Dermagraphics	91 N. Main Street	Harrisonburg	540-564-1671		
Mystic Tattoo Co. & Exotic Body Piercing	143 Russell Street	Lebanon	276-889-4302		
Insane Ink	7 N. King Street, Suite A	Leesburg	703-777-5377		
Insane Ink	6 W. Market Street	Leesburg	703-777-5377	www.insaneinktattoos.com	APT, NTA
Exposed Temptations Tattoo	8686 Liberia Ave.	Manassas	703-335-2134		NTA
Purple Dragon Tattoo & Body Piercing Studio	546 Park Ave. N.W.	Norton	276-679-7546		NTA
Gothic Arts	Main Street	Radford	540-639-5200		
Adams Street Tattoo	309 N. Adams Street	Richmond	804-643-8288		
Alive Tattoo	3125 W. Cary Street, 2nd Floor	Richmond	804-254-9006		
Capital Tattoo	6501 Midlothian Turnpike	Richmond	804-440-4255		
Creative Designs Tattoo Studio	6301 Hull Street Road	Richmond	804-745-5577		

Name	Address	City	Phone	Code
Enigma Tattoos & Body Piercing	1817 W. Broad Street	Richmond	804-353-8161	APT
Ink	1825A W. Main Street	Richmond	804-359-4755	
Red Dragon Tattoo	425 W. Broad Street	Richmond	804-648-3319	APT, NTA
River City Tattoo & Piercing Company	1128 N. Blvd.	Richmond	804-359-5252	
Alex's New Tattoo	3121 Franklin Road	Roanoke	540-982-8800	NTA
Southerncross Tattoo	1209 9th Sreet	Roanoke	540-520-2255	
Copy Cat Tattoo Studio	Hale Building Rte. 19	Rosedale	276-880-1211	
The Ink Works Inc.	153 Campbell Hwy.	Rustburg	434-332-3428 877-903-7997	APT
Tattoo-U	3895 Jefferson Davis Hwy. (Rte. 1)	Stafford	703-445-1067	
Ancient Art Tattoo	4978 Cleveland Street	Virginia Beach	757-497-8300	NTA
Lucky 13 Tattoos	1411 Old Bridge Road	Woodbridge	703-494-1281	

Washington

Name	Address	City	Phone	Code
Gargoyle Tattoo	104 S. H Sreet	Aberdeen	360-532-4645	
Bandana's Skin Art	1814 Commercial Ave.	Anacortes	360-299-9831	
Donovan's Tattoo	801 E. Main Street	Battleground	360-666-1121	APT
Camden Chameleon	1146 N. State Street	Bellingham	360-676-7330 www.camdenchameleon.com	APP
Old School Tattoo	209 E. Holly Street	Bellingham	360-715-8261	APP
#1 Action Tattoo	421 1/2 S.W. 152nd Street	Burien	206-988-5863	
Painless Ric's Tattoo Studio	315 N.E. Birch Street	Camas	360-694-3899	APT
Ink Expressions Tattoo	250 South Main Street	Colville	509-684-1600	
Illuminations	1261 Forbes Lane	Elum	509-929-1109	
Darkhorse Tattoo	3620 Rucker	Everett	425-317-9041	
Painless Steel Tattoo & Body Piercing	1809 Broadway	Everett	425-259-5110	NTA
The Enemy Tattoo	9701 Evergreen Way	Everett	425-348-3557	
Adams Tattoo Co.	32700 Pacific Hwy. S., Suite 2	Federal Way	253-815-8238	
Hoops Body Arts	115 W. Kennewick Ave.	Kennewick	509-586-4667	
Monarch Tattoo	320 W. Kennewick Ave.	Kennewick	509-582-5598	
Monarch Tattoo & Body Piercing	320 W. Kennewick Ave.	Kennewick	509-582-5598	NTA
Tattoo Alley	23800 Pacific Hwy. S., Suite 106	Kent	206-878-7171	
Bloodbought Tattoo Beat	1220 Ocean Beach Hwy., Suite D	Longview	360-414-4154	
Eclipse Ink	15315 Hwy. 99 #7	Lynnwood	425-742-8467 www.eclipseink.com	APP

Name	Address	City	Phone	Website	Codes
Lynnwood Tattoo	15315 Hwy. 99 # 7	Lynnwood	425-742-8467		APT
Primeval Ink Tattoo	112 N. Lewis	Monroe	360-805-6889		
The Hive	116 W. Broadway Ave.	Moses Lake	509-766-7418	www.hivetattoo.com	APP
Altered States Essential Body Art	307 E. 4th Ave.	Olympia	360-754-6623		
Spidermonkey Tattoos	215 E. 4th Ave.	Olympia	360-709-9650		
Tat2times Studio	504 Franklin Street S.E.	Olympia	360-754-4345		
Aarron Laidig's Tattoo Elegance	330 E. 1st #6	Port Angeles	360-457-0491		APT
Libertycall TATTOO	210 Taylor Street #4	Port Townsend	360-385-6579		
Silver City Tattoo & Body Piercing Studio	19559 Viking Ave.	Poulsbo	360-779-6799	www.silvercitytattoo.com	APT, NTA
Kingpin Tattoo Studios	9508 Canyon Road E.	Puyallup	253-535-6550		
The Tattoo Machine	13507 Meridian E., Suite I	Puyallup	253-770-7550		
Gypsy Jill Tattoo	By appointment only	Redmond	425-868-3578	www.gypsyjill.com	APT, NTA
Custom Skin Design	1393 George Washington Way	Richland	509-946-1847		NTA
85th Street Tattoo	315 N.W. 85th Street	Seattle	206-297-7438		
Anchor Tattoo	5317 Ballard Ave. N.W.	Seattle	206-784-4051		
Apocalypse Tattoo	1556 E. Olive Way	Seattle	206-320-8447		
Artcore Studios	5501A Airport Way S.	Seattle	206-767-CORE		
Body Circle Designs	PO Box 68249	Seattle	800-244-8430	www.bodycircle.com	APP
Chrome Ohm Tattoo	817 E. Thomas	Seattle	206-325-9482		
Laughing Buddha	219 Broadway E. Capitol Hill	Seattle	206-329-8274		APP
Lucky Devil	1720 12th Ave.	Seattle	206-323-1637		
Slave to the Needle Tattoo	508 N.W. 65th Street	Seattle	206-789-2618	www.slavetotheneedle.com	APT, NTA
Tina Bafaro Tattooist	79 S. Main Street	Seattle	206-749-4059	www.bafaro.com	
Vyvyn's Tattoo	1516 Western Ave. N.	Seattle	206-622-1535		NTA
Top Tattoo & Body Piercing	19918 Aurora Ave. N.	Shoreline	206-533-TOPS		APP
A Mark of the Vampire	15712 1st Ave.	South Burien	206-243-1219		
Constant Creations Tattoo	7524 W. 1st Ave.	Spokane	509-747-8600	www.constantcreationstattoo.com	APT
Lady Luck Tattoo	8611 E. Sprague	Spokane	509-922-8120		NTA
Tiger Tattoo	825 W. Garland Ave.	Spokane	509-325-8265		NTA
Tsunami Tattoo	3213 S. 38th Street, Suite B	Tacoma	253-476-4053		
Storybook Ink Tattoo	200 E. "W" Street, #E	Tumwater	360-701-9633		
Necronomicon Tattoo	4619 N.E. 112 D 106	Vancouver	360-891-6561		
Panda Media	504 Washington Street	Vancouver	503-310-9677		

Name	Address	City	Phone	Website	Notes
Paul Massaro & Family Tattoo Works	8600 E. Mill Plain Blvd., Suite D	Vancouver	360-881-1313		NTA
C & L Tattooing & Body Piercing	76 Wallula Ave.	Walla Walla	509-522-1732		NTA
Immortal Ink	2007 E. Isaacs Ave.	Walla Walla	509-529-5033		NTA
S & M Studios	1047 Frankland Street	Walla Walla	509-525-6294		
Zoo Tattoo Studio	515 N. Wilbur Ave.	Walla Walla	509-526-7270		
Body Art Studio	201 N. 25th Ave.	Yakima	509-469-2050		
Jim & Jenni's Quality Tattoos & Body Piercing	814 N. First Street	Yakima	509-452-8287		APT, NTA

West Virginia

Name	Address	City	Phone	Website	Notes
Danny Fowler's Ancient Art	3812 Maccorkle Ave.	Charleston	304-925-8240		
Thinkin Ink Tattoo Studios	508 Race Street	Fairmont	304-366-1279		
New World Tat2	Rte. 2, Main Street	Follansbee	304-527-9872		
Body Art by Brian	320 Bridge Street	Huntington	304-522-0224	www.geocities.com/bodyartbybrianinc	APT, NTA
Dreamquest Tattoo Studio	519 W. King Street	Martinsburg	304-262-4662		NTA
Lure Tattoo & Piercing	3206 Dudley Ave.	Parkersburg	304-422-6228	www.luretattoo.com	APT
Custom Dreams	1123 Mercer Street	Princeton	304-431-1170		APT, NTA
Temple Tattoo	35 Potomac Street	Ridgeley	304-738-1671		NTA
Mountain Ink Tattoo	Main Street	White Sulphur Spring	304-536-2219		NTA
Skin Deep Tattoos	By appointment only	Winfield	304-586-2349		

Wisconsin

Name	Address	City	Phone	Website	Notes
Touch of Class	309 Main Street	Cornell	715-239-6605		
Exotic Ink	4903 S. Packard Ave.	Cudahy	414-294-3903		
Skinprints Tattooing & Bodypiercing	309 E. Grand Ave.	Eau Claire	715-831-8780		
In Your Face Tattooz	270 S. Main Street	Fond Du Lac	920-922-8323		
Arrrageous Ink	1035 Main Street	Green Bay	920-435-7152		NTA
Tattooing by Mark	8250 Fawn Lake Road	Harshaw	715-277-3732		
In Your Face Tattooz	211 N. Main Street	Hartford	262-673-5739		NTA
Ink Factory Tattoos & Body Piercings	406 Second Street	Hudson	715-381-2957		

Name	Address	City	Phone	Website	Notes
Blue Line Tattoo & Body Piercing	523 Main Street	La Crosse	608-784-1290		
Steve's Tattoo	1205 Williamson Street	Madison	608-251-6111	www.stevestattoo.com	APT, NTA
Tears & Laughter Tattooing	PO Box 260203	Madison	608-217-6122		
Ultimate Arts Custom Tattoo	3236 Commercial Ave.	Madison	608-249-7352		
Doc's Tattoo Studio	603 S. Park Ave.	Medford	715-748-3558		NTA
Needle Freaks	546 3rd Street	Menasha	920-729-1550		
Absolute Tattooing	N89W. 16687 Church Street	Menomonee Falls	262-255-4884		NTA
Adam Bomb Galleries	524 S. 2nd Street	Milwaukee	414-276-2662		
Bodyworks	4380 S. 76th Street	Milwaukee	414-321-1336		
Gothic Body Tattoos	1653 N. Farwell Ave.	Milwaukee	414-223-4244		
Dermagraphics by Doc	1518 11th Street, Suite 1-2	Monroe	608-328-2900		
Steve's Tattoo	139 High Ave.	Oshkosh	920-426 8336	www.stevestattoo.com	APT
Modern Image Tattoo	1705 Douglas Ave.	Racine	262-619-9520		
Skin Candy Tattoo	3113 Washington Ave.	Racine	262-632-0549		
Tattoos by Hoss	320 Ross Ave. #3	Schofield	715-241-8288		
Blackwater Tattoo Studio	5608 Business Hwy. 51 S.	Schofield	715-241-7999		
Steve's Tattoo	913 Main Street	Stevens Point	715-344-4739	www.stevestattoo.com	APT
Black Dragon Tattoo	321 W. Main Street	Waukesha	262-521-1177		NTA
Altered Evolution	7234 W. Greenfield Ave.	West Allis	414-302-1777		
Sacred Skin Inc.	9509 W. Greenfield Ave.	West Allis	414-259-9930		
Images In Ink Tattooing	3321 8th Street S.	Wisconsin Rapids	715-423-6656		
Diamond Ted's Tattoo Studio	941 N. Washington Street	Janesville	608-754-8288	www.diamondted.com	APT

Wyoming

Name	Address	City	Phone	Notes
Uncle Freaky's Tattoo & Piercing	252 2nd Ave. W.	Deaver	307-664-2236	
Art from the Heart	702 Douglas Hwy.	Gillette	307-682-7898	
Pleasures Body Art	208 W. Grand Ave.	Laramie	307-742-5501	APT
Blue Dragon Tattoo	330 B Street	Rocksprings	307-362-6150	